The Sea

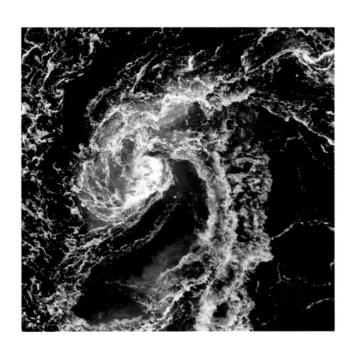

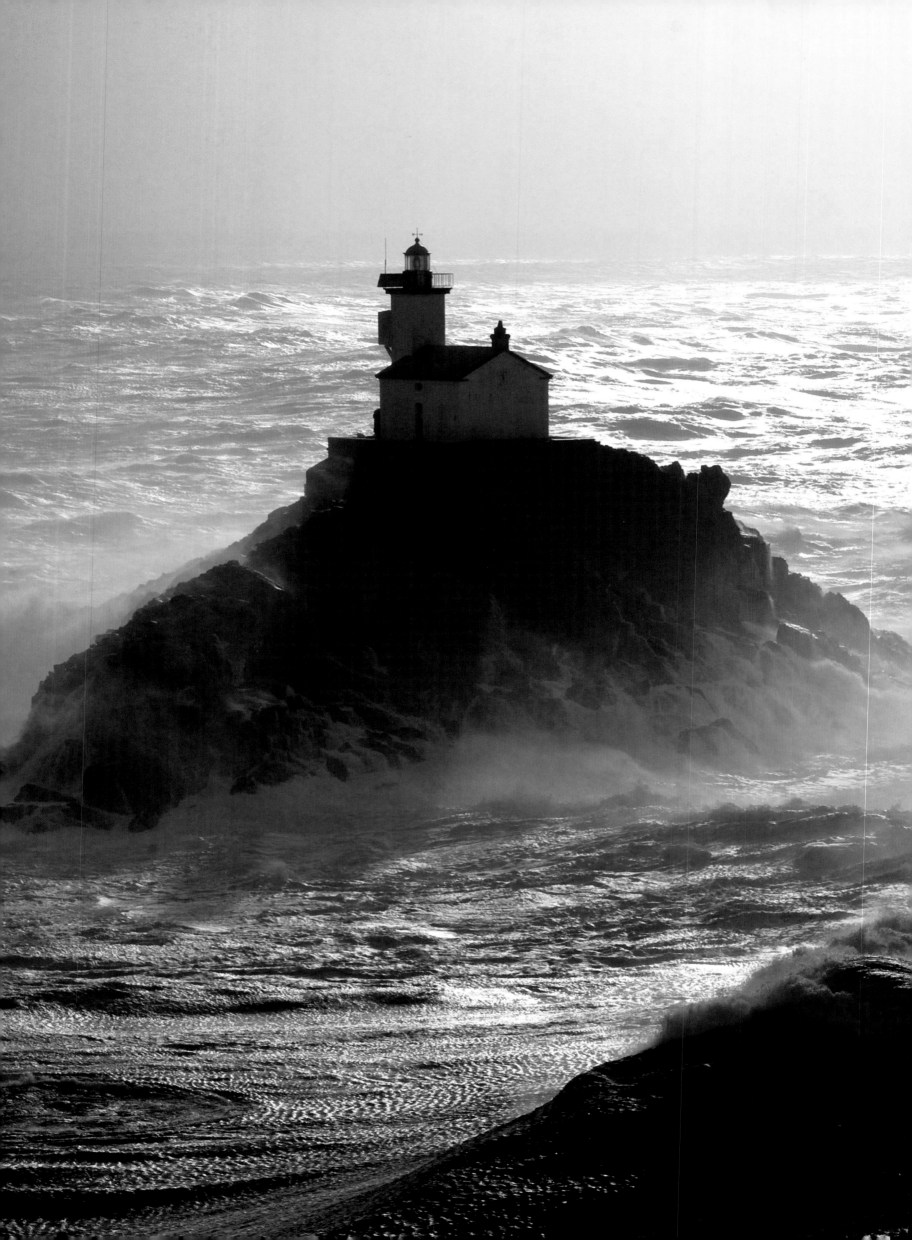

The Sea

A Photographic Celebration
of the First Wonder of the World

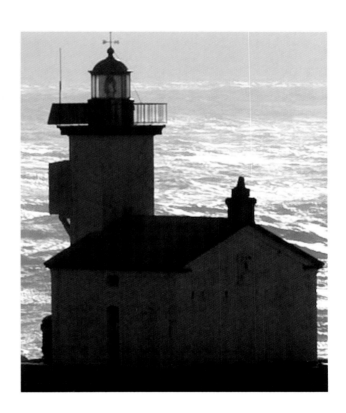

ADLARD COLES NAUTICAL
LONDON

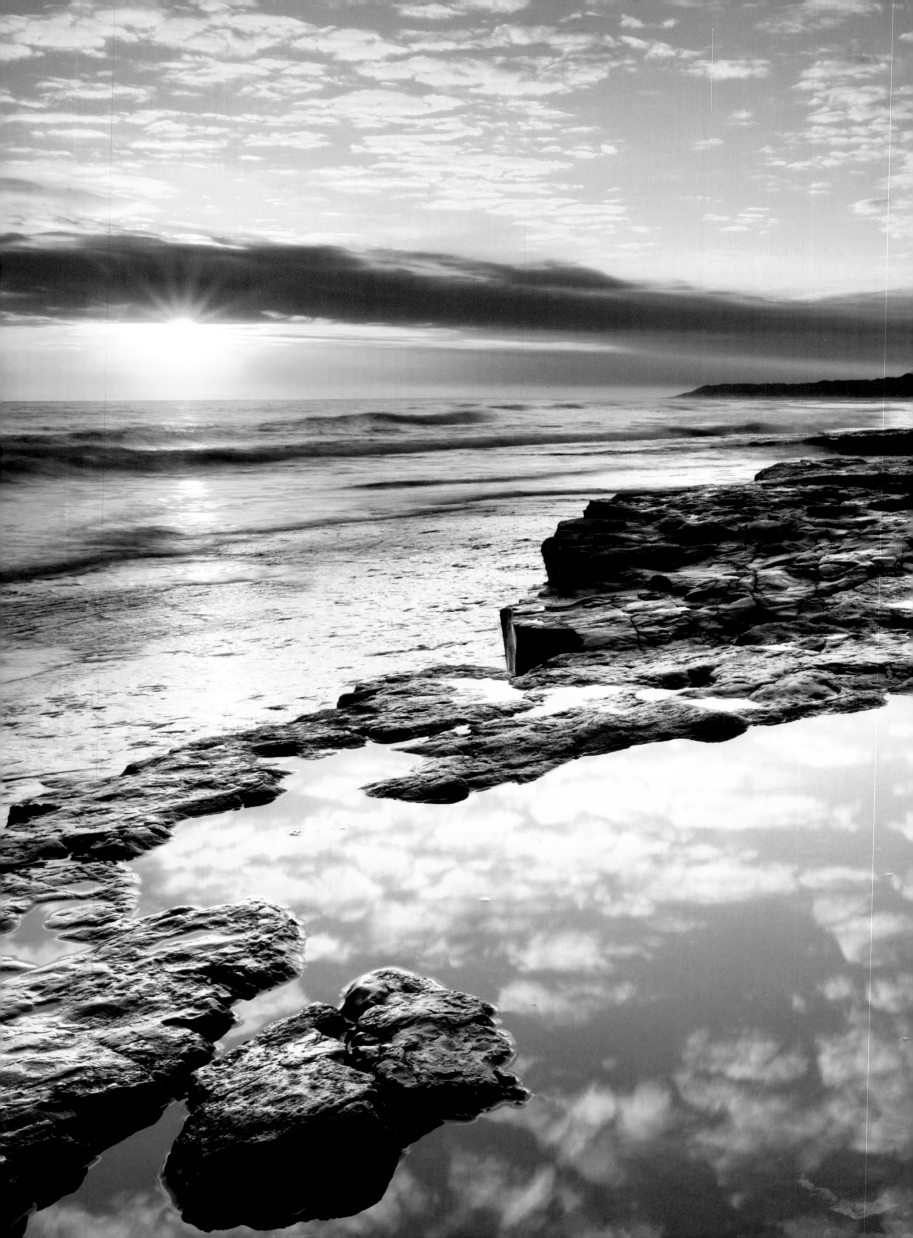

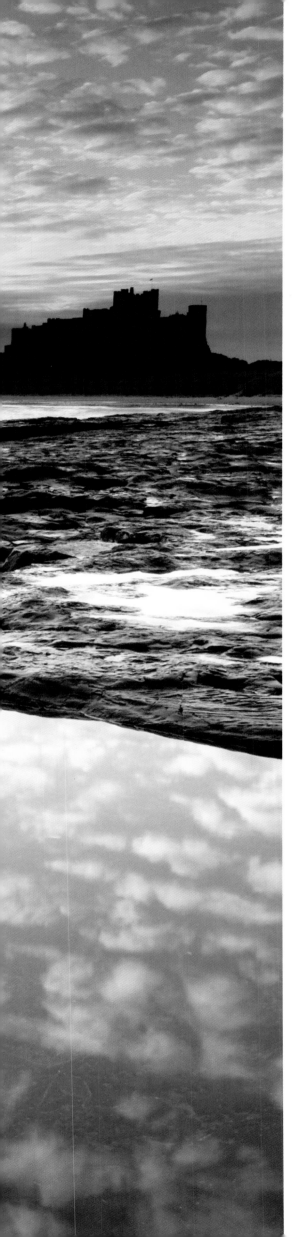

Contents

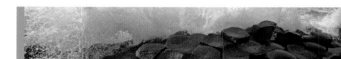

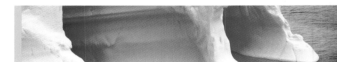
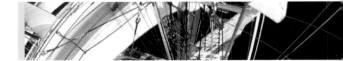

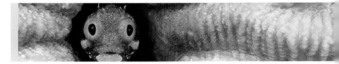
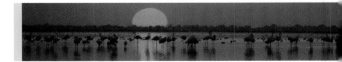

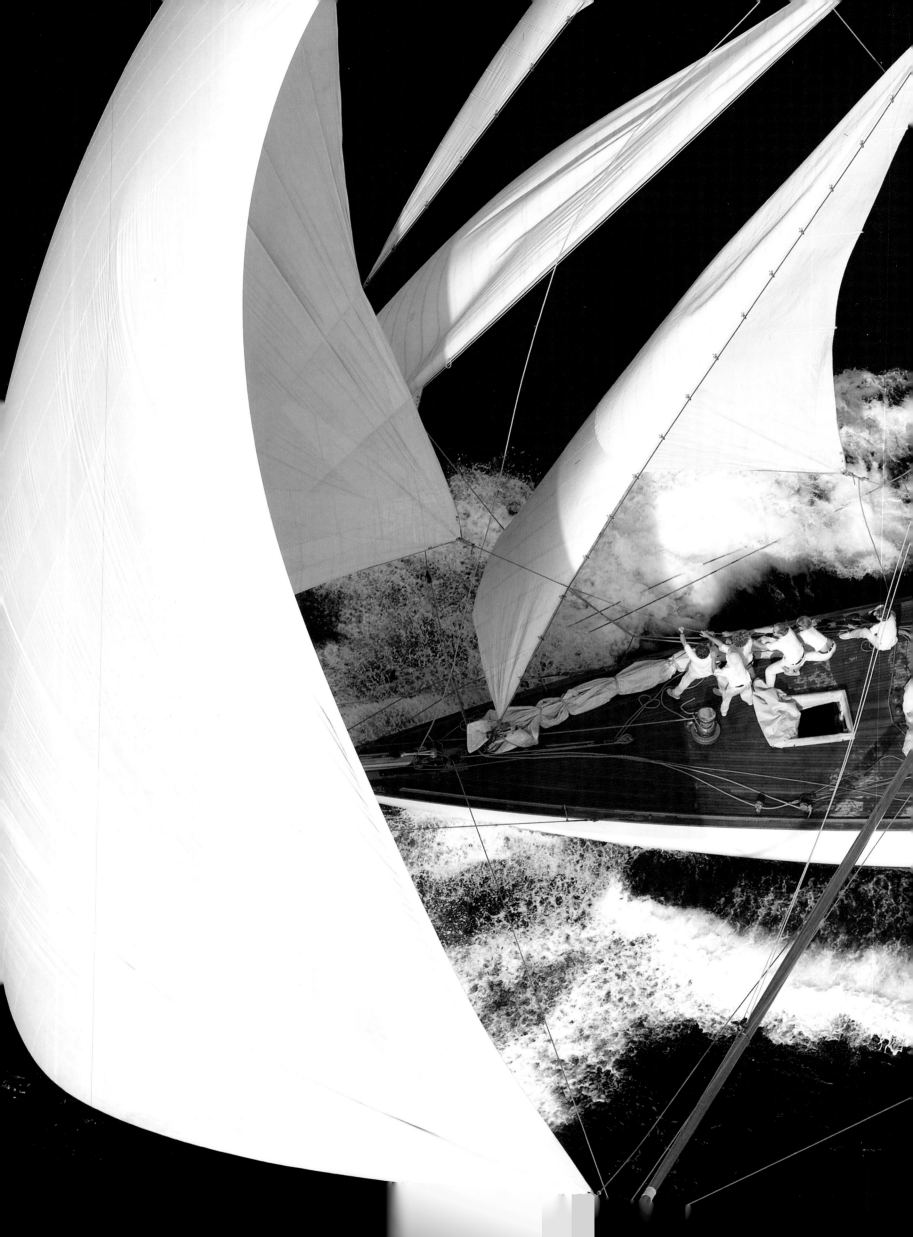

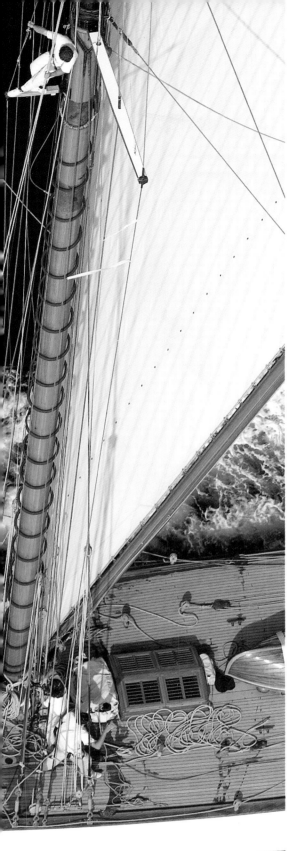

Introduction

It is no coincidence that so many of the world's creation myths involve water. From the native tribes of North and South America to the prehistoric people of ancient Egypt and Mesopotamia, the beginning of the world is often described as one vast featureless ocean. Out of this apparent void, all else is born — be it by animals forcing themselves through the surface or, according to the Christian version, God dividing sky and earth from sea. Indeed, modern science supports the idea of a vast ocean in which the first forms of life evolved and from which, some 400 million years ago, we were all created.

Not surprising, then, that the sea holds such a primeval fascination, not just for people who live close to its shores, but for those who live far inland and may have only occasionally glimpsed it on their summer holidays or in the movies. We are, in so many ways, made of water.

But why go to sea in the first place? At first, there must have been the simple need to cross a body of water, to travel from one bit of land to another, perhaps to reach better hunting grounds or new sources of timber. Later, there would have come the need to trade with other people and, perhaps simultaneously, the realization that the sea could be used as a means of war as well as friendship.

Even now, as we go about our lives in increasingly populous urban environments, the sea dominates our lives without us even knowing it. About 71 per cent of the earth's surface is covered in water, of which 97.5 per cent is sea. That's seven seas or five oceans, depending how you look at it, which add up to a

Crew working on the foresails of a yacht at Les Voiles de Saint-Tropez, France.

total of 140 million square miles — or 37 times the size of the United States of America.

The effects of this vast volume of water on our lives are hard to overestimate. Weather systems formed over the Atlantic influence the climate of the whole of Western Europe, while the Indian Ocean is responsible for the monsoon rains, which dominate life throughout Asia. On the other side of the world, relatively small changes in the temperature of the Pacific cause the unpredictable shifts in weather patterns known as El Niño and La Niña. Although the effects of these are felt most immediately by the local fishermen of South America, the knock-on effects reverberate worldwide. Which is why a warm current off the Chilean coast can quite literally result in landslides in California and forest fires in Indonesia.

It is this interconnectedness that makes the sea so important — and yet so vulnerable. Just as the human skin is an organ which reveals the health of the whole body, so the sea can be regarded as a vast living mechanism which both controls and measures the health of our planet. If the sea is sick, it doesn't just affect everything else: it means the rest of the world is already sick too.

The images in this book celebrate the sea at its healthy best: sometimes calm, often excitable, occasionally menacing — but always sublime. It is a sea teeming with life, colours and shapes. A sea of a thousand different moods and characters. A sea which is sometimes a friend and sometimes an enemy. It is a sea which is utterly oblivious of mankind, yet which ultimately depends on us for its wellbeing. Whether it stays in good health will be a measure of our success as caretakers of this planet.

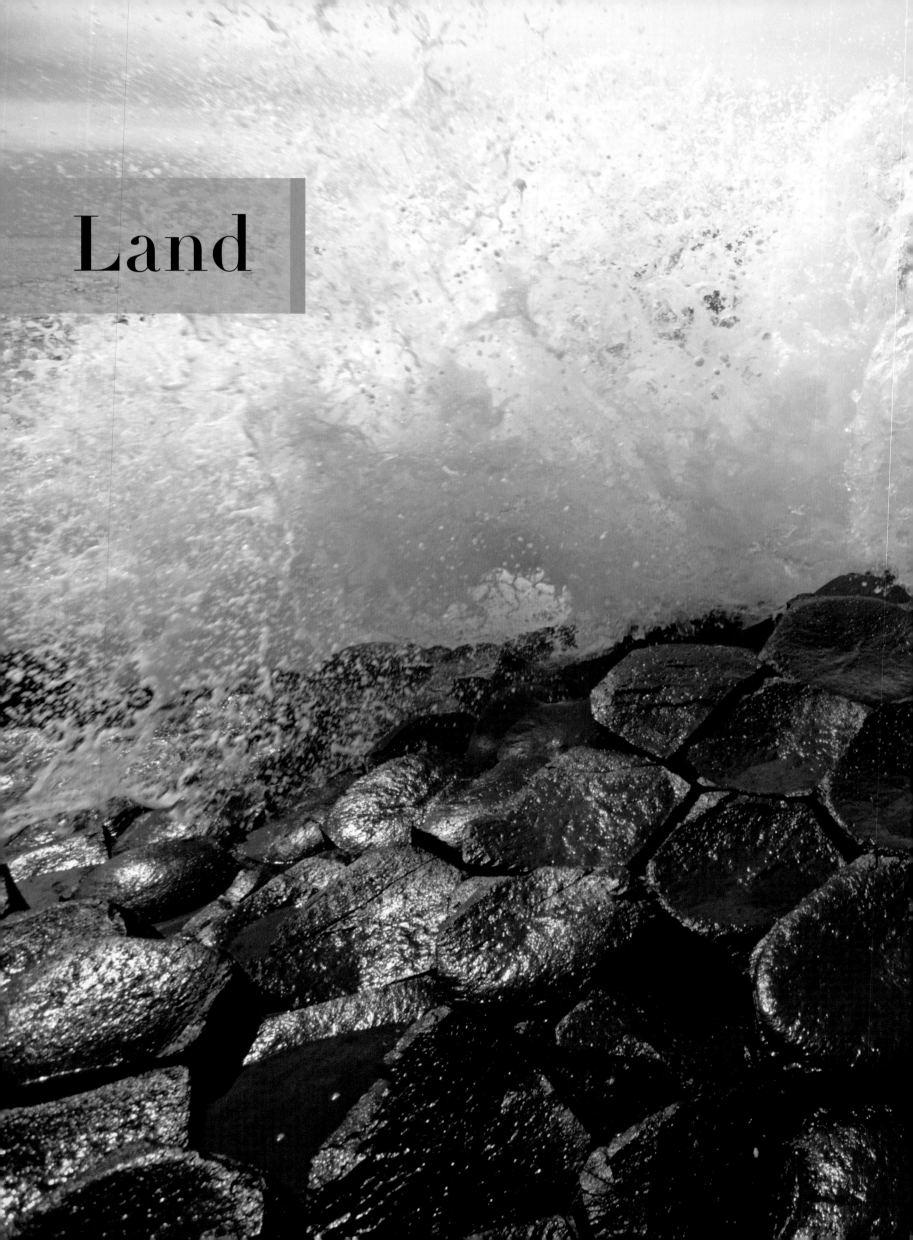

Land

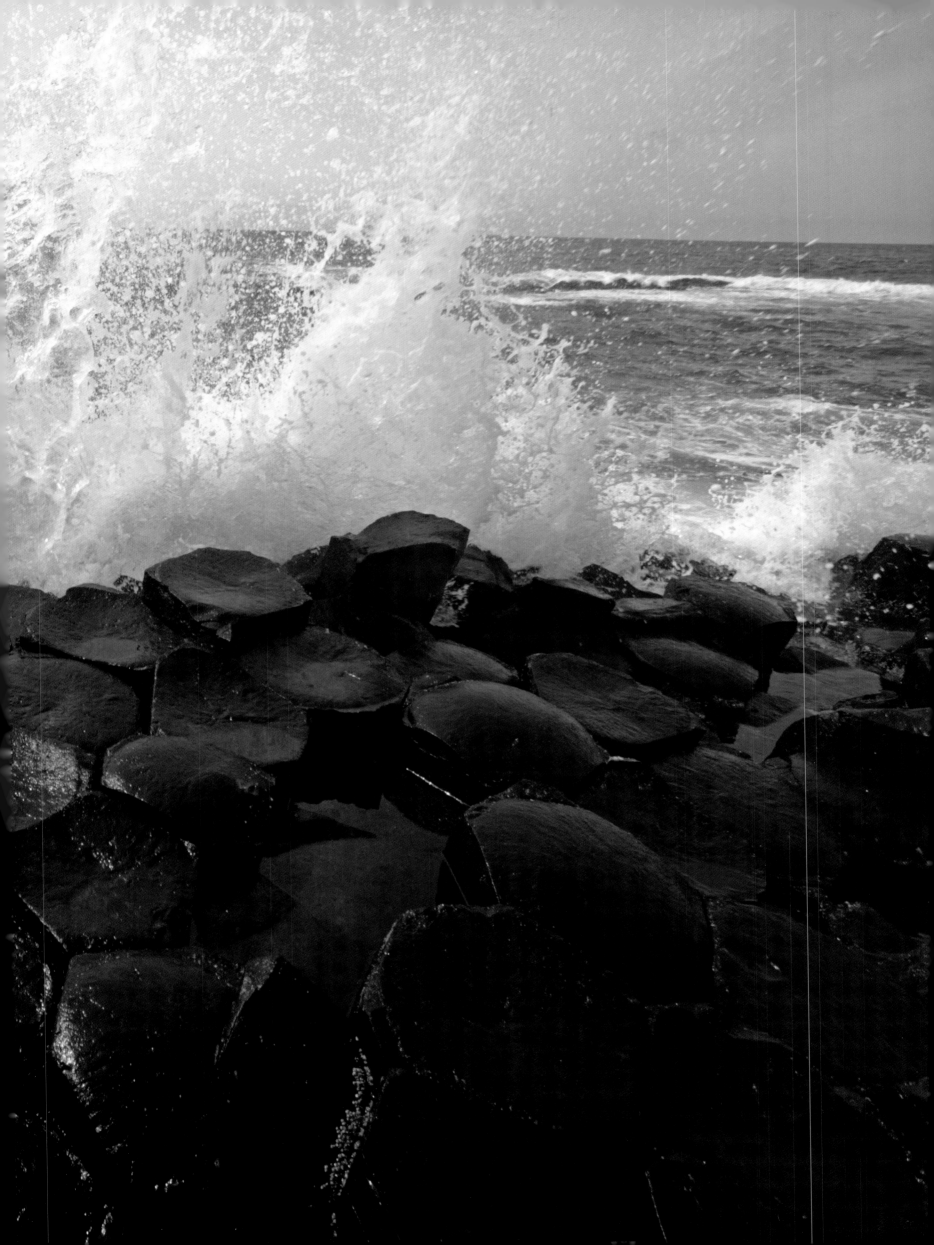

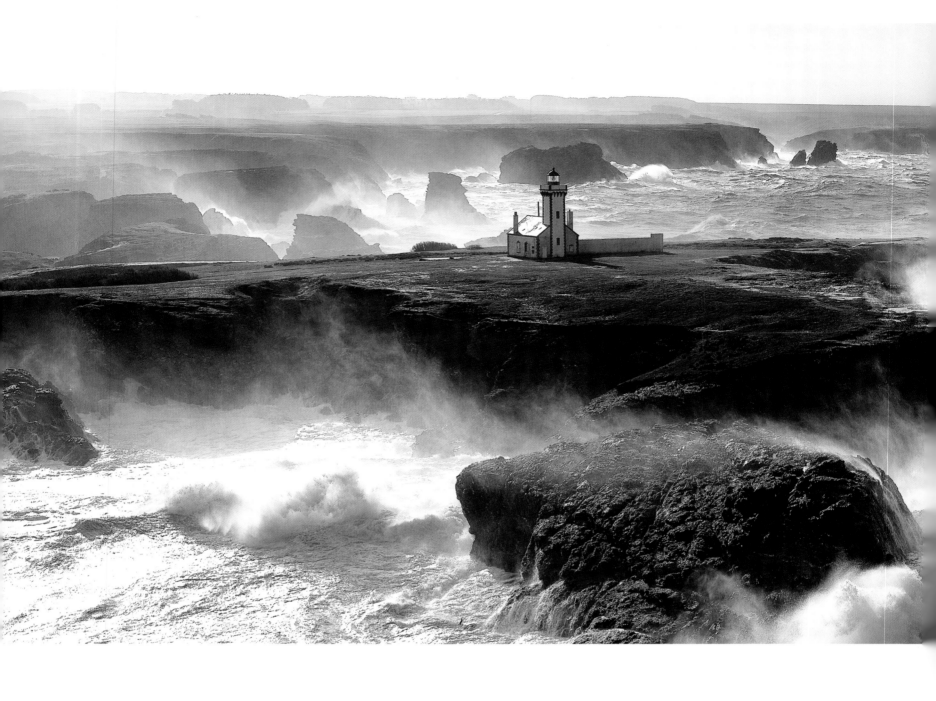

When the sea meets the earth

What happens when an unstoppable force meets an immovable object? In the case of the sea meeting the land, the answer is that you get some very spectacular pictures indeed. It would be tempting to say that the sea must ultimately yield to the immovability of the land but, as the jagged, sea-worn cliffs depicted in several of the following images suggest, it may be that in the long term the unstoppable force has the advantage. For, as far as the sea is concerned, everything is just

material waiting to be pounded into sand.

In the meantime (and it may take a few billion years, so we may as well enjoy ourselves until then) the meeting of land and sea provides one of the richest habitats in the world – for animals and humans alike. Further away from land, as the sea deepens, oxygen and light are reduced, and most forms of life struggle to survive. But the particular combination of sunlight and warm water prevalent in coastal waters creates a fertile environment in which plankton and algae thrive.

These in turn attract animals of all shapes and sizes, which feed in the nutrient-rich waters, and provide food for other predatory creatures. It's a potent cycle that makes these areas among the most bio-diverse habitats in the world.

Wherever there's a reliable source of food, you'll usually find humans settled nearby, and coastal waters are no exception. Even before mankind built the first boats, we were already reaping a rich harvest from the sea, collecting shells and seaweed from the shore. Once we were able to take to

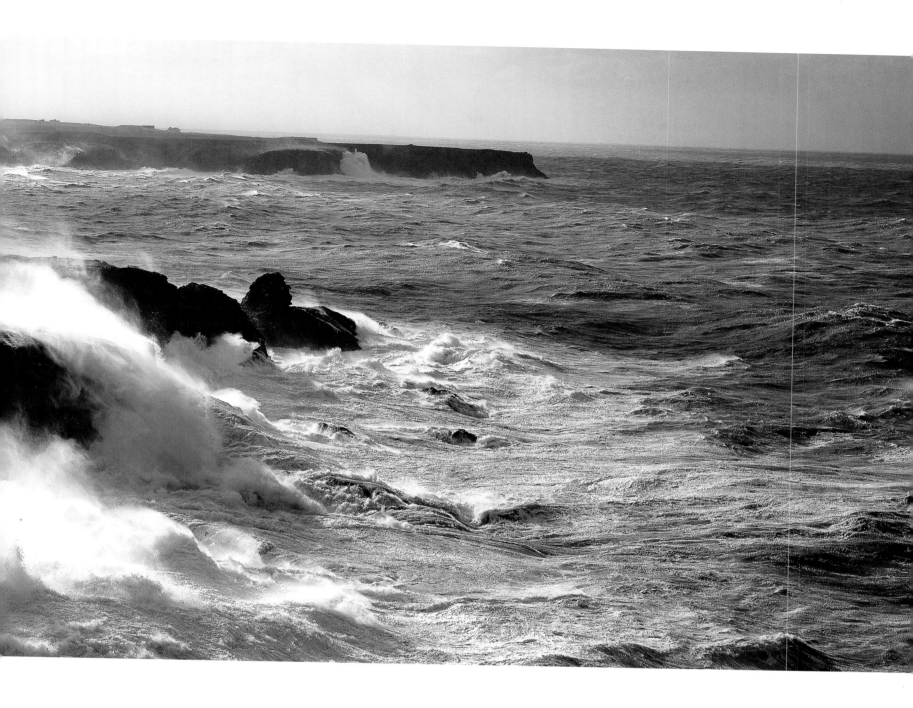

the water, our bounty expanded exponentially. Coastal communities developed to service this activity and to collect and process the fruits of the sea – from fish to salt and, in some places, whale blubber.

With the advent of international trade, the role of these 'littoral' communities widened, and they became gateways to the rest of the world. The increase in trade marked a fundamental shift in mankind's relationship with the sea. For thousands of years sailors had ventured no further than they needed to fill their nets, but now they were required to sail to strange lands and negotiate unknown waters. Whereas before, they were able to avoid the sea's worst tempers, now they were forced to endure them. The sea was becoming a foe as well as an ally.

And, as every sailor knows, the most dangerous place to be in a storm is close to land. While out at sea, a sailor had to put his faith in the strength of his ship and the skill of his fellow sailors, but once in sight of land he also had to contend with the additional dangers of navigational errors, unknown rocks and meeting other ships. Not for nothing was the arrival at harbour both the most anticipated and the most feared part of any voyage.

Pointe des Poulains lighthouse, Belle-Ile Island, Morbihan, Brittany.

Previous pages: Waves crashing onto basalt rocks, Giant's Causeway, Unesco Heritage Site, Northern Ireland.

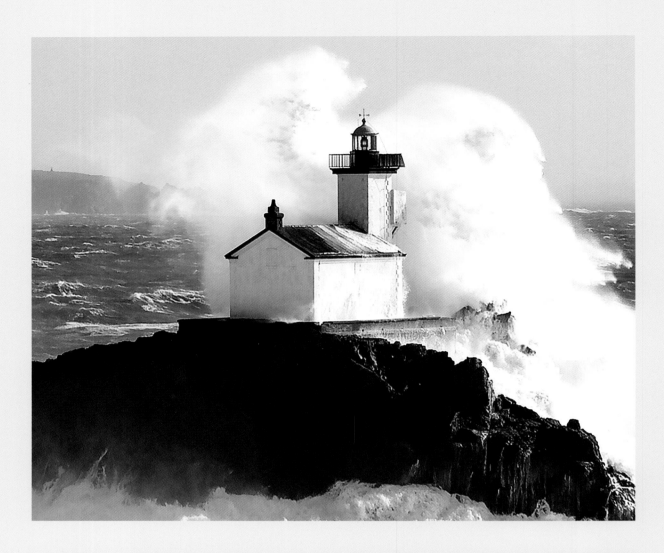

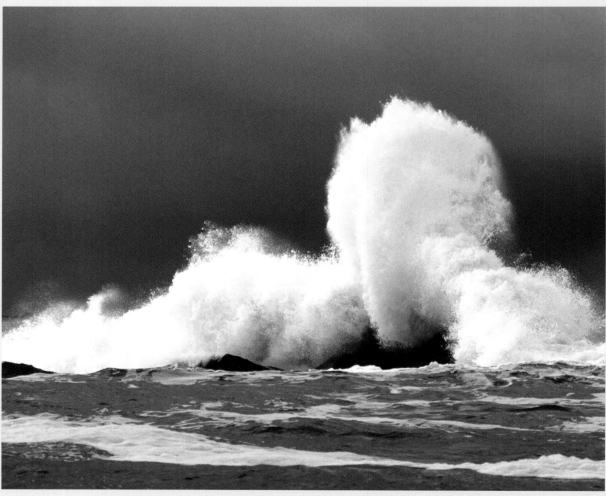

Top: Waves breaking over Tevennec lighthouse, Finistère, Brittany.

Bottom: A wave breaking on the rocks near Valentia, south west Ireland.

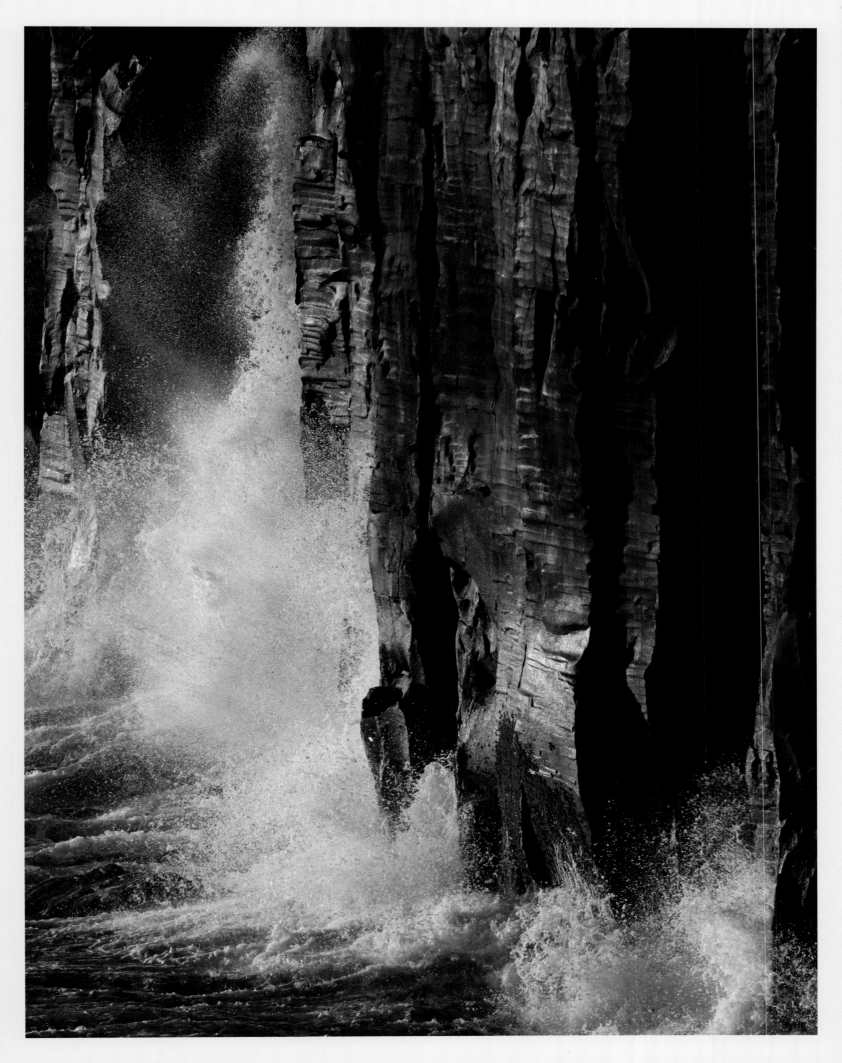

*The sea beats against basalt columns at
sunrise, Langanes peninsula, Iceland.*

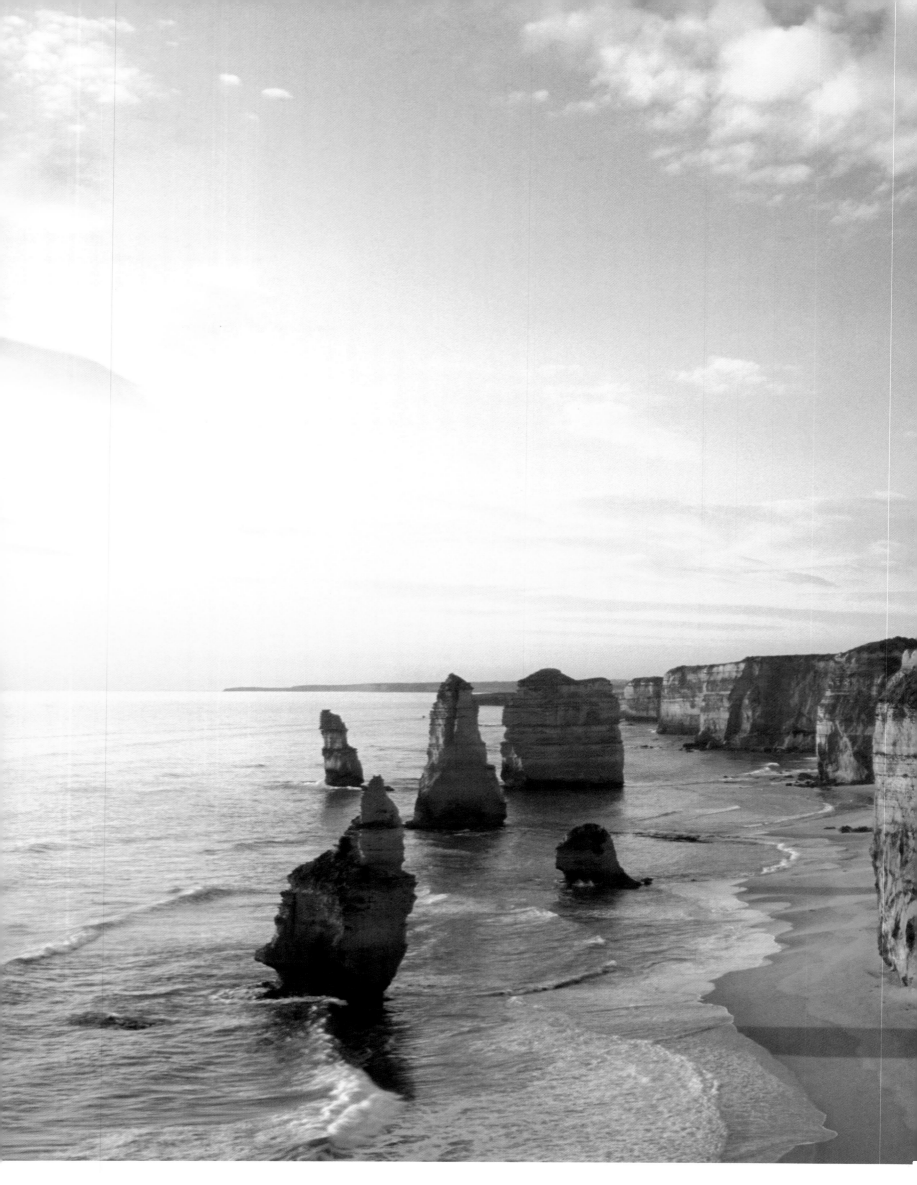

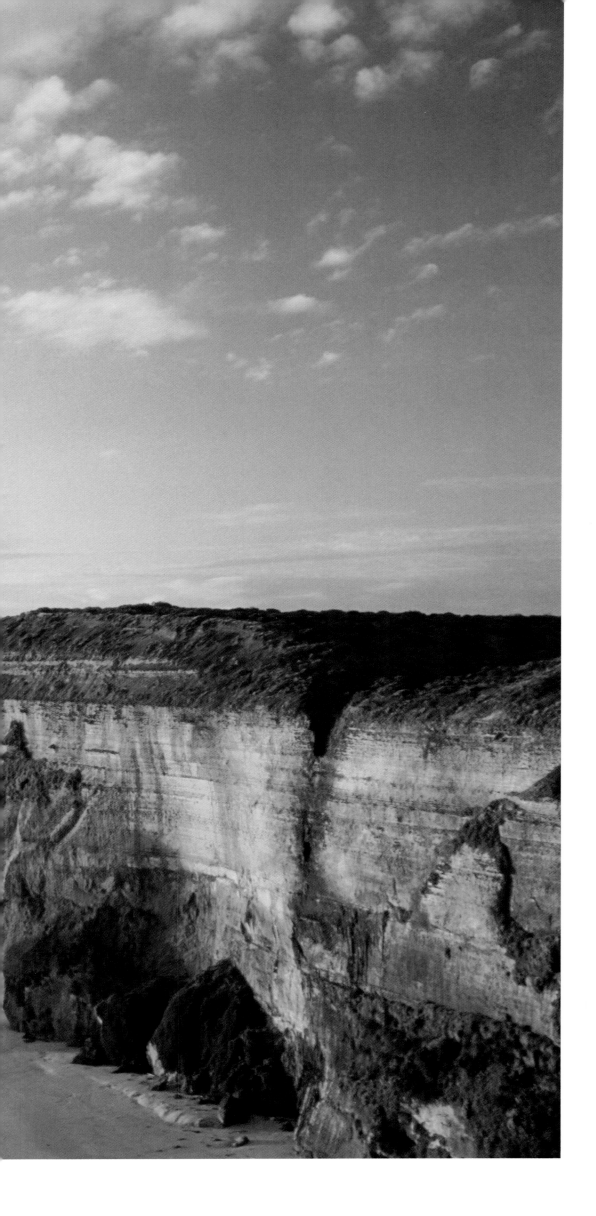

The limestone sea stacks known as the
Twelve Apostles, Port Campbell coast,
Victoria, Australia.

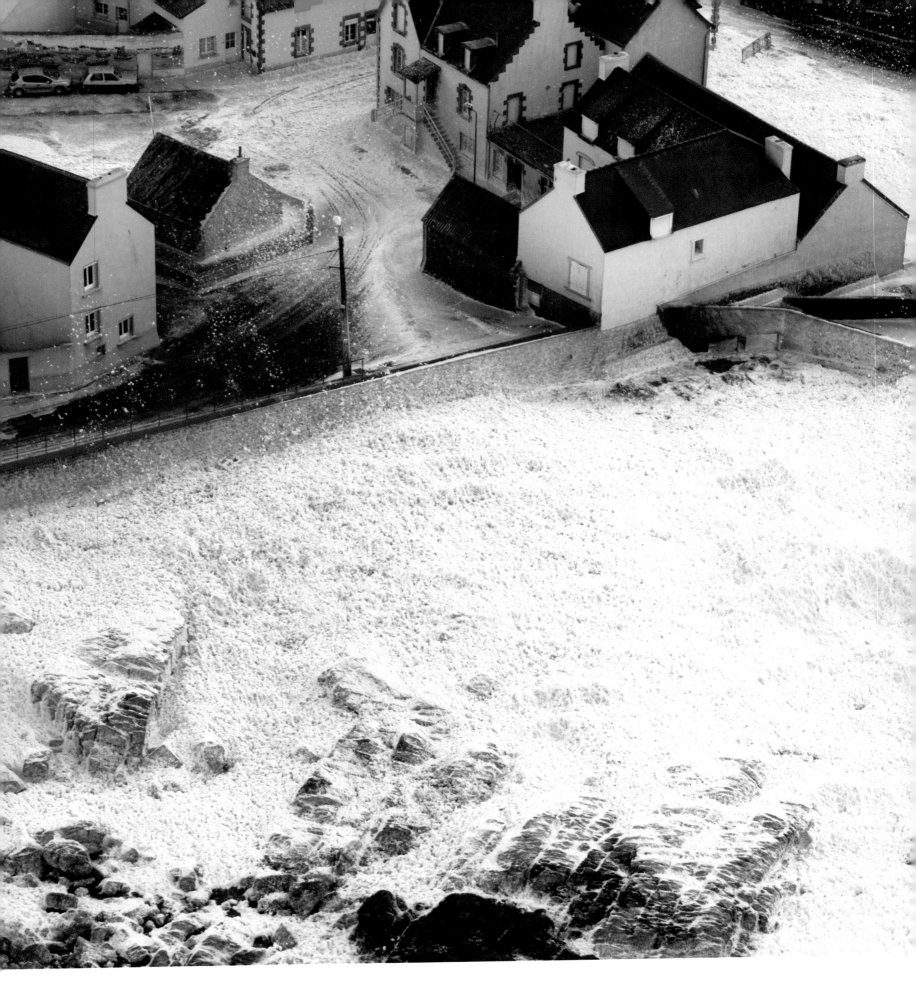

The town of Saint-Guénolé has its streets flooded in a storm, Finistère, Brittany.

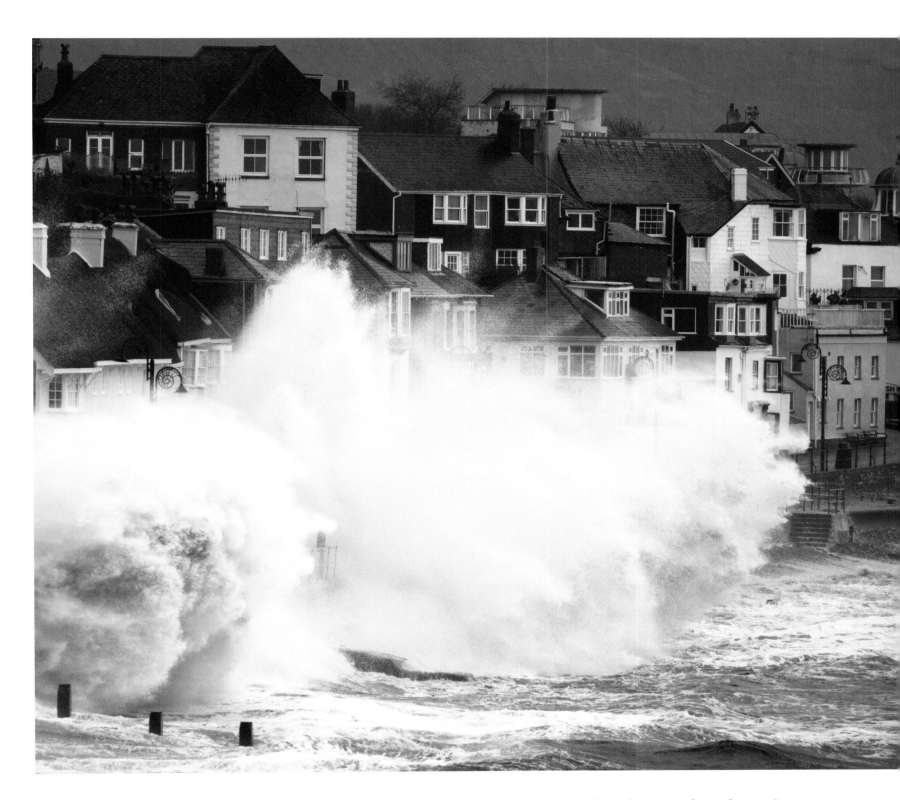

Storm battering the seafront at Lyme Regis, Jurassic Coast World Heritage Site, Dorset.

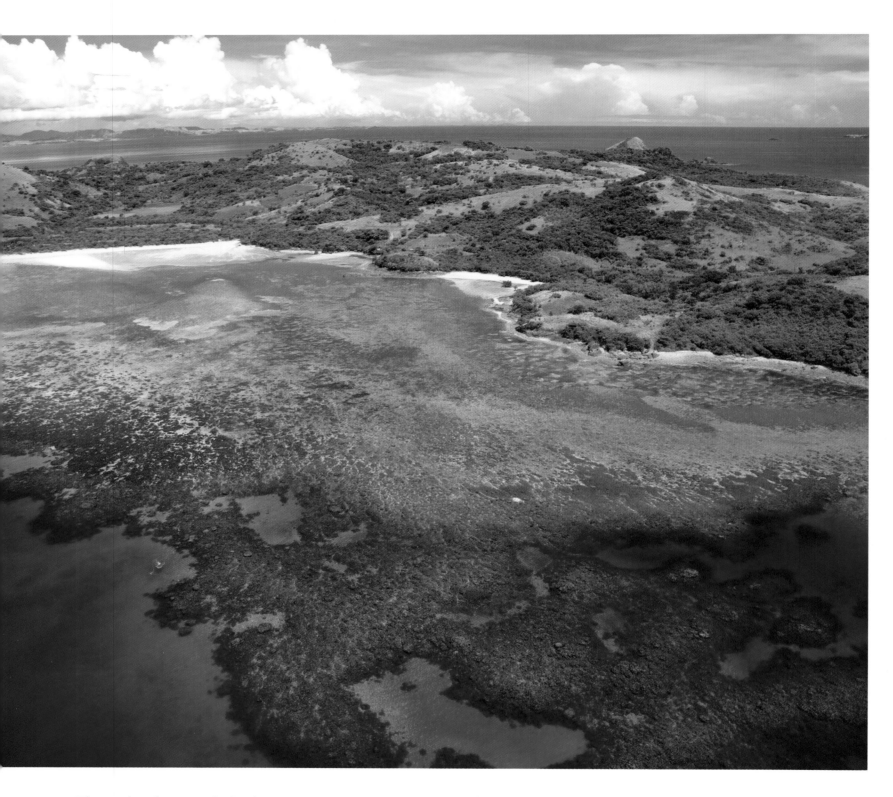

The coral reef, coast and islands,
Camarines Sur, Luzon, Philippines.

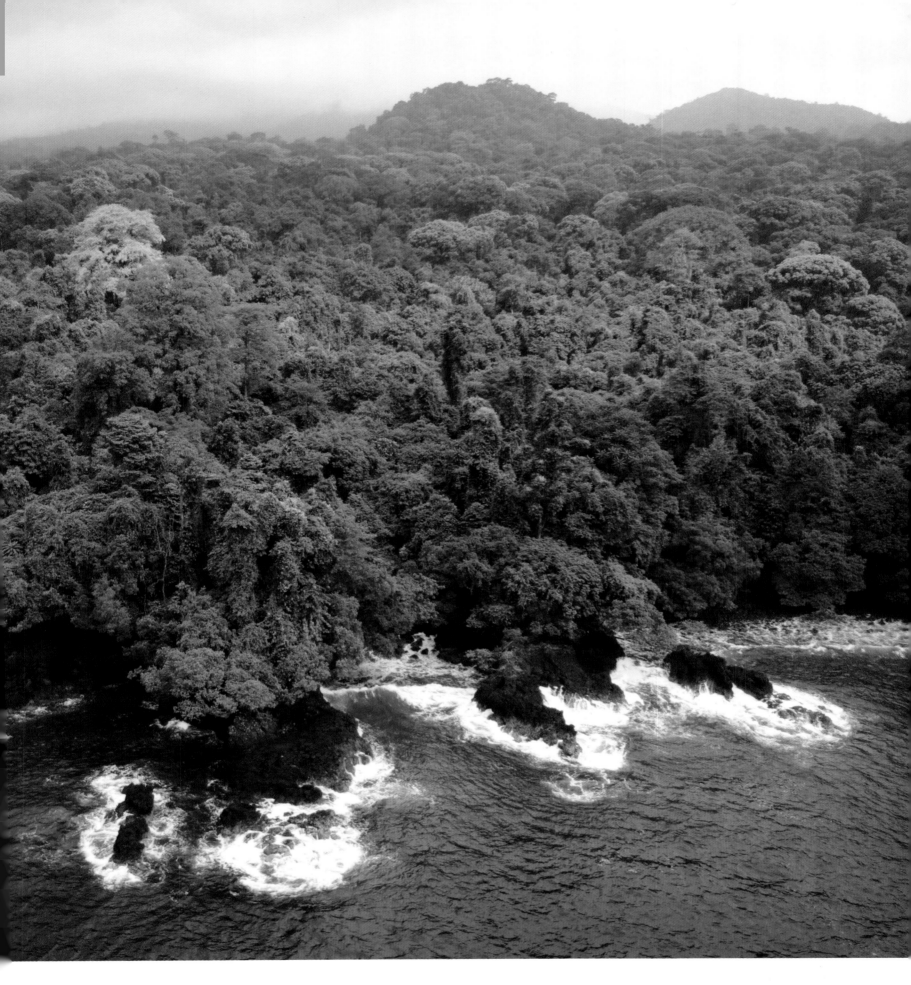

The rainforest canopy on the southern coast of Bioko Island, Equatorial Guinea, Central Africa.

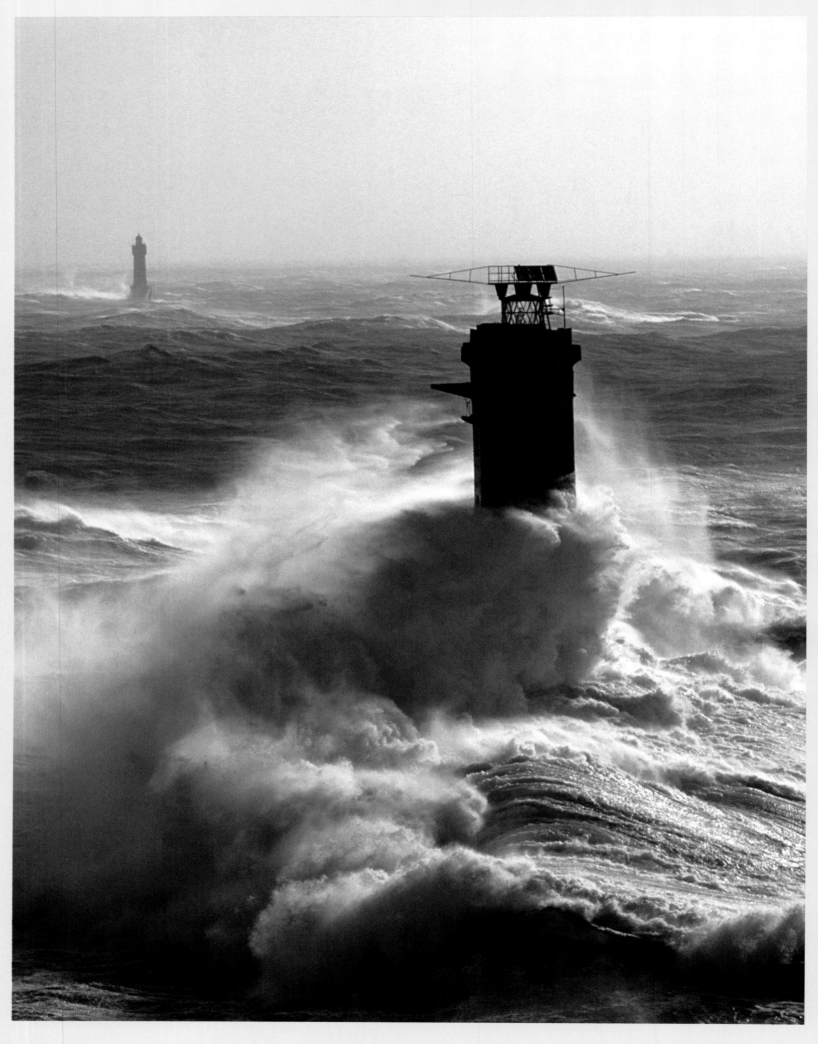

Above: Nividic lighthouse, in the Iroise Sea, during a storm. Ouessant, Finistère, Brittany.

Right: Looking out from the cliffs of Pico Island, the Azores.

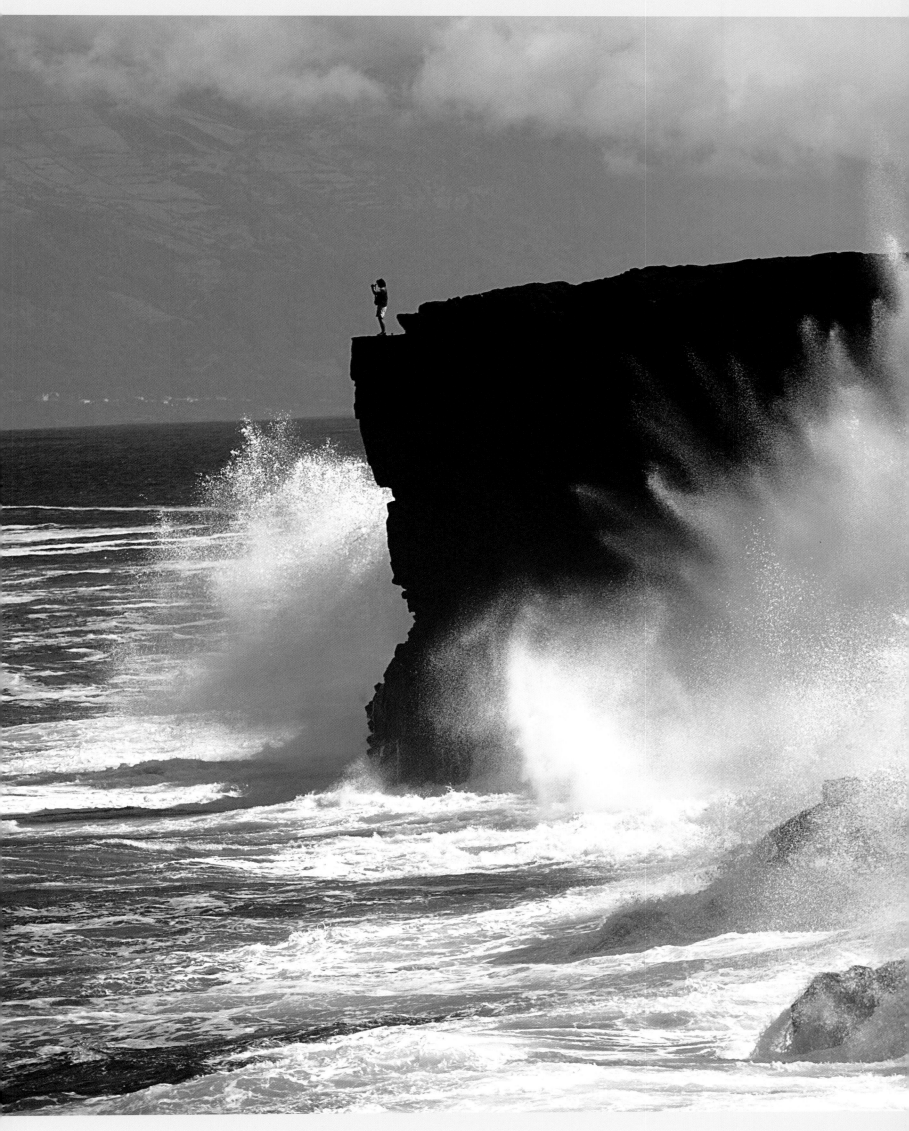

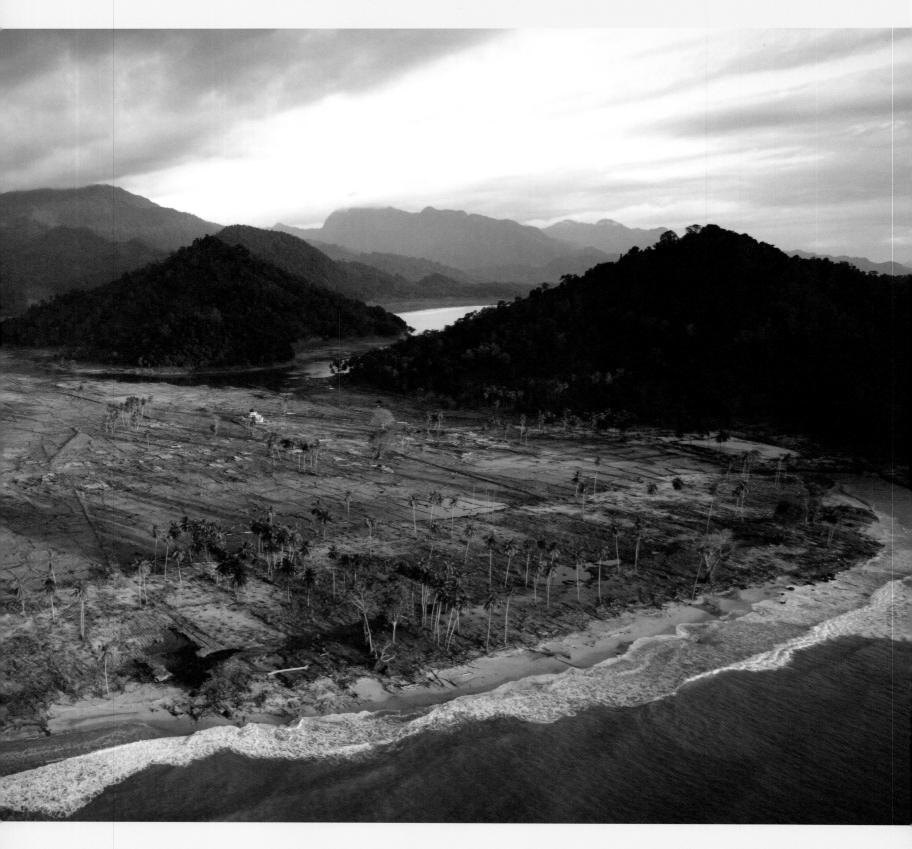

Above: Devastation after the 2004 tsunami on the island of Sumatra, Indonesia.

Right: Lava flow reaching the ocean in a spectacle of molten rock and steam, Fernandina Island, Galapagos Islands.

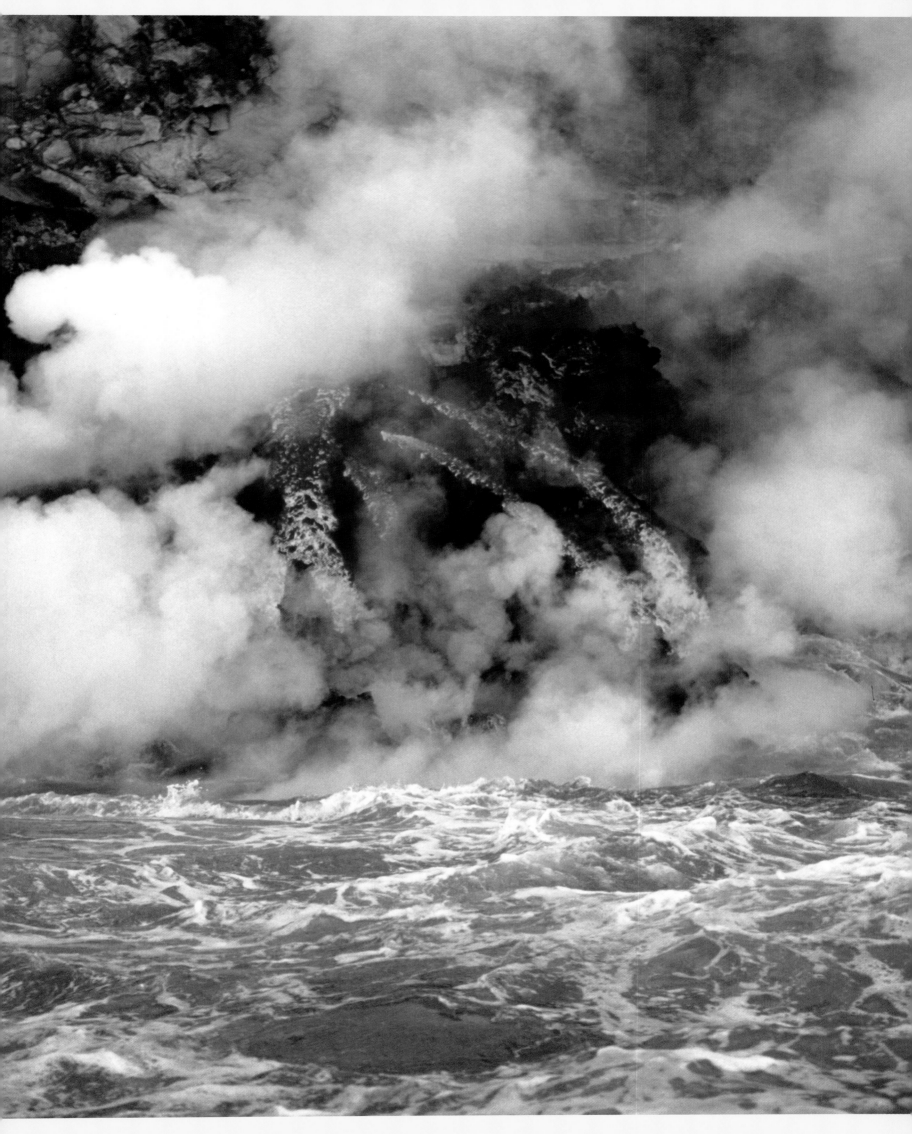

The cliffs and beaches along the coastline of Martha's Vineyard, Massachusetts, USA.

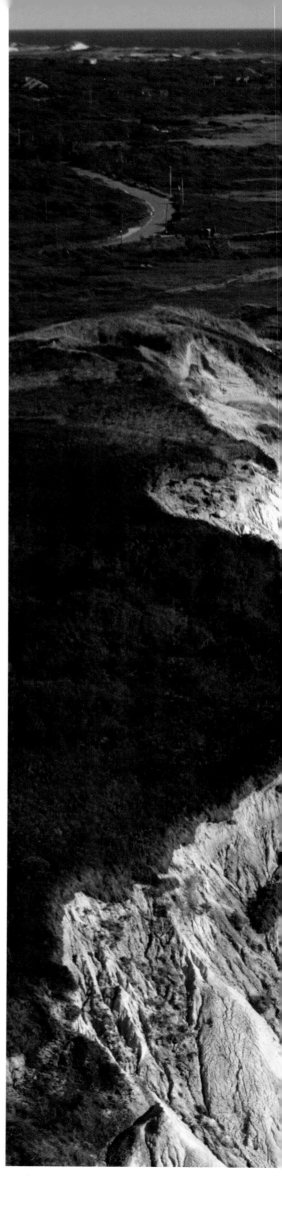

Pierres Noires lighthouse, Brittany.

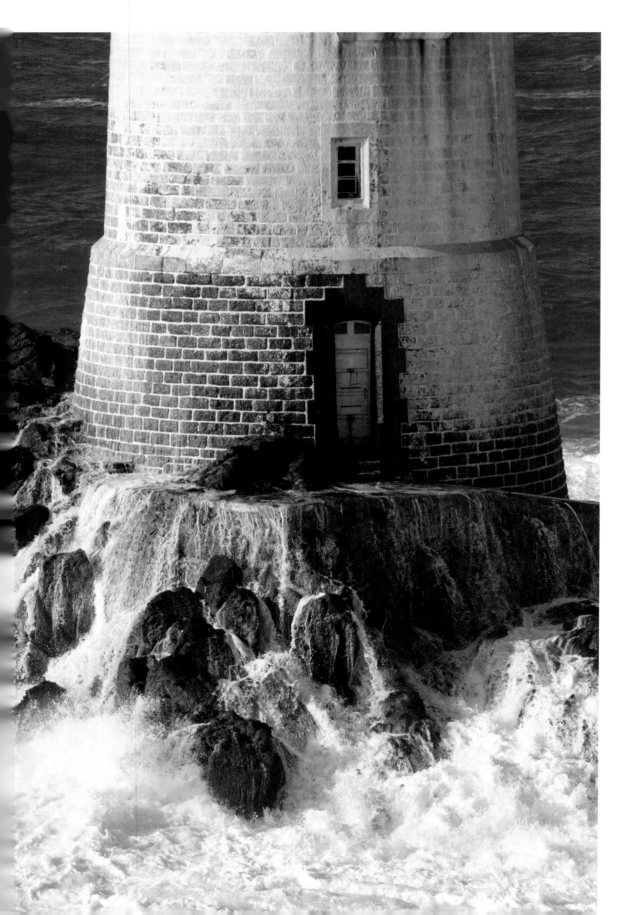

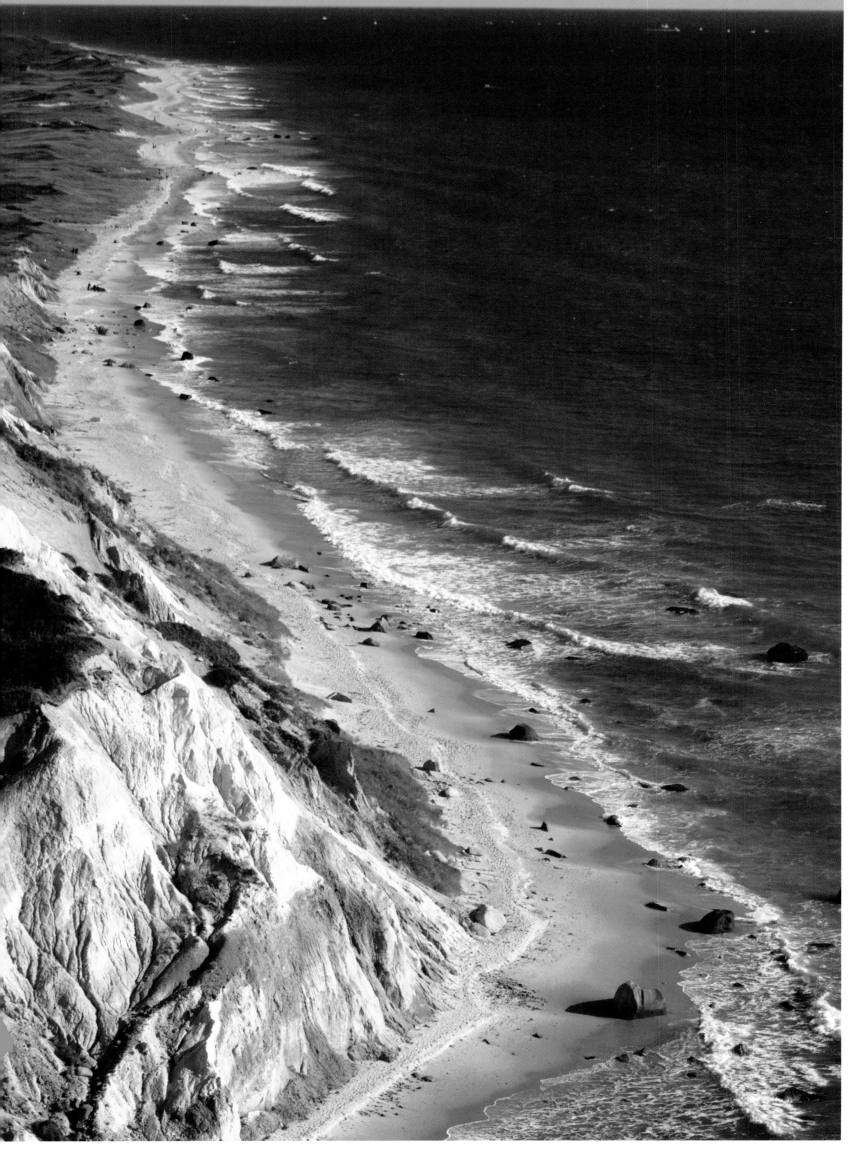

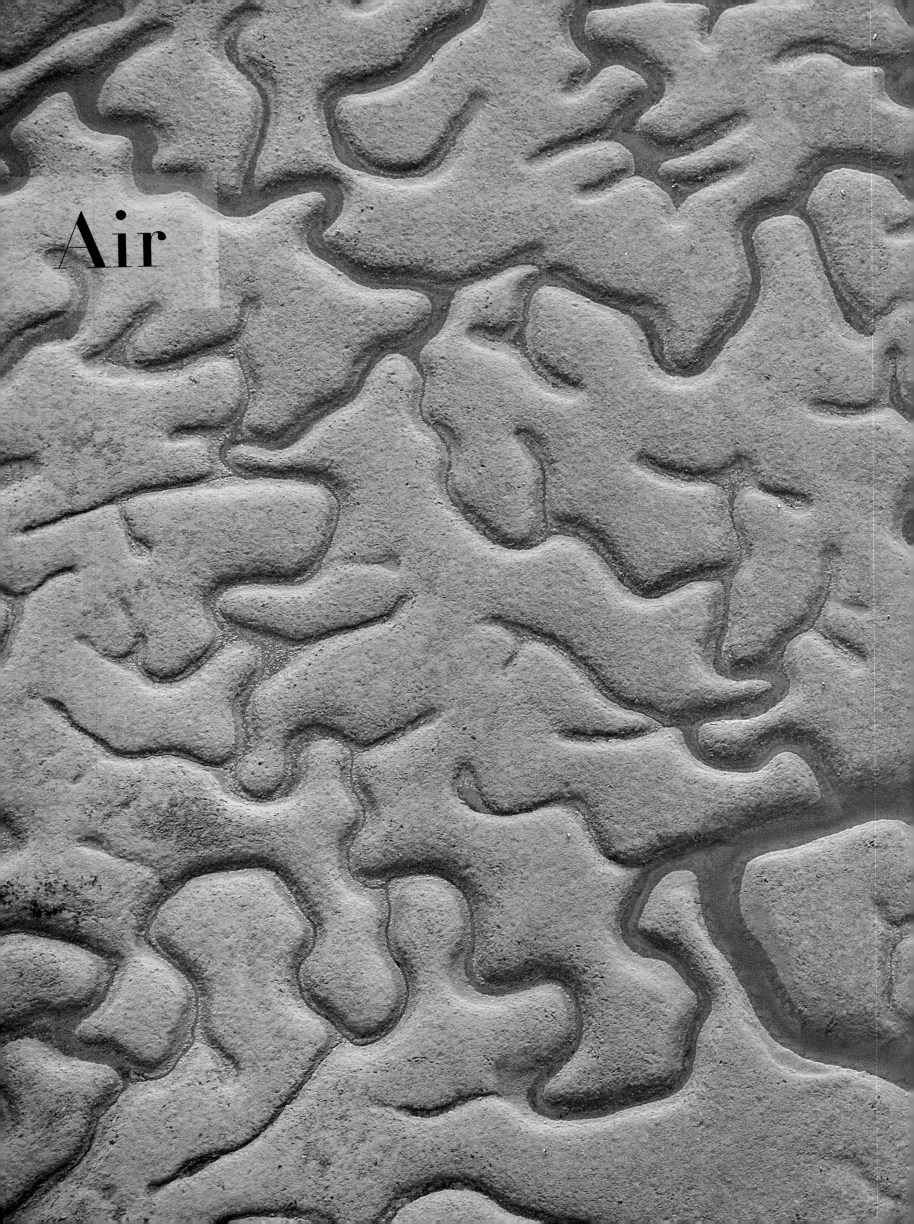

Air

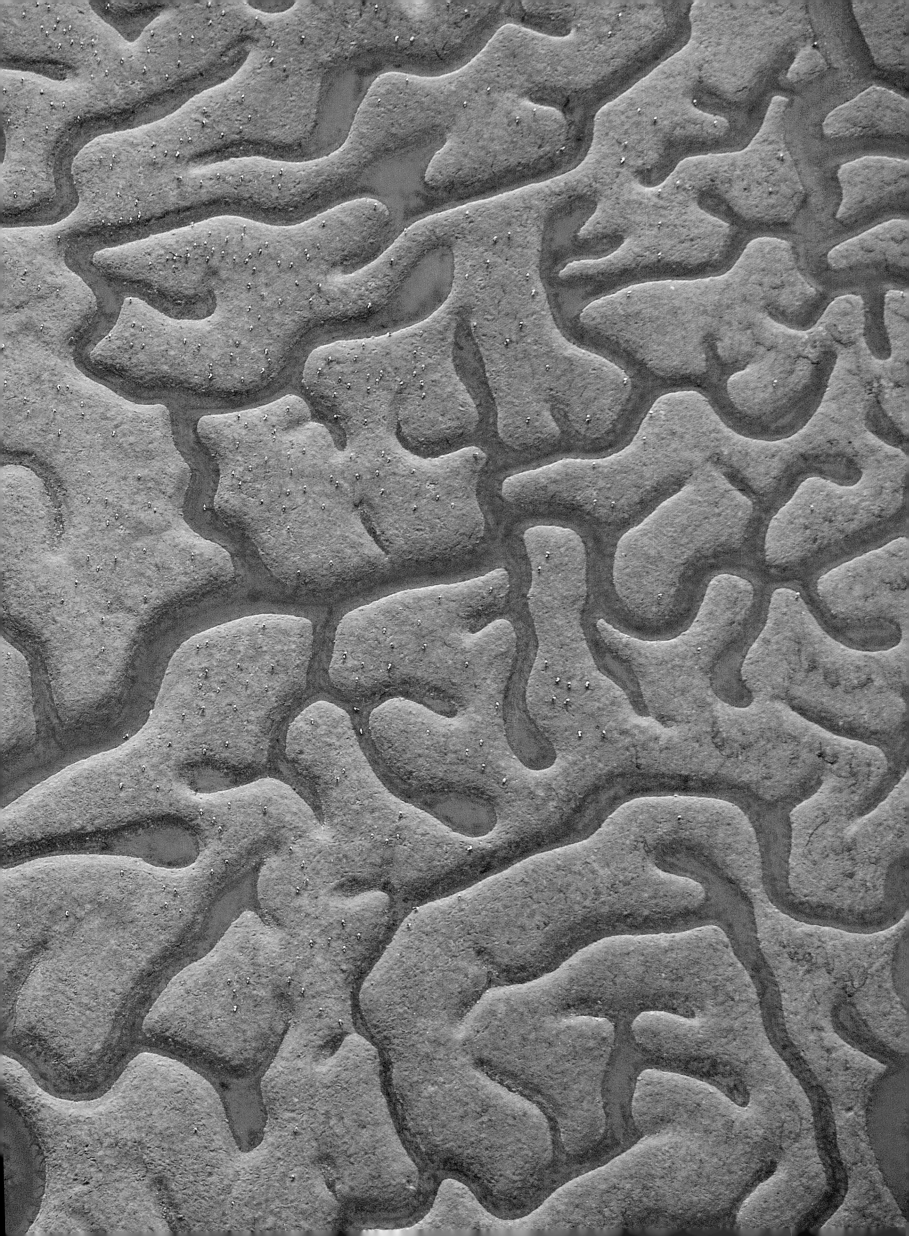

The sea from the skies

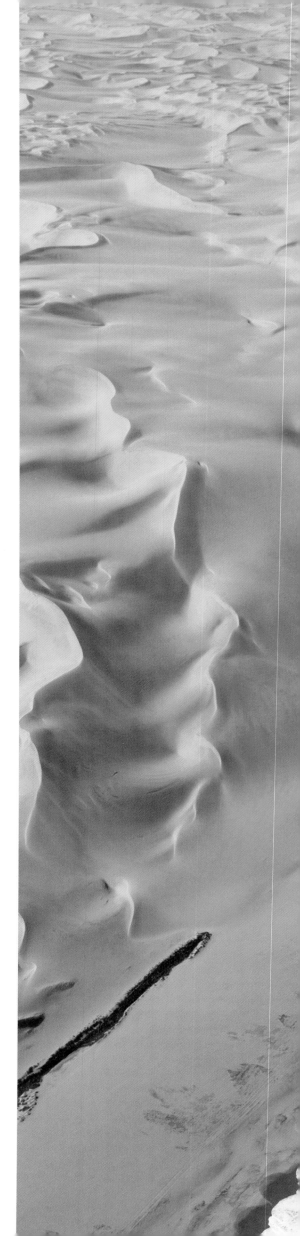

There's nothing like jumping in an aeroplane to see the world anew. Mountain ranges suddenly seem puny, mighty rivers are reduced to trickling streams, and the human species looks increasingly like an overgrown colony of ants.

Not so the sea. To fly over mile upon mile of empty sea is to realise how truly enormous the oceans of this planet are. It takes 14 hours to fly from San Francisco to Sydney, and along the way you won't see much else apart from an endless expanse of sea and, if you're lucky, the occasional small island. There isn't an equivalent journey over land, simply because the Pacific Ocean alone is three times the area of all the land in the world combined. In terms of wilderness, nothing else compares.

Closer to shore, aerial images show the intricate interplay between land and sea. At its grandest scale, the sea defines the shapes of continents and countries but, in a more humble way, it also traces the contours of headlands and bays, and of individual rocks and pebbles – even a grain of sand. It is these subtle undulations – changing continually, with the rise and fall of every tide – that are the subject of some of the most absorbing images in these pages. Viewed from above, our shores form intricate natural patterns that are invisible from our normal perspective. An island turns into a question mark; a salt pond farm turns into a check tablecloth; water channels in seaweed turn into a tree of life. Nothing looks the same; our sense of scale vanishes, and new patterns emerge from old shapes. Our assumptions are thrown on their heads, and we are asked to think again.

As well as sometimes confusing our senses, the view from above can give us greater clarity. For a start, the higher we go, the further we can see. From 6ft above sea level, our horizon is limited to just 3 miles; rise up to 100ft and it increases to 14 miles; go further to 1,000ft and on a clear day it will stretch out 42 miles in each direction. Not only that, but the higher we go, the less reflection there is on the surface of the sea, and the more easily we can see the seabed. What might at sea level look like twinkling water with a few mysterious shadows underneath, from the air becomes a teeming underwater world, with patterns of rocks, seaweed, reefs, shells, fish, and perhaps even the occasional shipwreck.

It's more than 150 years since the French balloonist Gaspard Felix Tournachon (otherwise known as 'Nadar') took the first aerial photographs, yet they still have the power to confuse, amaze and fascinate us. Partly this is just another form of narcissism; a rare opportunity to gaze at ourselves from a stranger's perspective. But more significantly, these images can awaken the child in ourselves and encourage a sense of wonder. Because often the simplest and most honest response to such provocative images is just, 'Wow…'.

Sand dunes on the Atlantic coast, near Swakopmund, Namib desert, Namibia.

Previous pages: Marshes with seaweed exposed at low tide, Bahía de Cádiz Natural Park, Andalusia, Spain.

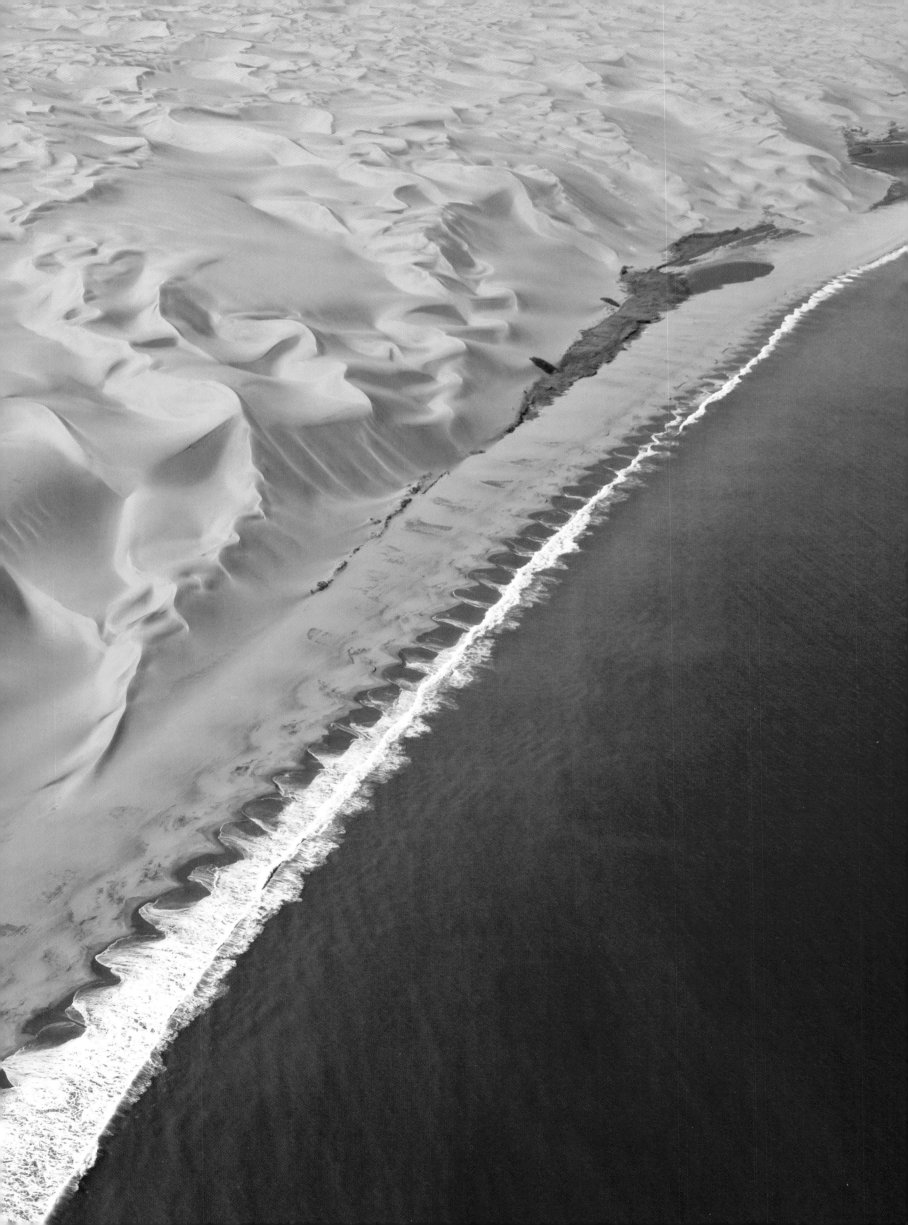

Exuma, part of the chain of 365 islands
that form the Bahamas.

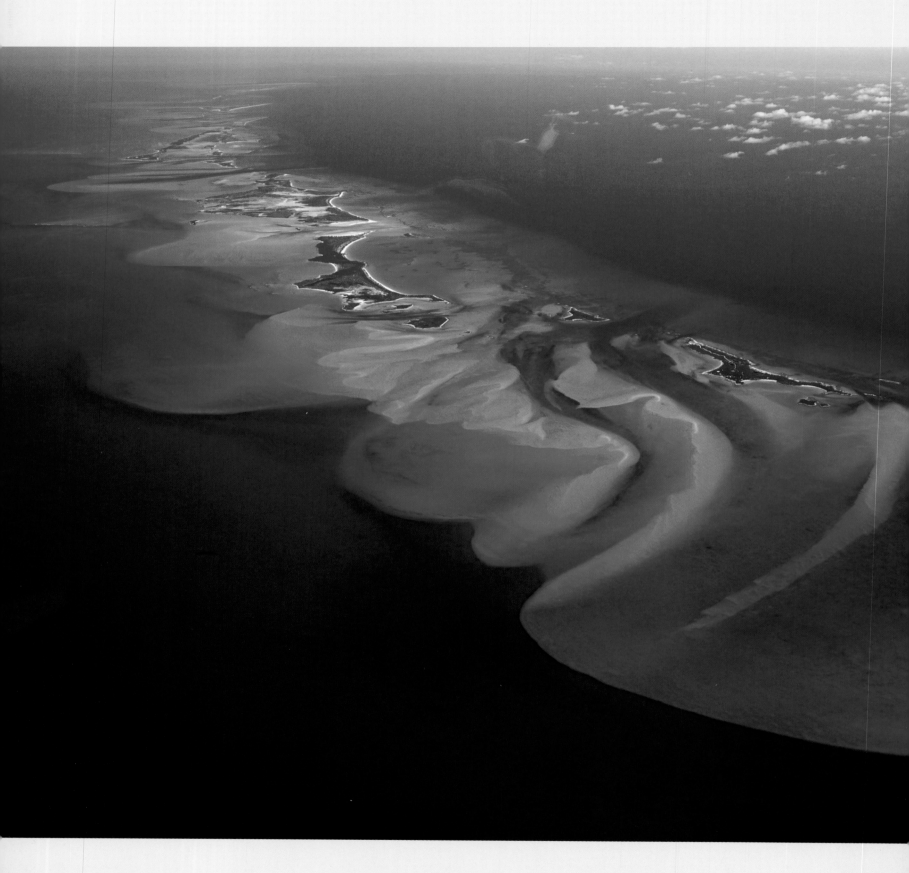

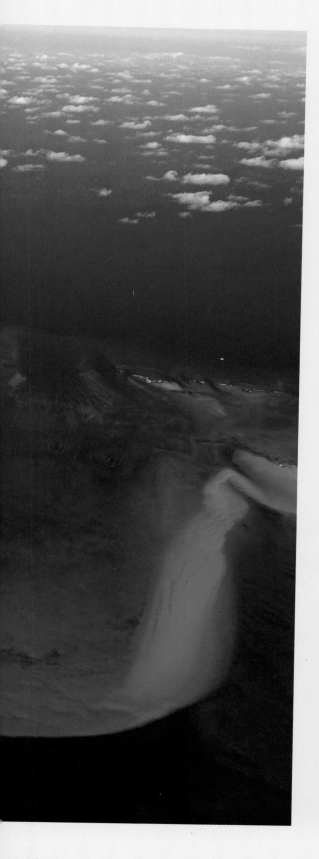

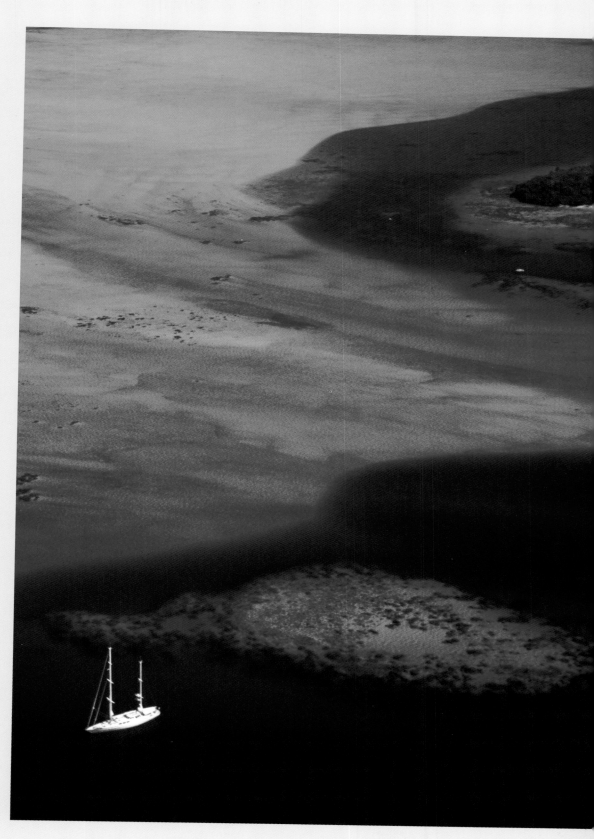

A yacht moored off shallow sandy bars in the south-east Bora Bora lagoon, French Polynesia.

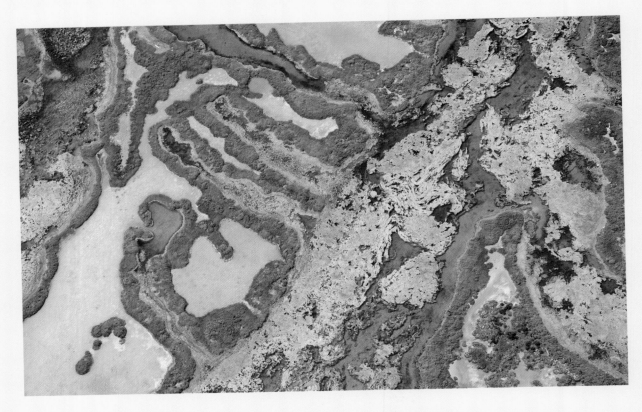

*Above and opposite: Marshes with
seaweed exposed at low tide, Bahía de
Cádiz Natural Park, Andalusia, Spain.*

*Below: The coast, river beds and
saltmarshes of the Bahía de Cádiz
Natural Park, Andalusia, Spain.*

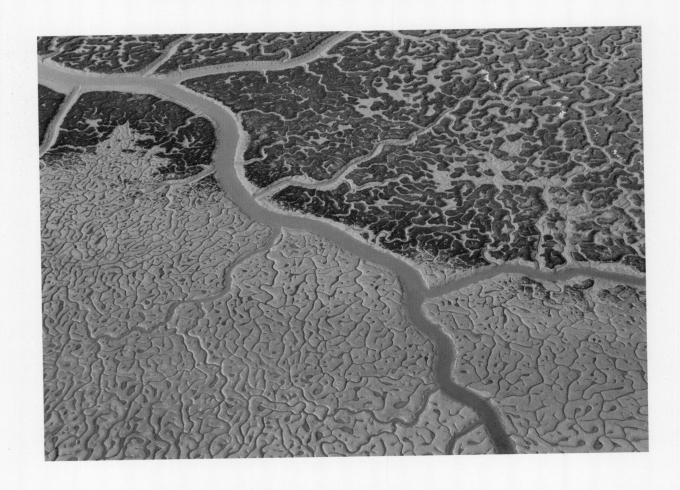

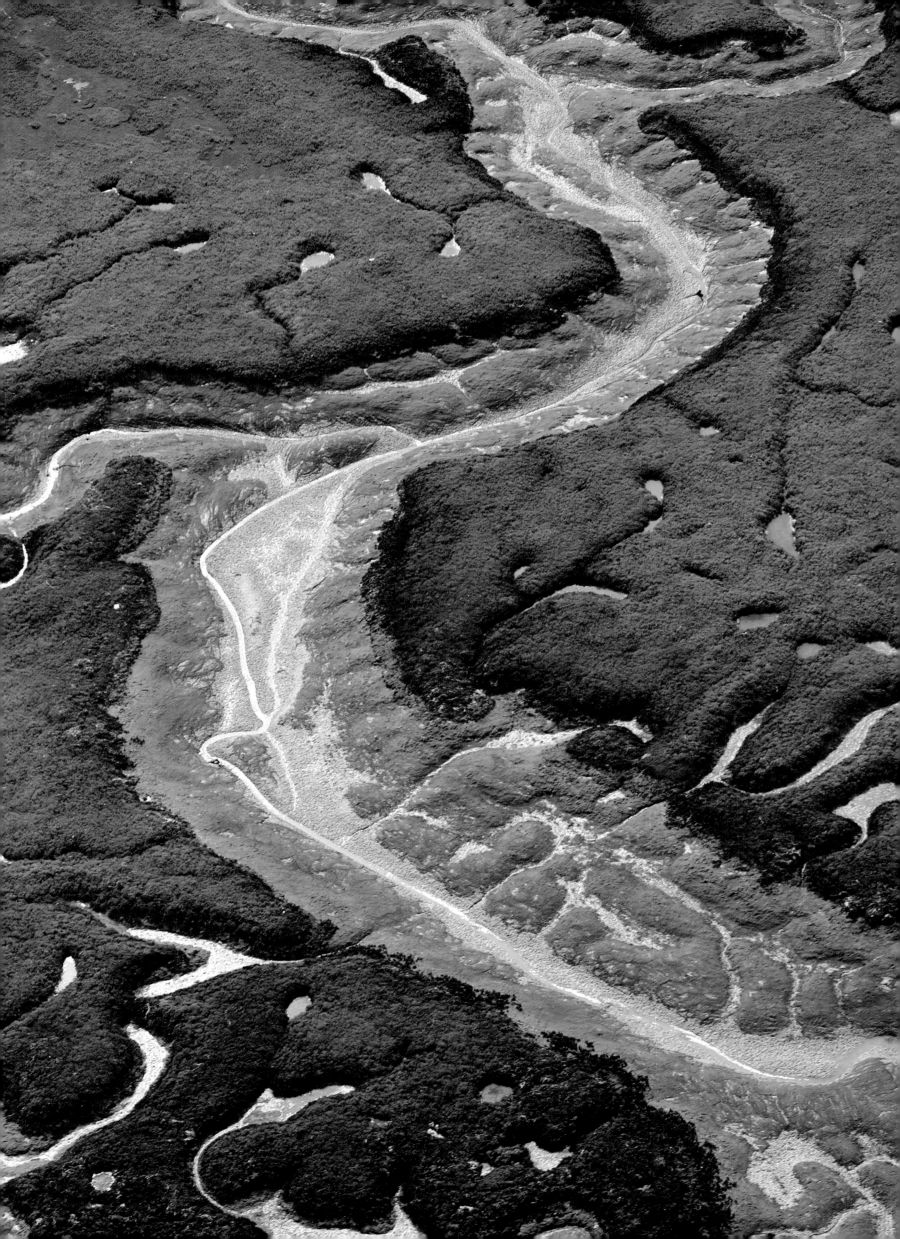

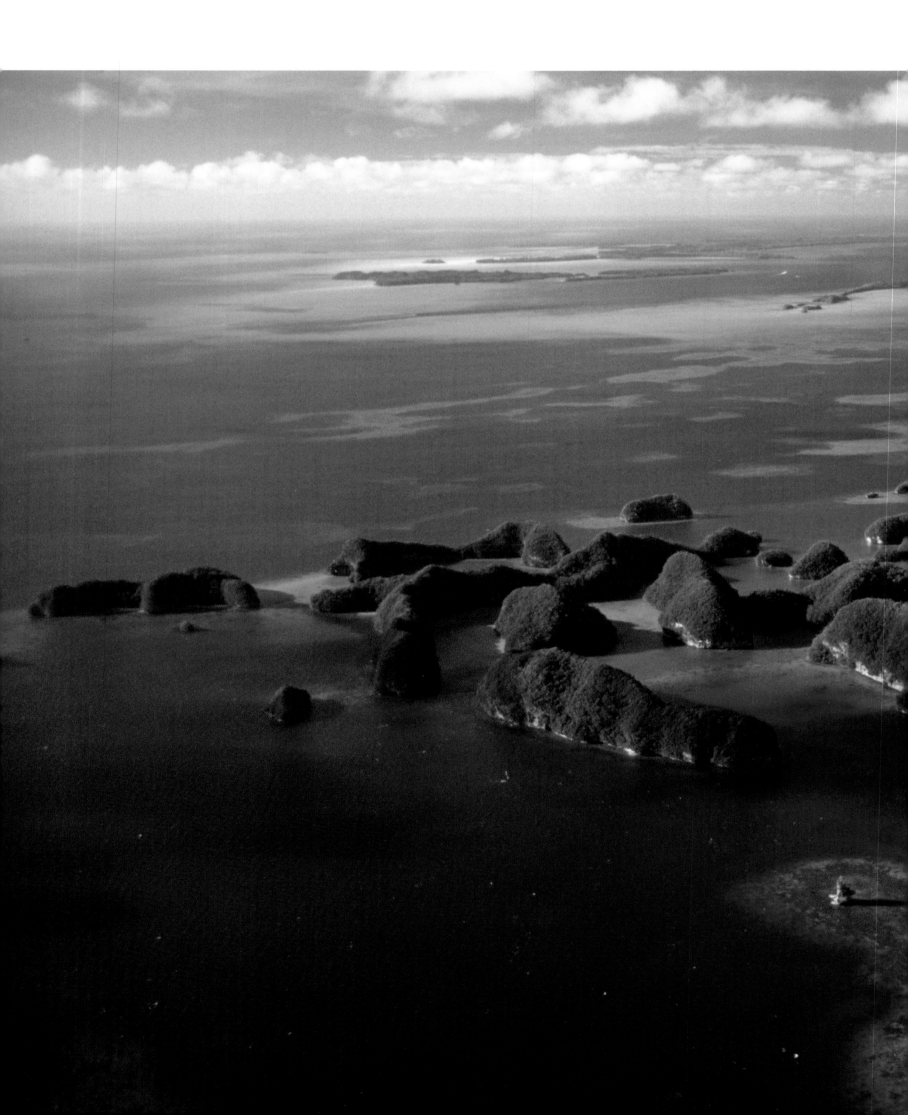

The Seventy Islands, Palau, Micronesia,
Pacific Ocean.

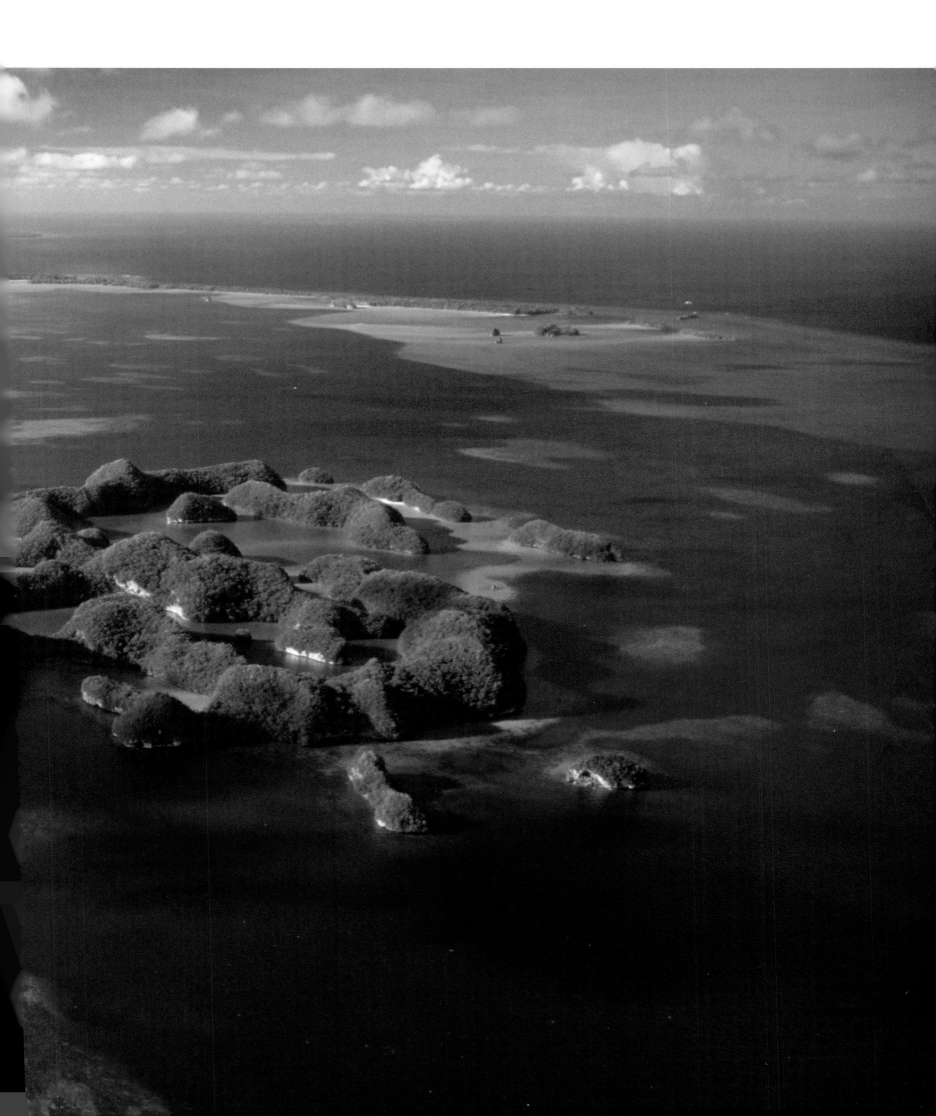

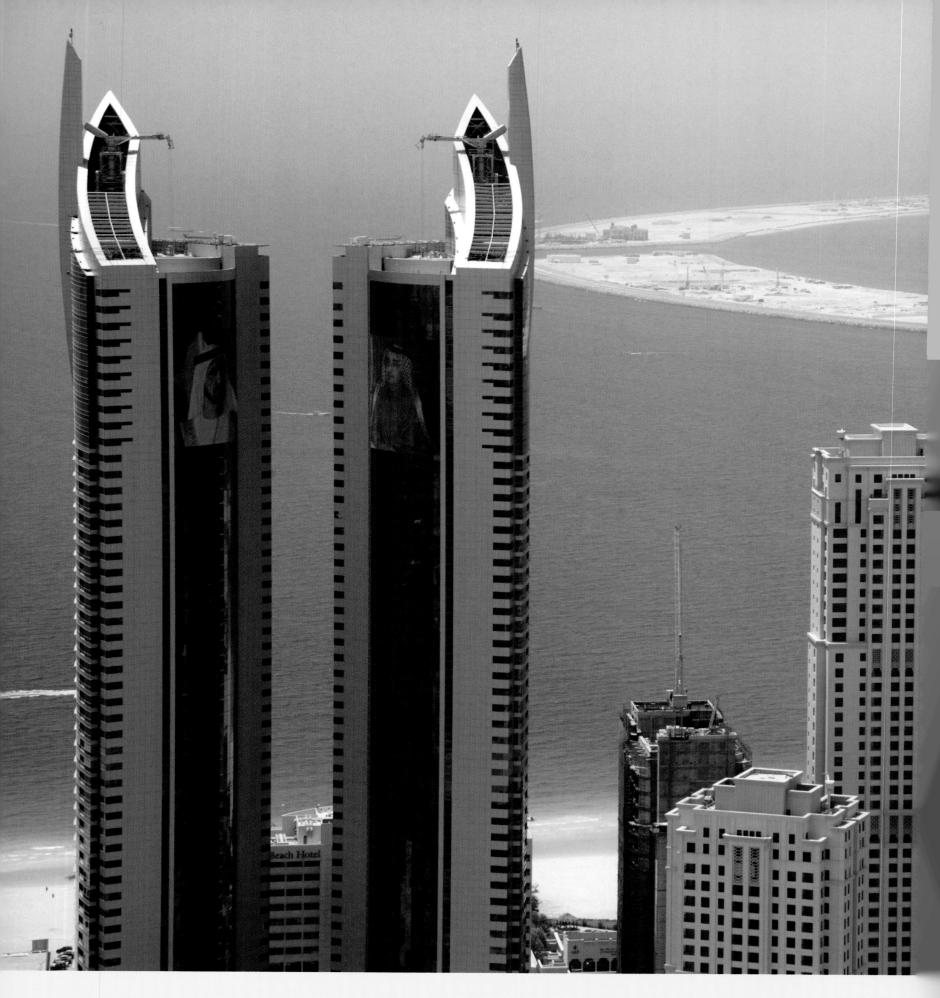

Dubai's skyscrapers overlooking the sea, with one of the Jumeirah Palm Islands in the background.

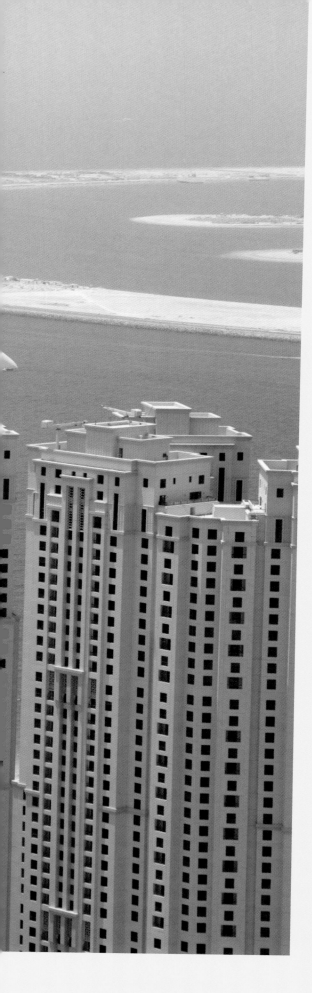

A Vezo fishing village, Tulear, Madagascar. 'Vezo' literally means 'the people who fish' but has also been known to mean 'to struggle with the sea'.

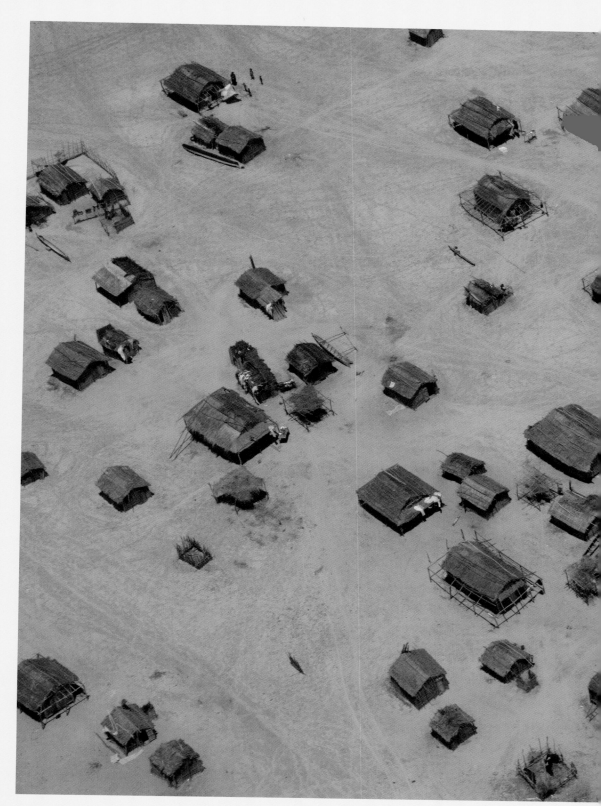

The Horizontal Waterfalls, located within Talbot Bay in the Buccaneer Archipelago, Derby, Western Australia.

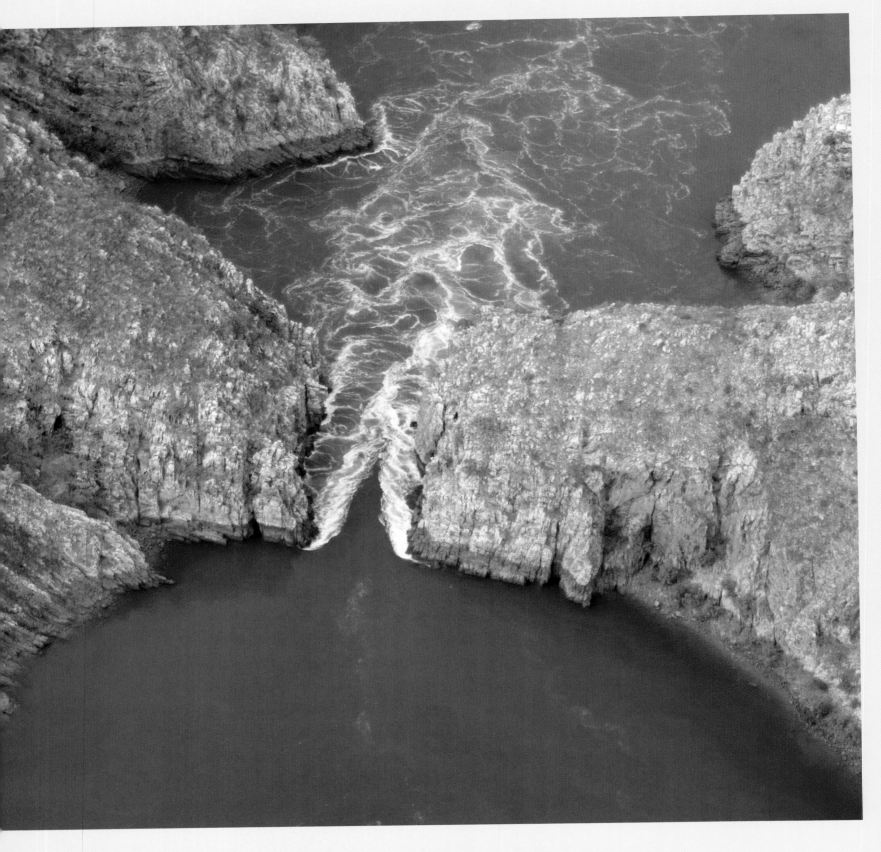

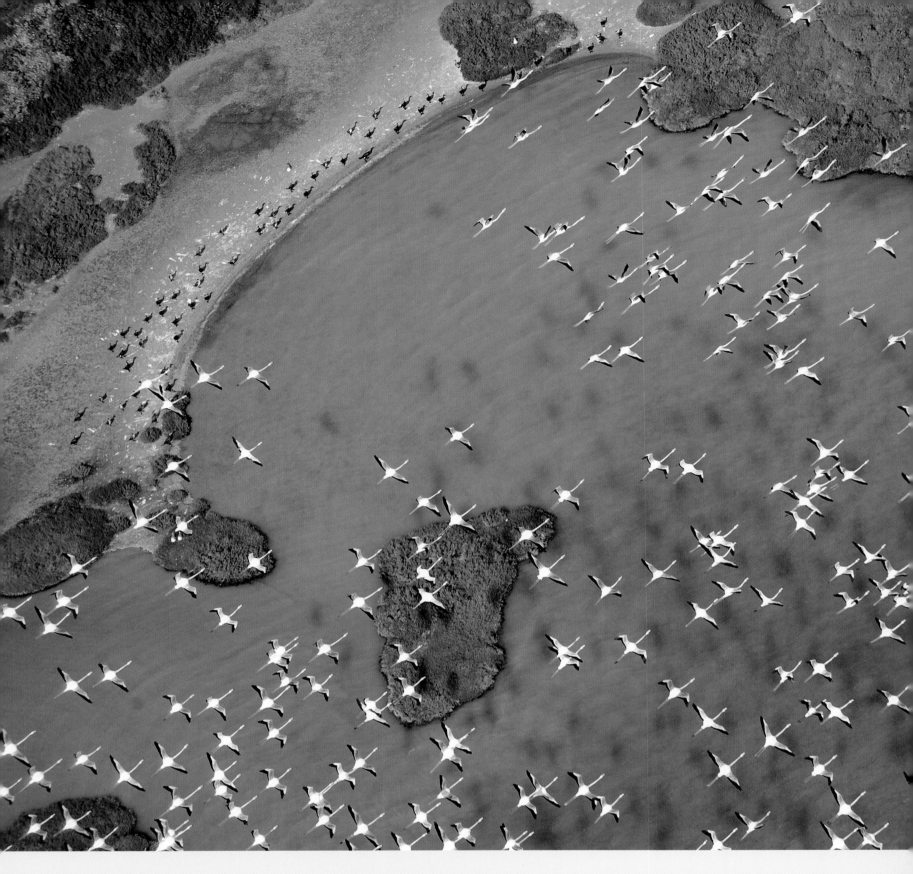

Greater flamingo flock in flight, Bahía de Cádiz Natural Park, Andalusia, Spain.

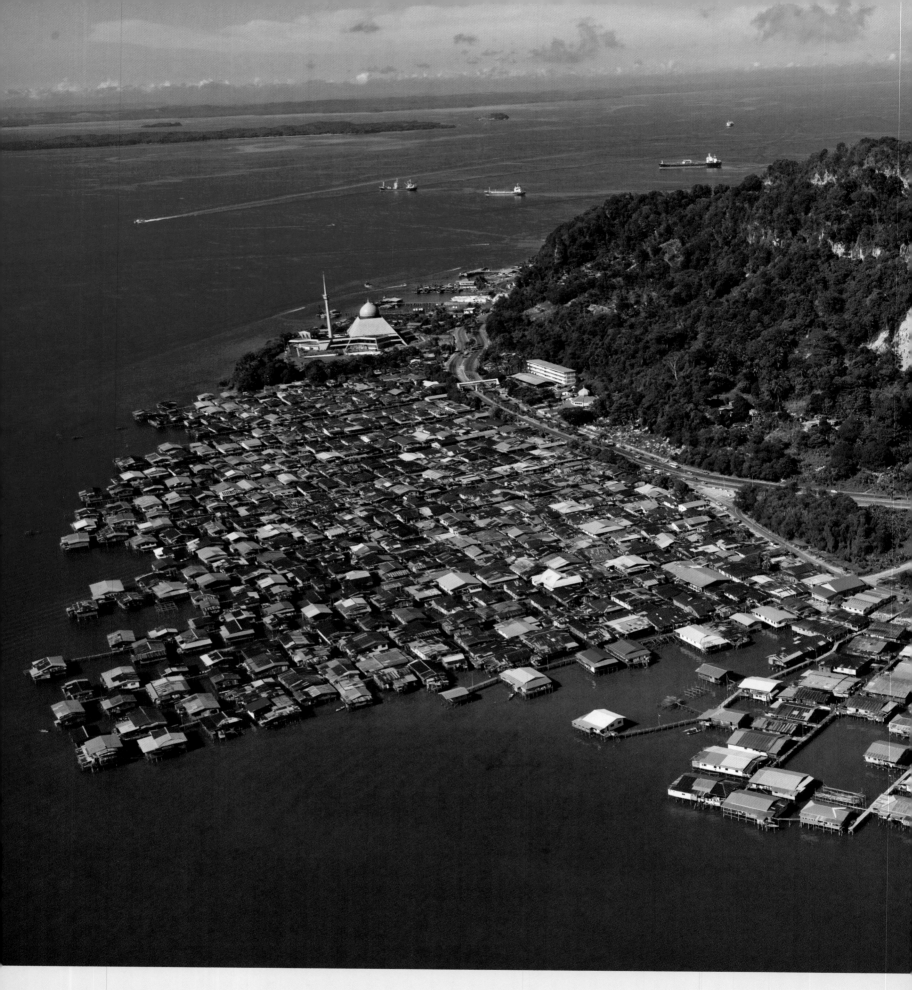

*Homes built on stilts on the edge of the
Kinabatangan River, Sandakan, Sabah,
Malaysia.*

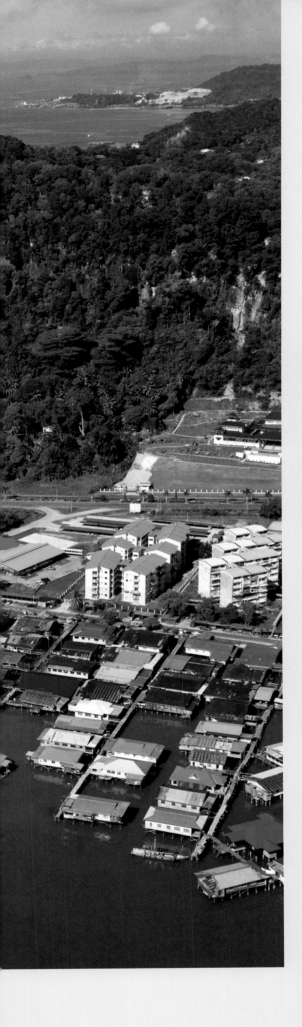

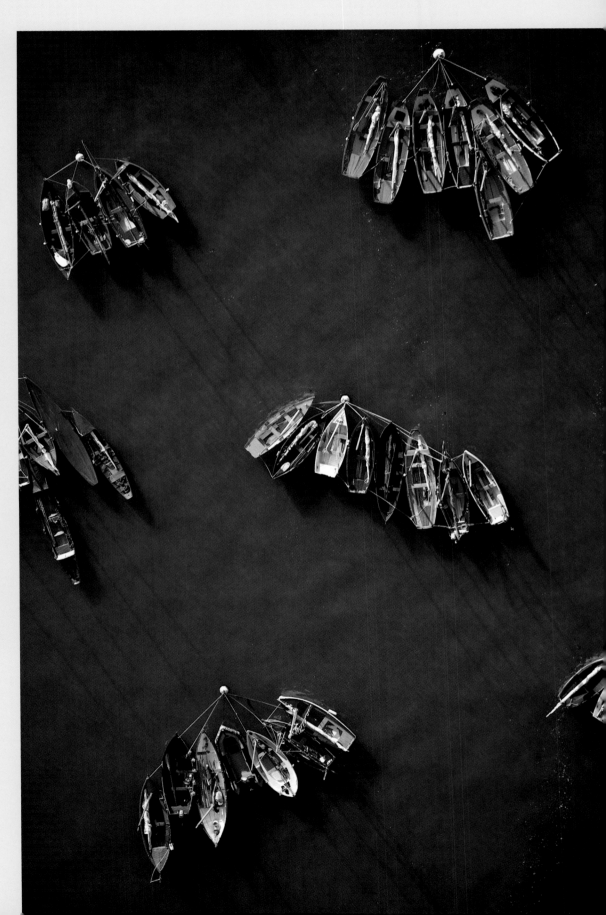

Boats moored at Port Blanc en Baden, Morbihan, Brittany.

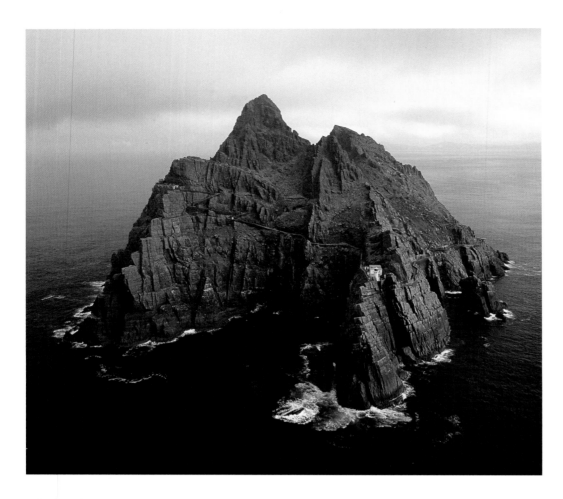

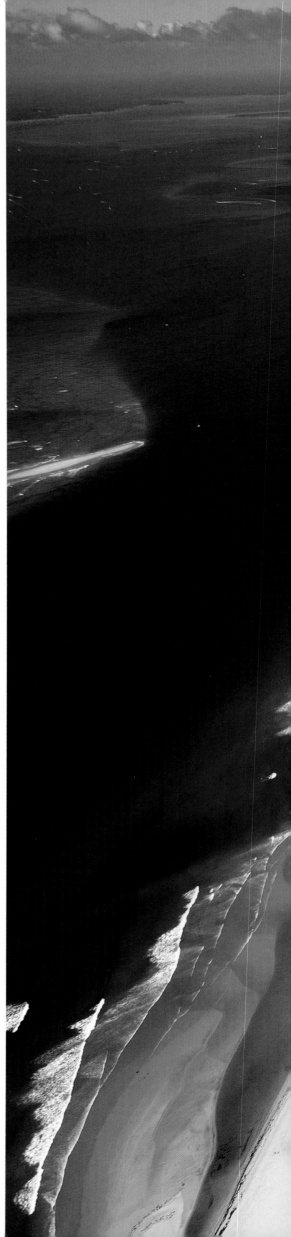

Above: The island of Skellig Michael, off County Kerry, Southern Ireland. The larger of the two Skellig islands, it was the site of a 7th-century monastery.

Right: The Dune of Pilat and sand bars in the Arcachon Basin, Gironde, Aquitaine, France.

The volcanic island of Stromboli, Aeolian Islands, north of Sicily.

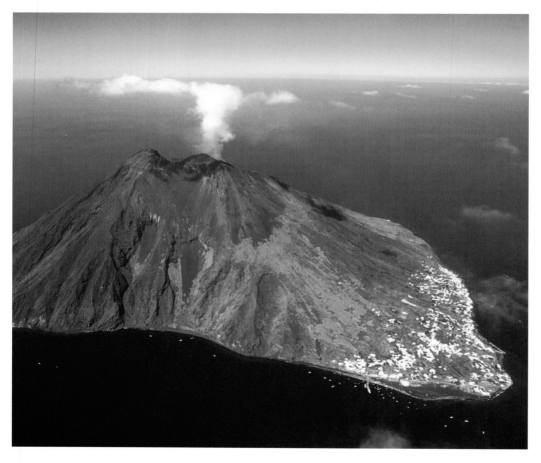

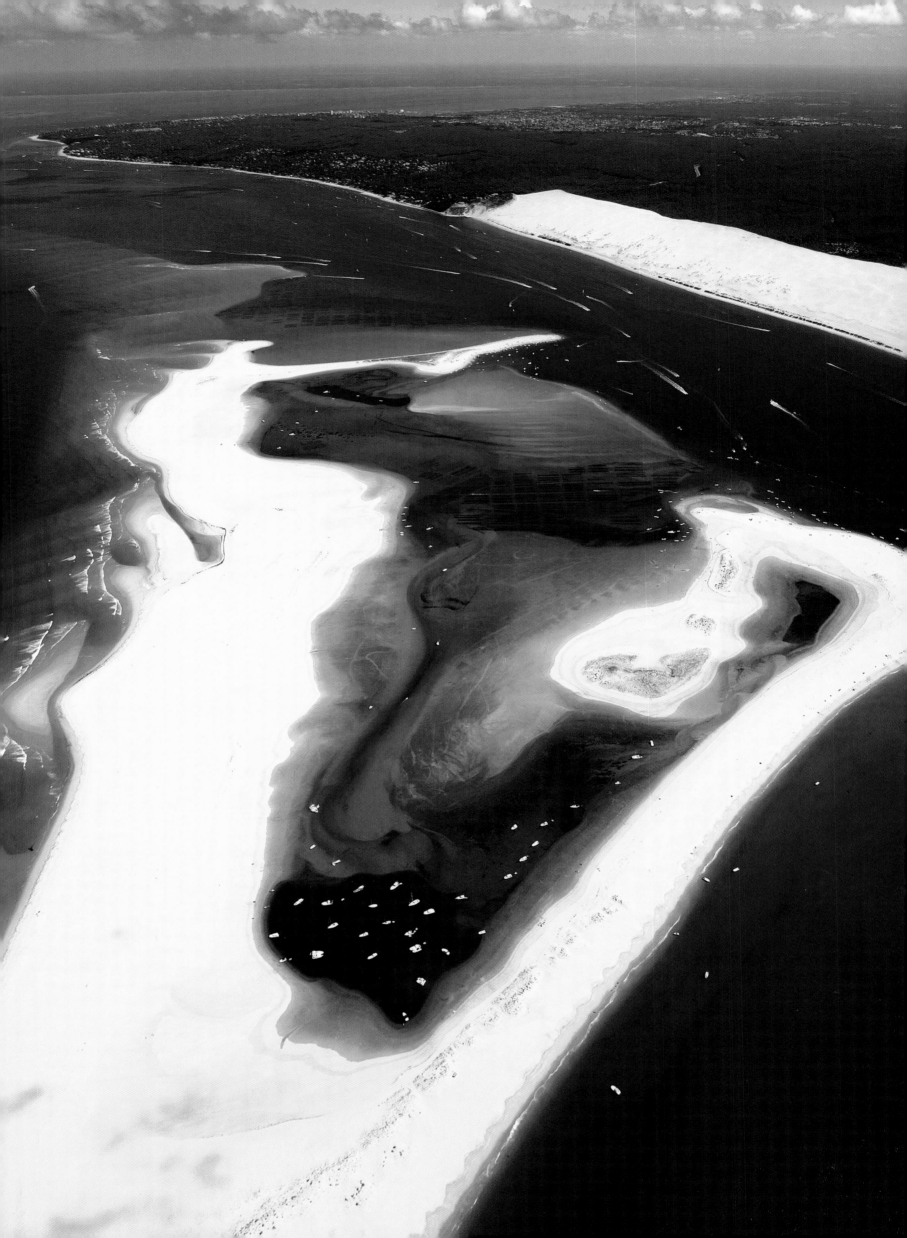

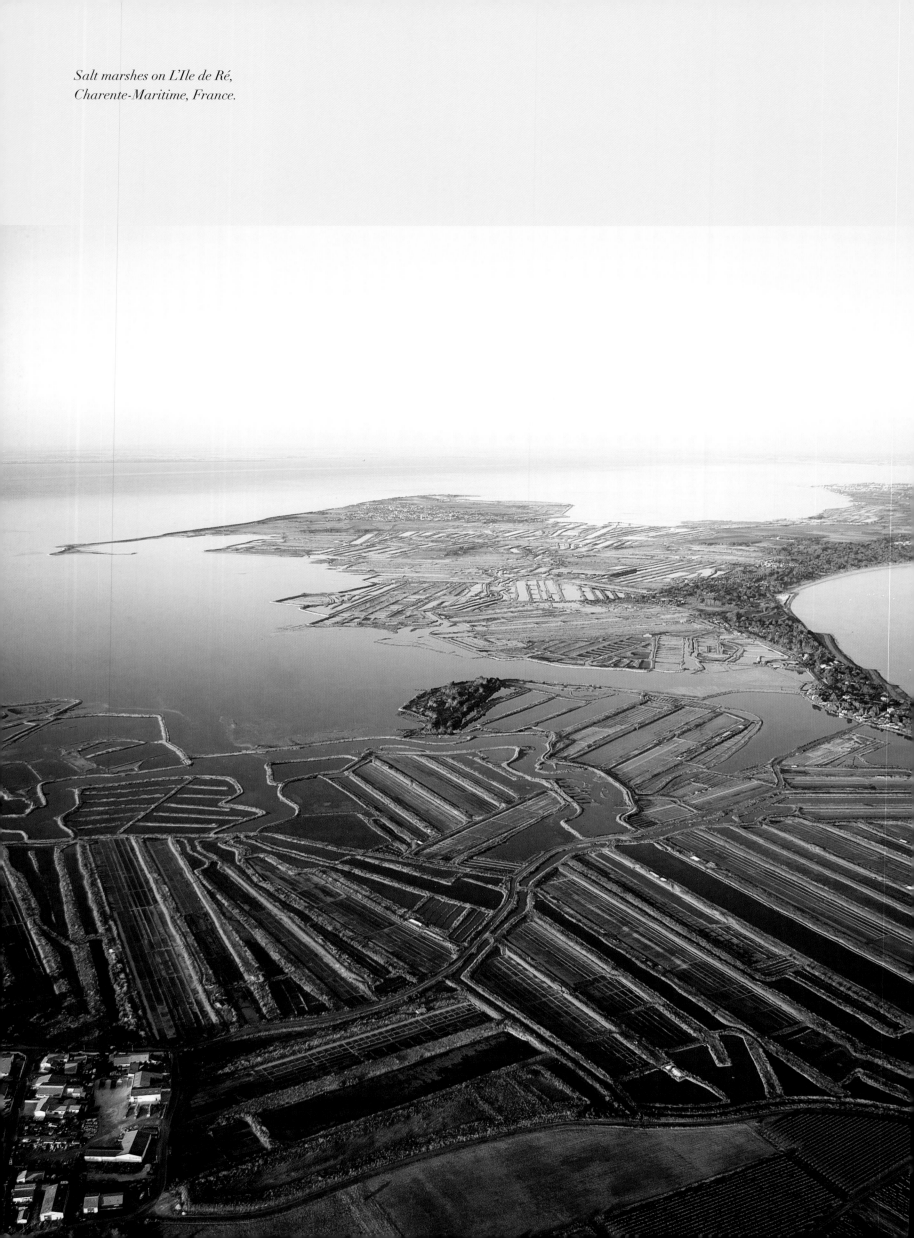

Salt marshes on L'Ile de Ré,
Charente-Maritime, France.

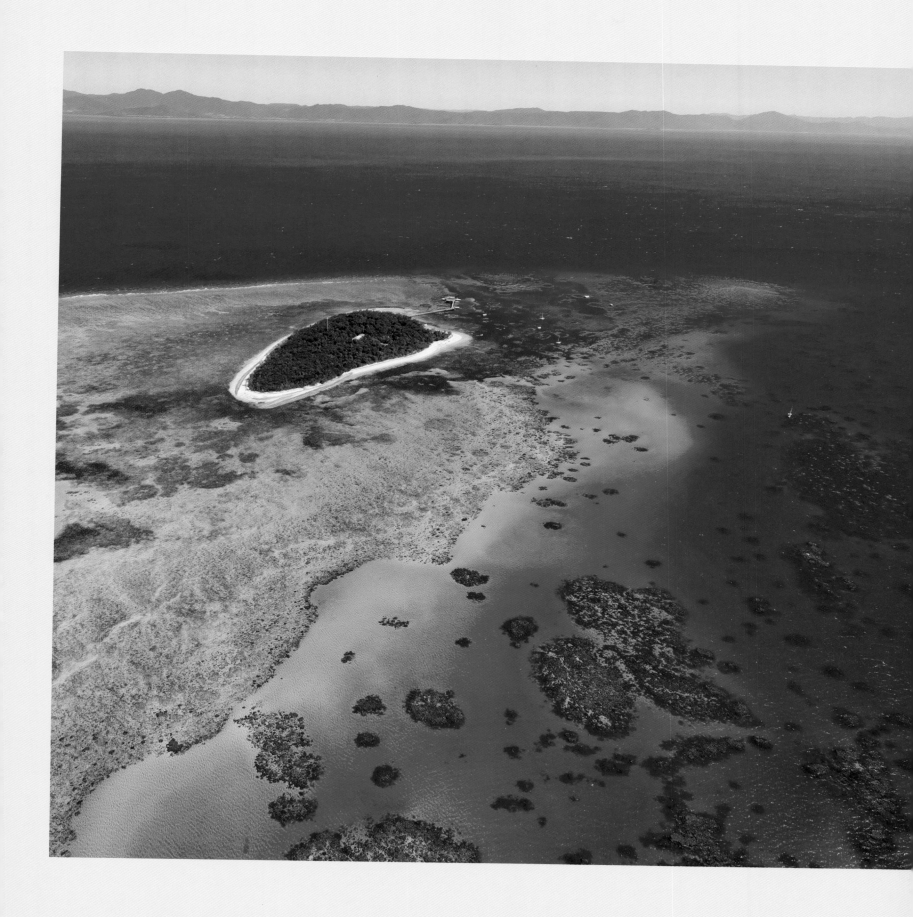

Below: Islands with fringing coral reefs, New Georgia, Solomon Islands, Pacific Ocean.

Right: Blue Hole, a karst-eroded sinkhole on the Lighthouse Reef System, Belize, Caribbean. In 1971 Jacques-Yves Cousteau declared it one of the top ten scuba diving sites in the world.

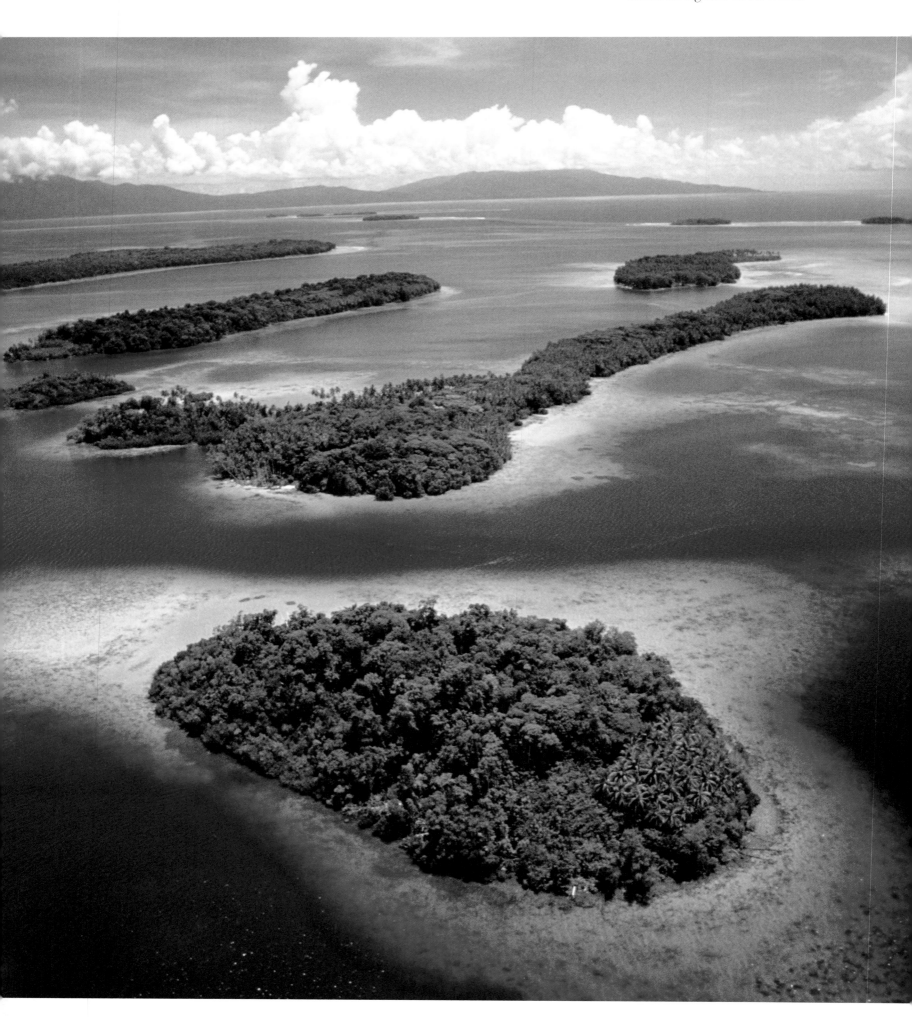

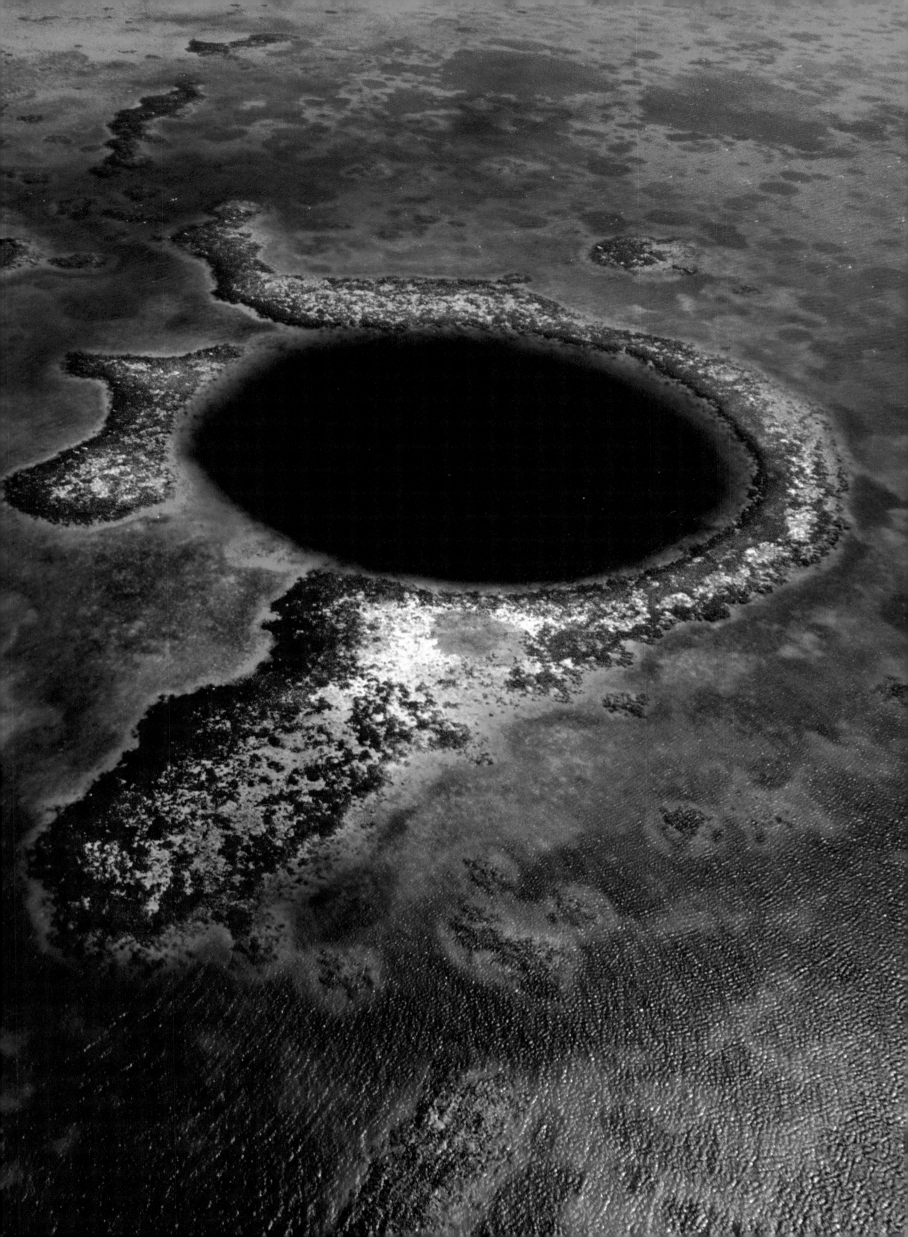

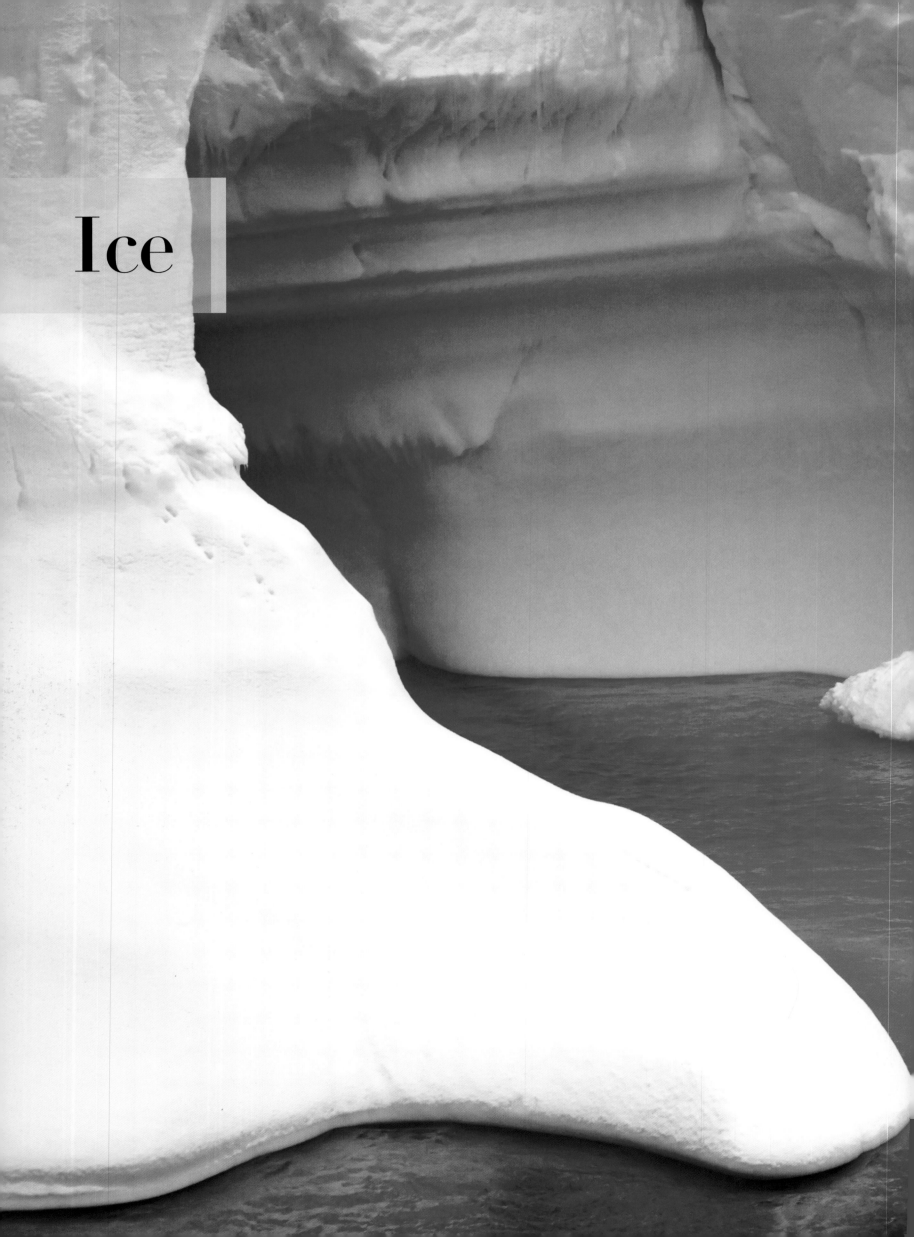

Ice

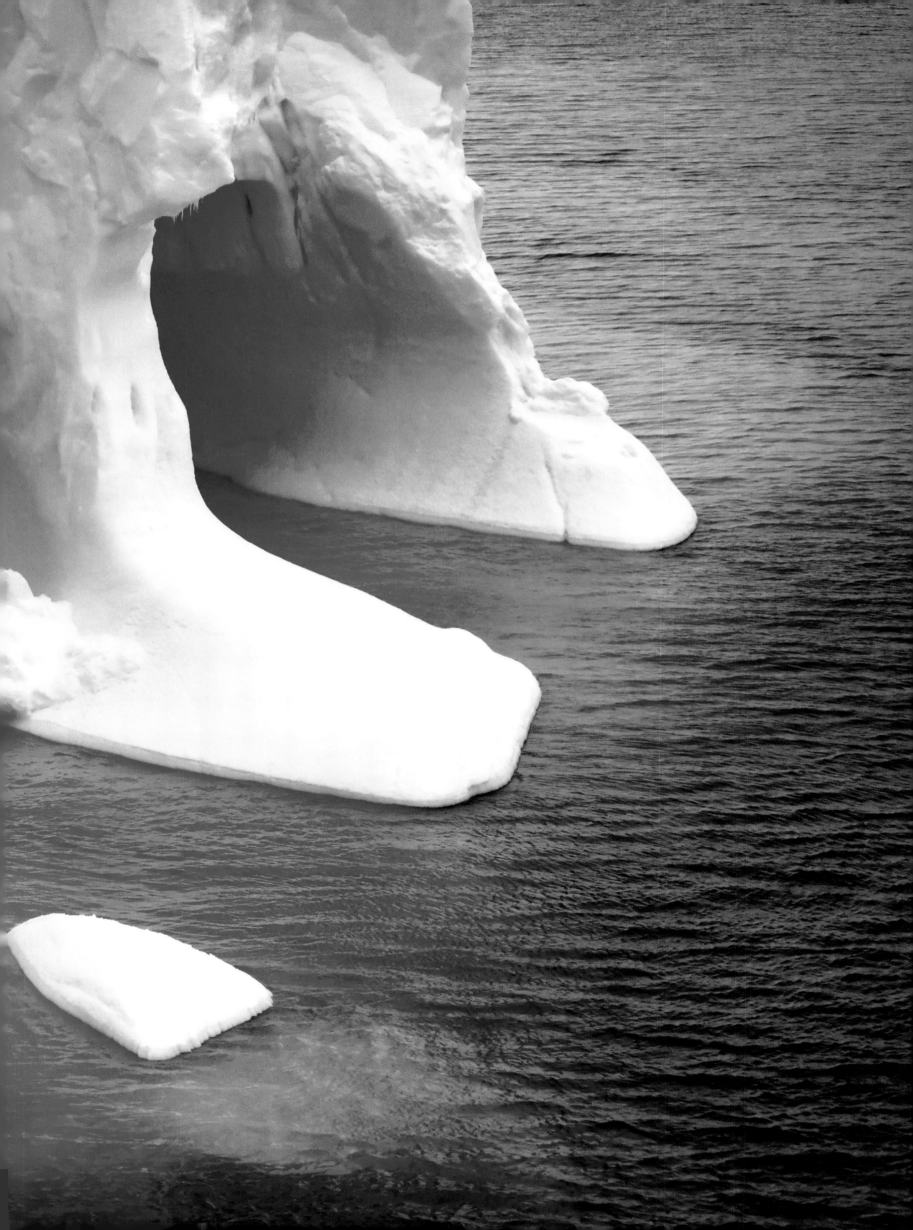

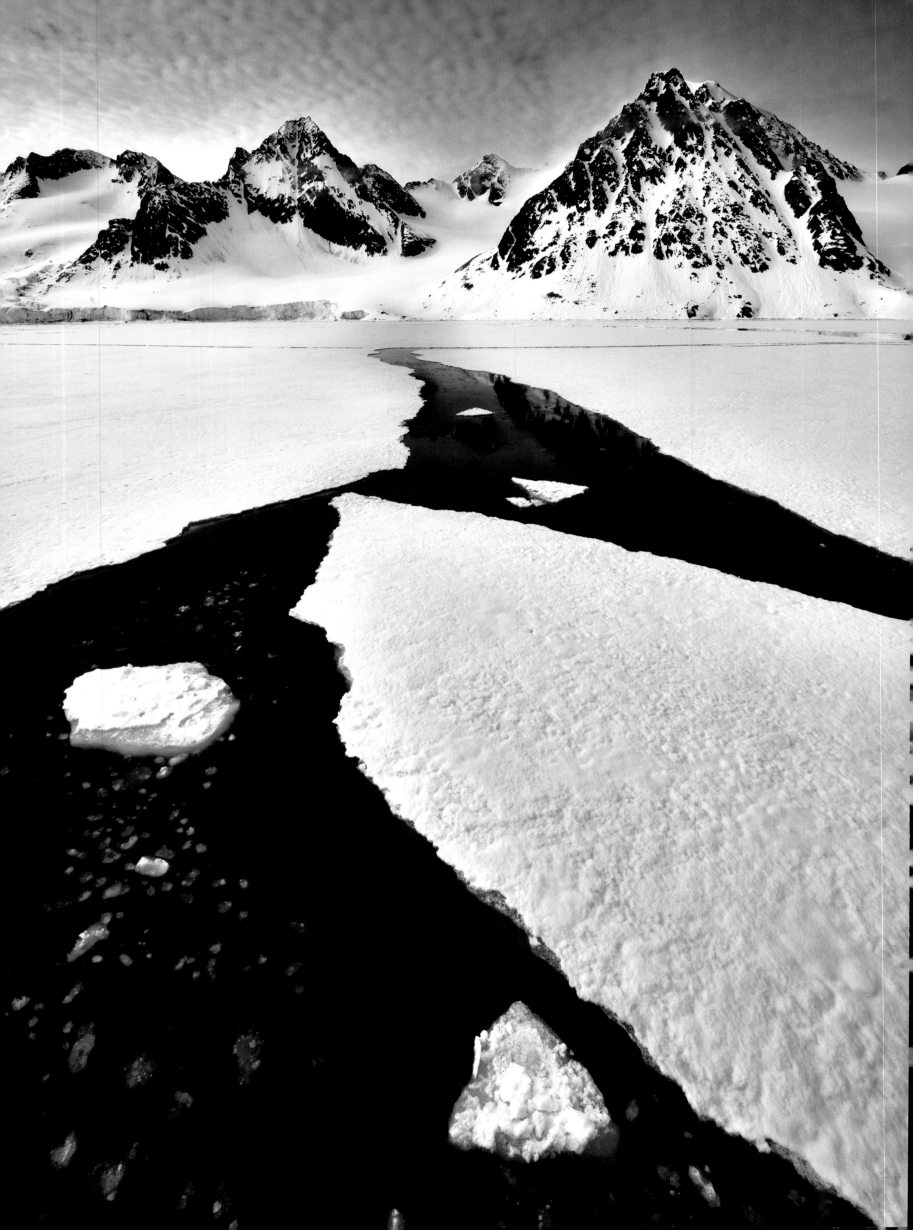

When water freezes

At the northern and southern tips of the world lie the Arctic and Antarctic. These are places of extremes, where the sun never rises in winter and never sets in summer; where average temperatures are around 0°C (32°F) in summer and –34°C (–30°F) in winter. With few natural barriers to slow it down, the wind blows uninterrupted, adding a bitter chill to the already freezing temperatures. These are the most inhospitable living conditions on earth, and few forms of life can survive here throughout the year.

And yet there is an imposing majesty about these waters that compels travellers to return again and again. Towering icebergs, some up to 550ft high, dominate the coast, and the sea, when not frozen over, is peppered with growlers. The cold, dry air produces an almost freakishly clear light, while the

Coastal mountains with sea ice breaking up, Svalbard, Norway.

Previous pages: Iceberg drifting off the Antarctic Peninsula coast.

presence of so much snow means it is hardly ever completely dark. And, while few creatures live on the ice all year round, the coastal areas of both the Arctic and Antarctic provide a unique habitat for certain animal species in summer months.

All of this makes for a stunning location for those photographers brave enough to don their extreme weather gear and join one of the few vessels daring to venture to these regions. Their reward is a closer connection with the elements, a greater realisation of our place in the world and, if they are lucky, some of the most memorable photos they are ever likely to take. Man's hold in these parts is fragile, and nature still reigns supreme.

Yet, despite nature's omnipotence, the reality is that the future of these wild spaces will be decided a long, long way away – in the meeting halls of places such as Kyoto, Copenhagen and Cancun. For, however powerful nature appears to be, it is not powerful enough to prevent mankind burning the world's fossil fuels at a prodigious rate. The resulting

global warming, most scientists agree, is melting the ice caps at an alarming rate.

This affects the rest of the world not only in terms of rising sea levels, but also more generally in destabilizing our climate. And the more ice that melts, the more sea is exposed, and the more heat is absorbed by the earth, accelerating the rate of warming. Rising temperatures pose an even greater threat to Arctic species such as seals and polar bears, as their natural habitat disappears and their very existence is threatened. The repercussions on other native species, and indeed the whole of the global ecosystem, is still unknown. The likelihood, however, is that a change of temperature of even just a few degrees will have a major adverse effect on biodiversity.

Meanwhile, the great expanses of ice at the top and bottom of our planet continue to exercise a hold on our collective imagination. And for good reason. For, even in this age of travel, there is truly nowhere else like them on earth.

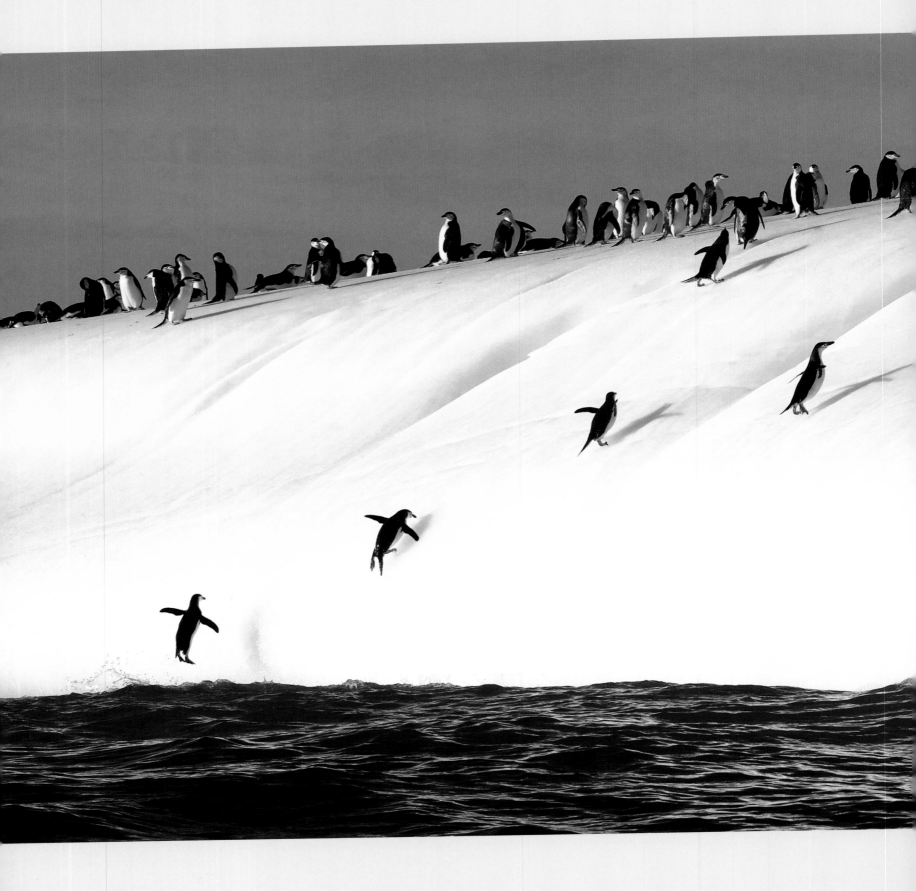

Chinstrap penguins jumping out of the water onto an iceberg to rejoin the colony, South Georgia Island.

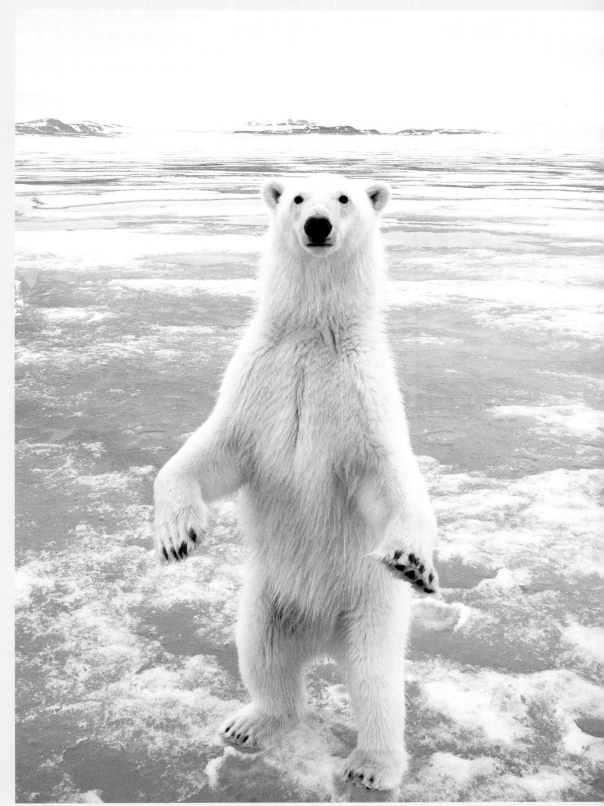

*Polar bear standing on its hind legs on
sea ice, off the coast of Svalbard, Norway.*

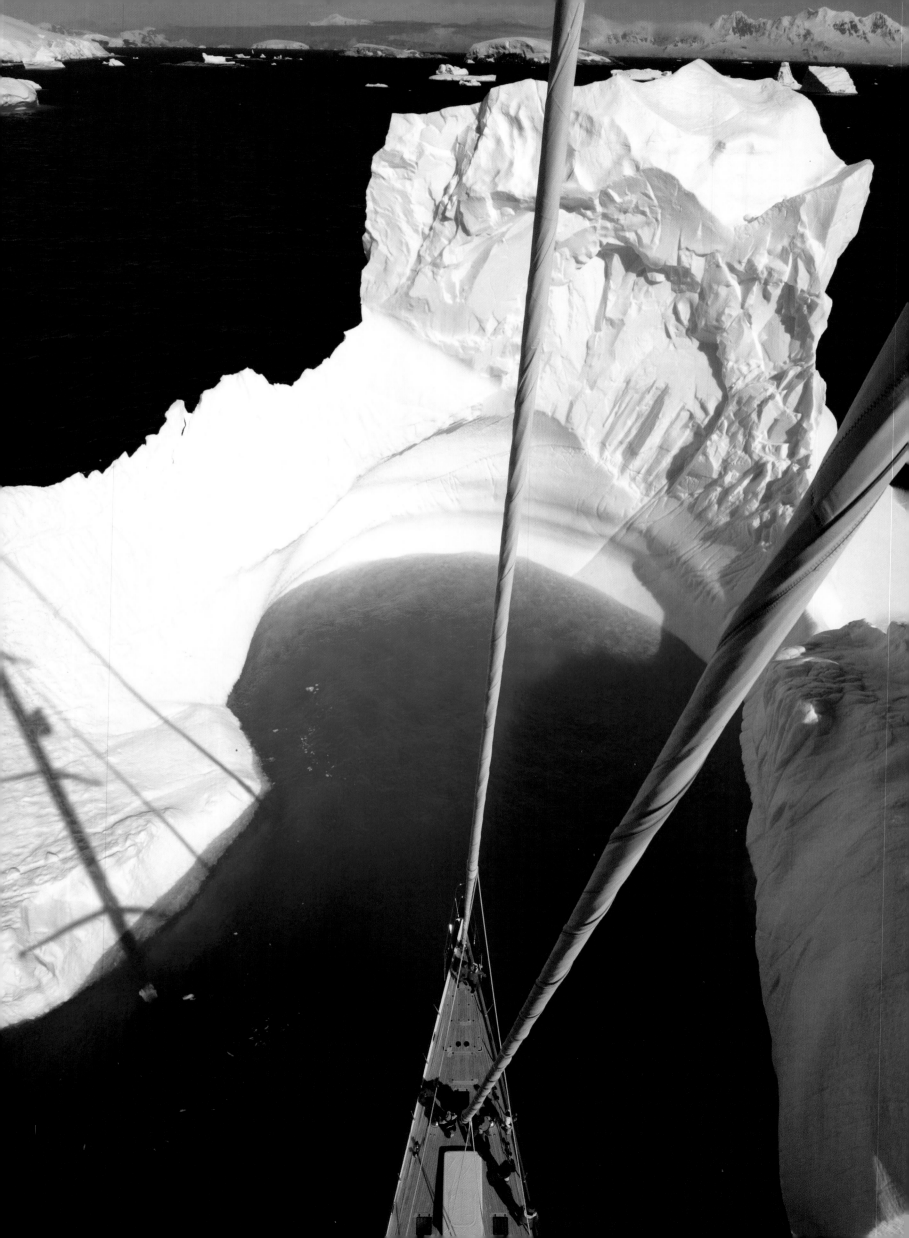

Left: View taken from the mast of SY *Adele's bow in the bay of an iceberg at Portal Point, Reclus Pennisula, Antarctica.*

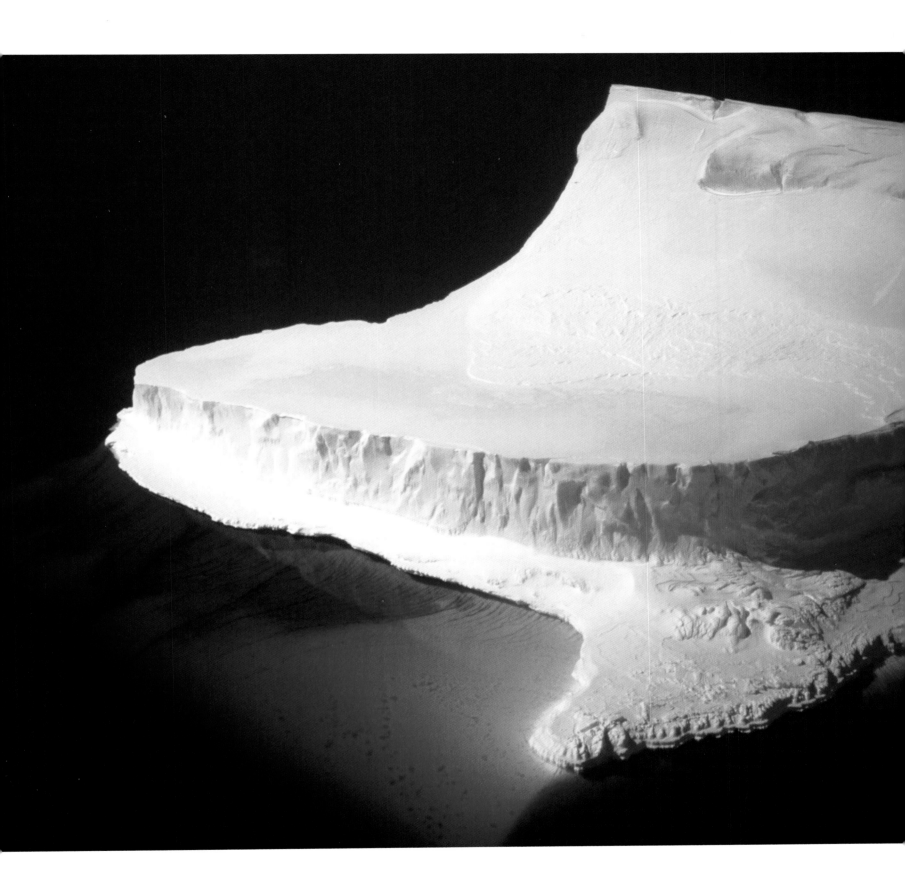

Above: A bergy bit (or small iceberg), Cape Darnley, Australian Antarctic Territory.

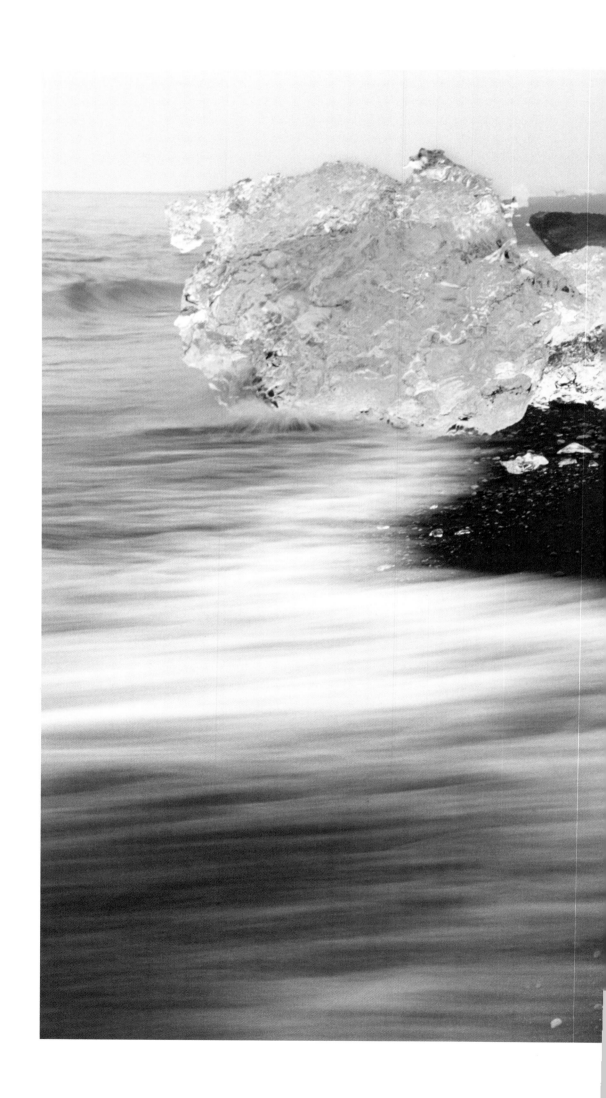

*Pieces of iceberg calved from the
Vatnajokull glacier resting on a black
sand beach, Iceland.*

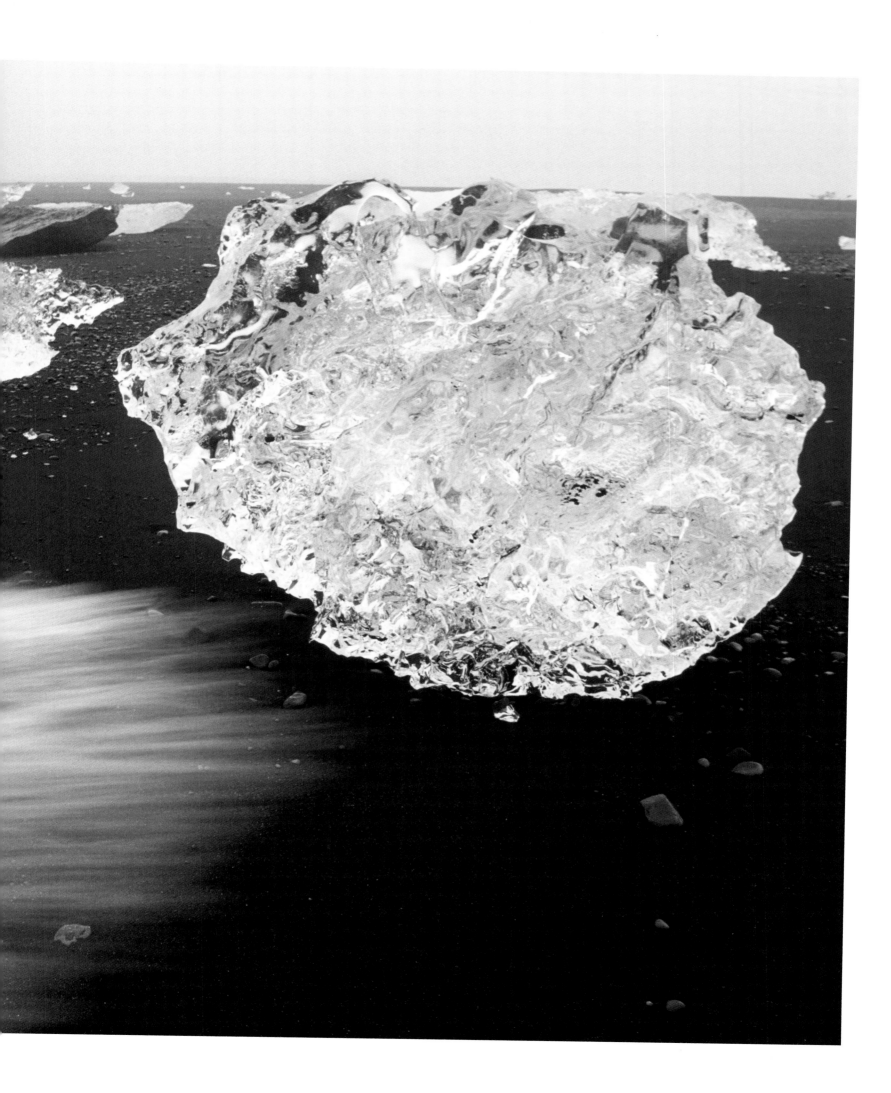

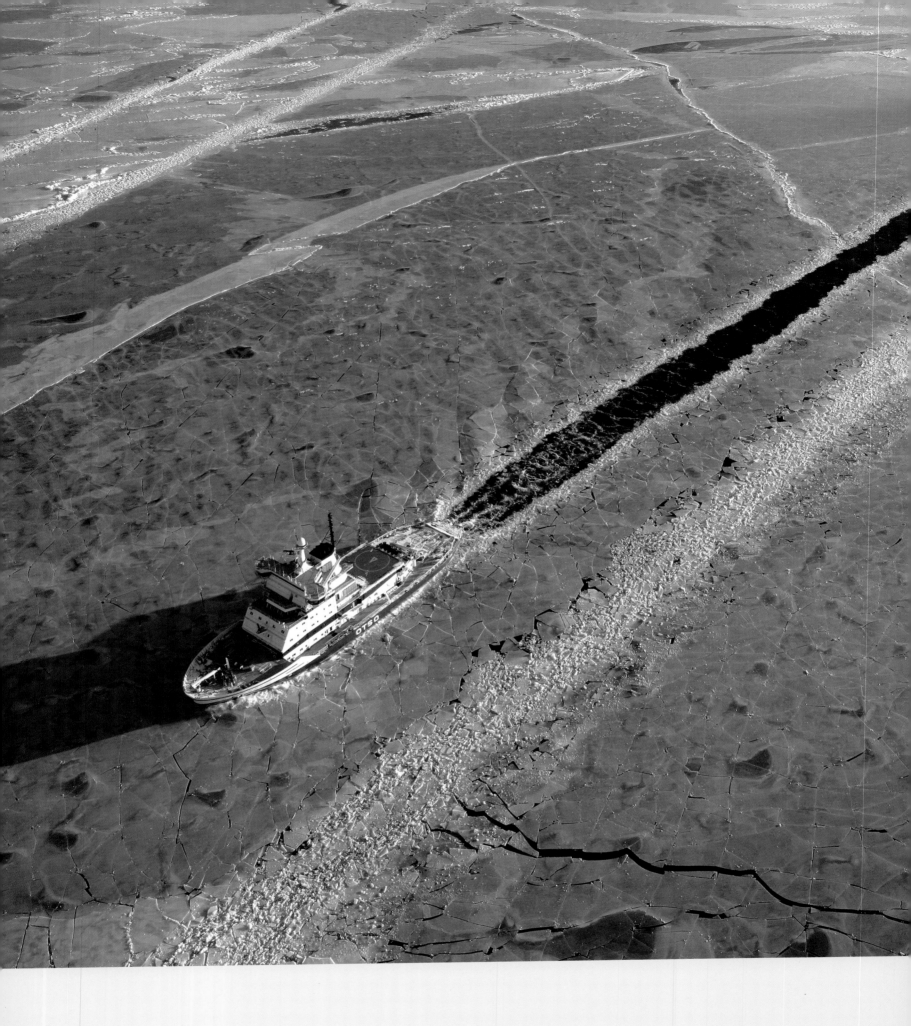

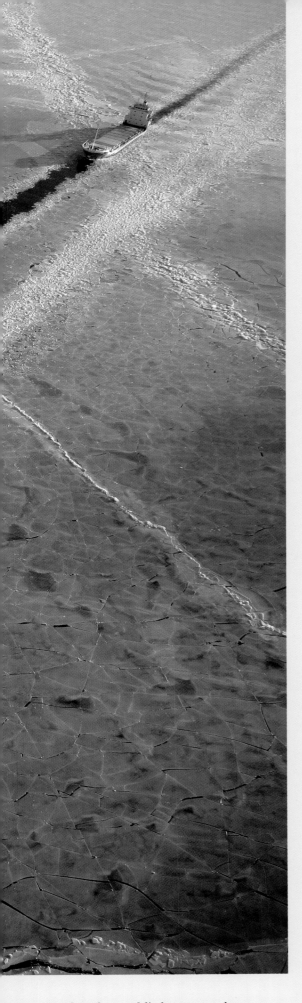

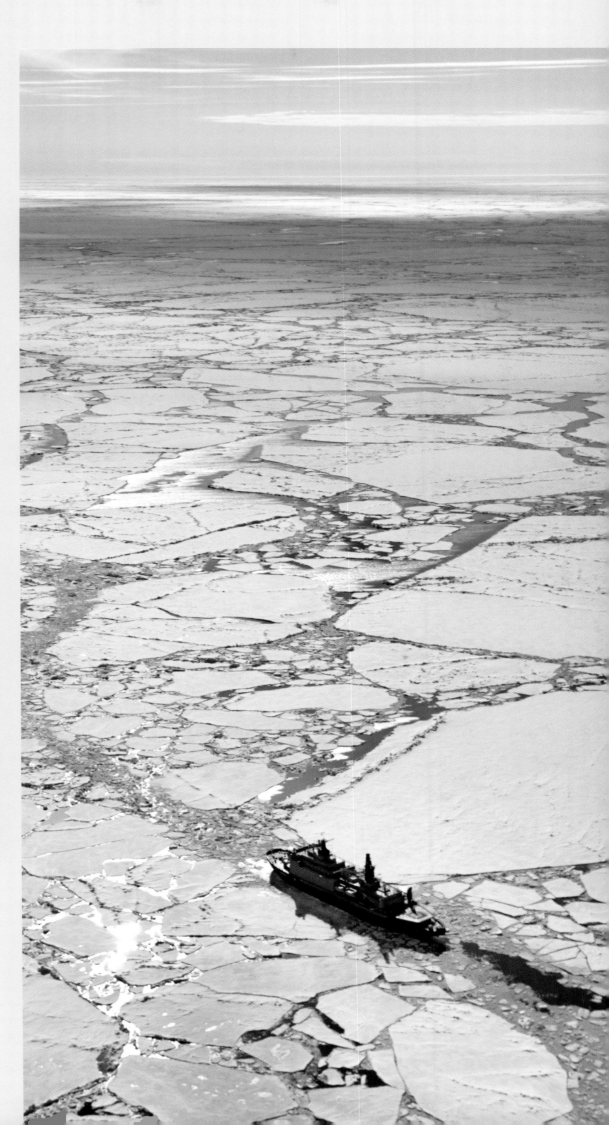

Left: An ice breaker clearing a path for a tanker in the Baltic Sea, off Finland.

Right: The world's largest nuclear icebreaker, NS 50 Lyet Pobyedi (50 Years of Victory), en route to the Russian Arctic.

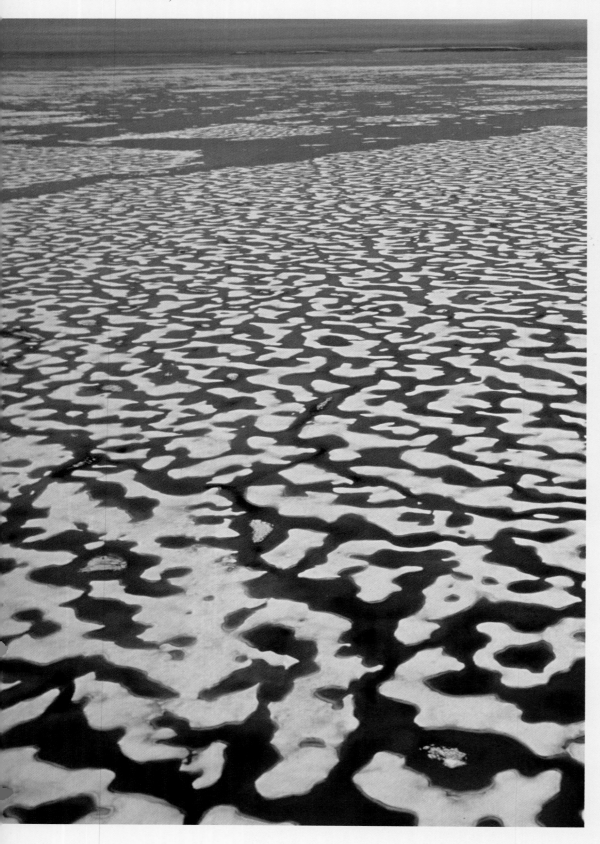

Aerial view of sea ice melting, creating patterns over the spring sea surface in Lancaster Sound, Canadian Arctic.

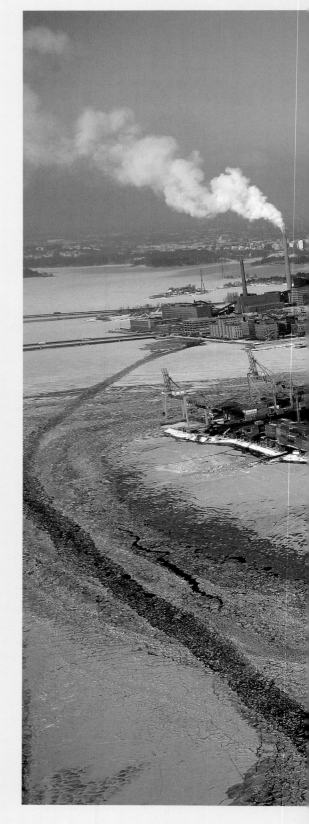

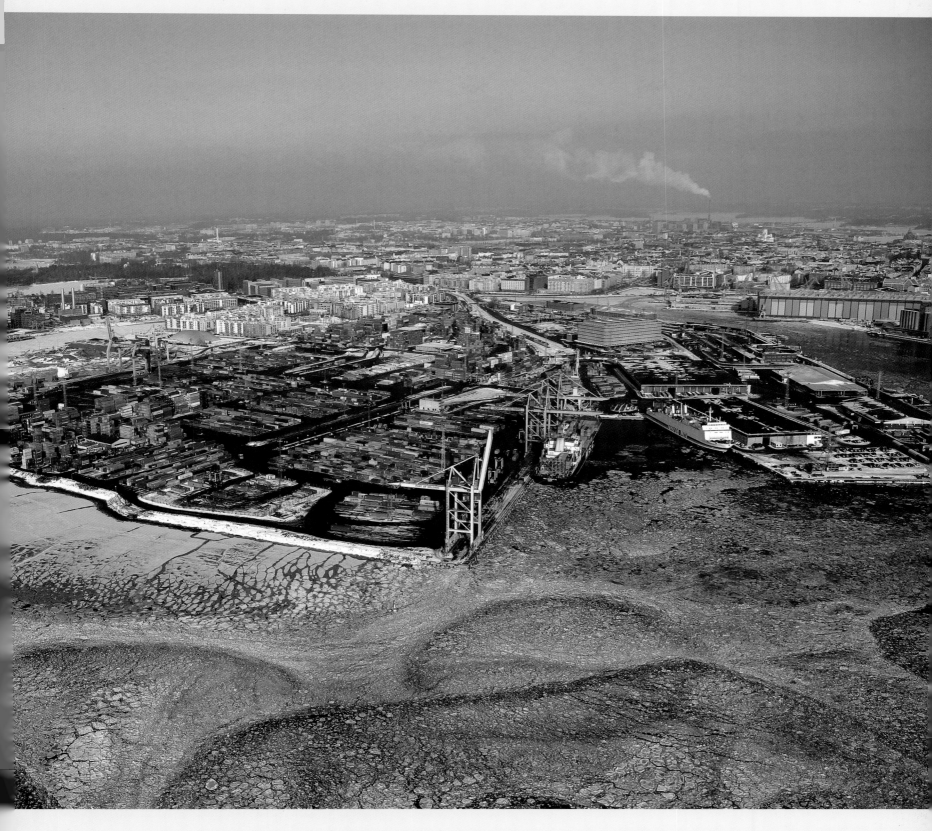

Helsinki commercial port, ice-bound in March. Finland.

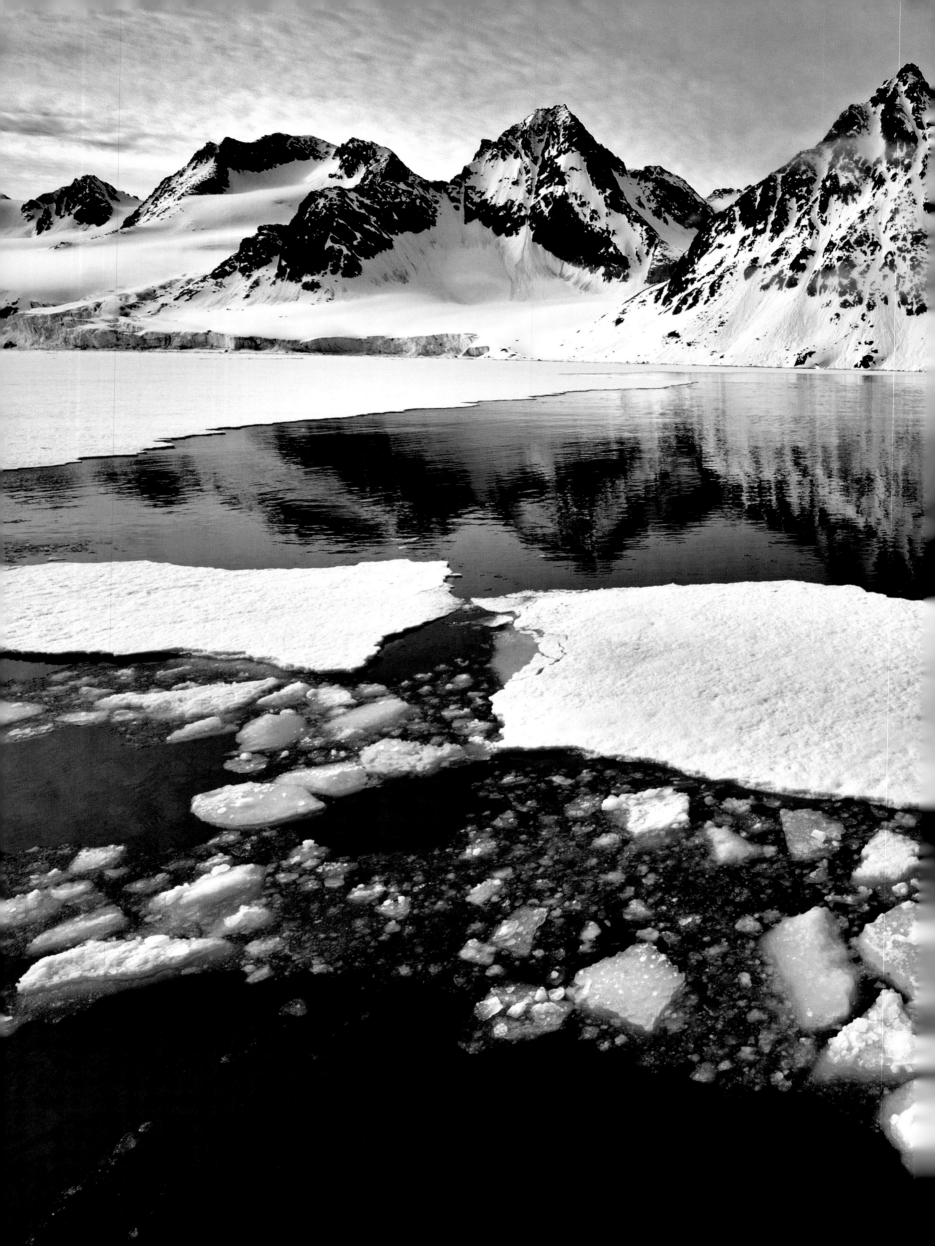

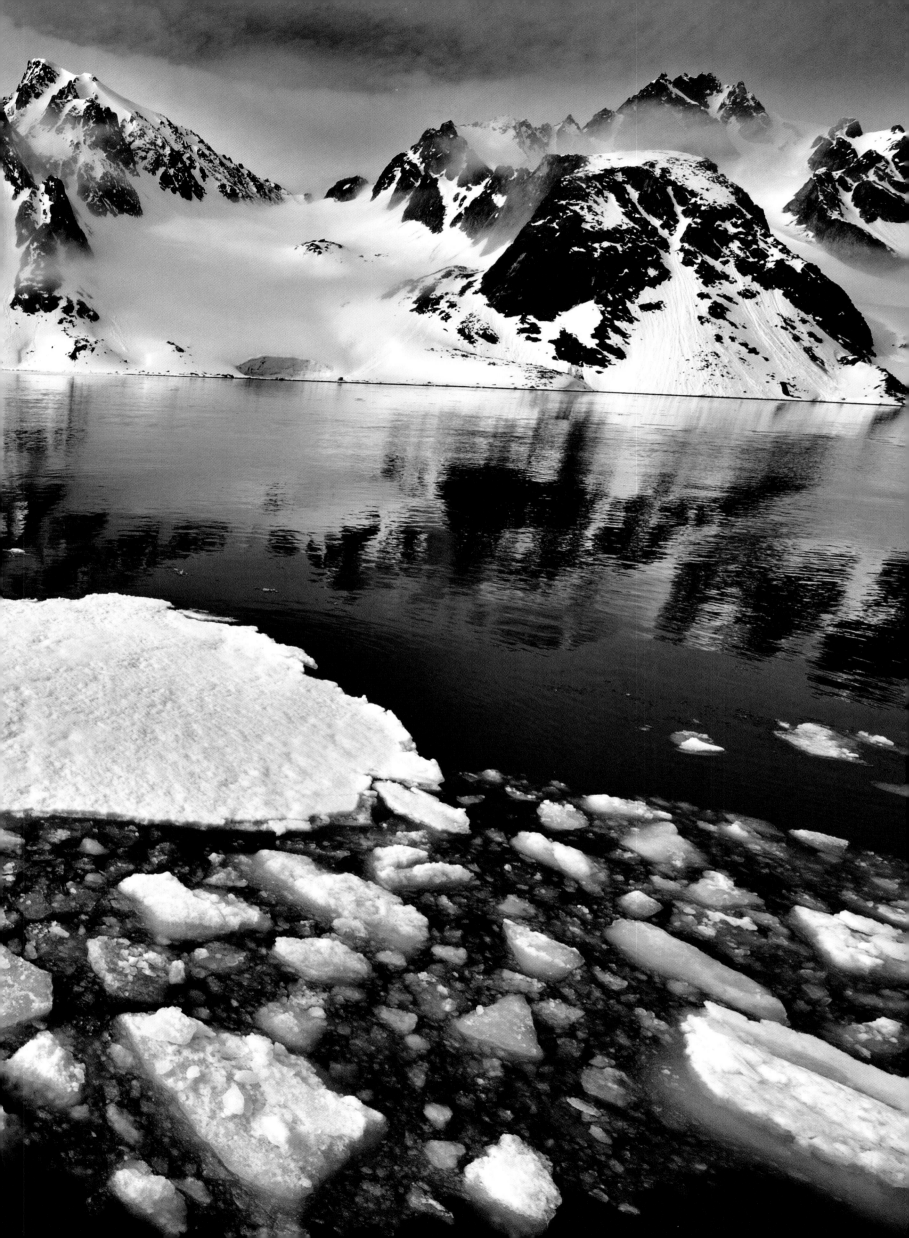

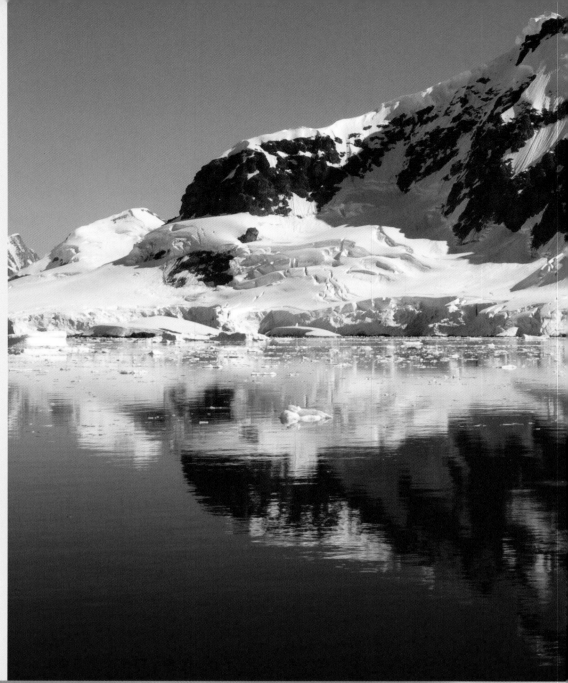

Previous pages: Coastal mountains with broken ice floating on the sea in Svalbard, Norway.

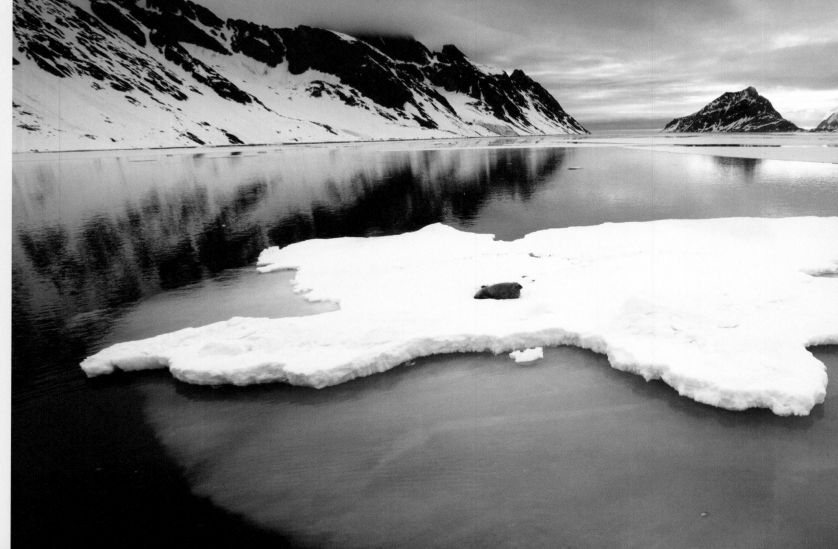

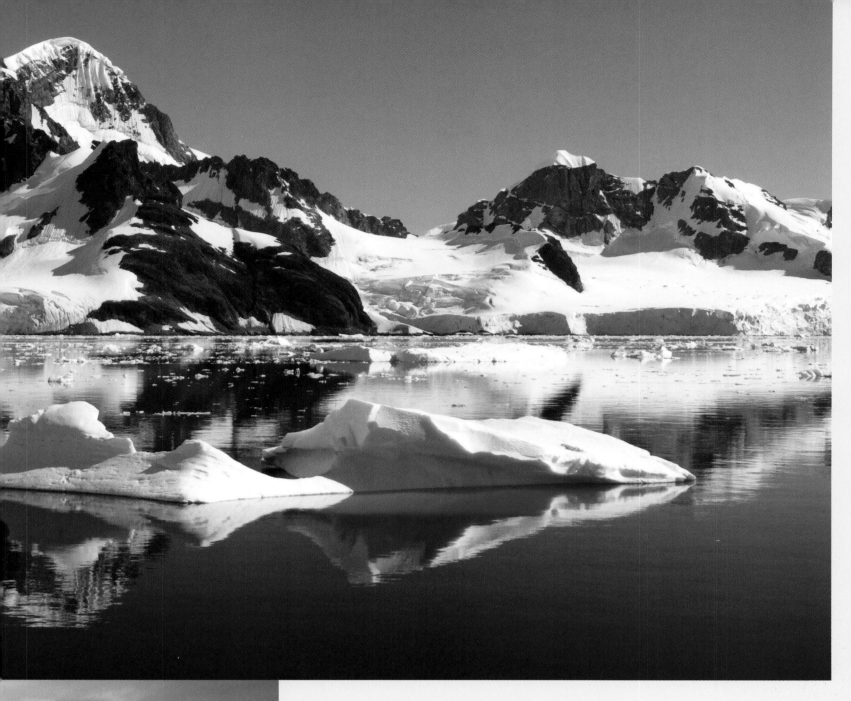

Above: Esperanza Bay on the
northwestern side of the Antarctic
Peninsula.

Left: Walrus on ice, Spitsbergen,
Svalbard, Norway.

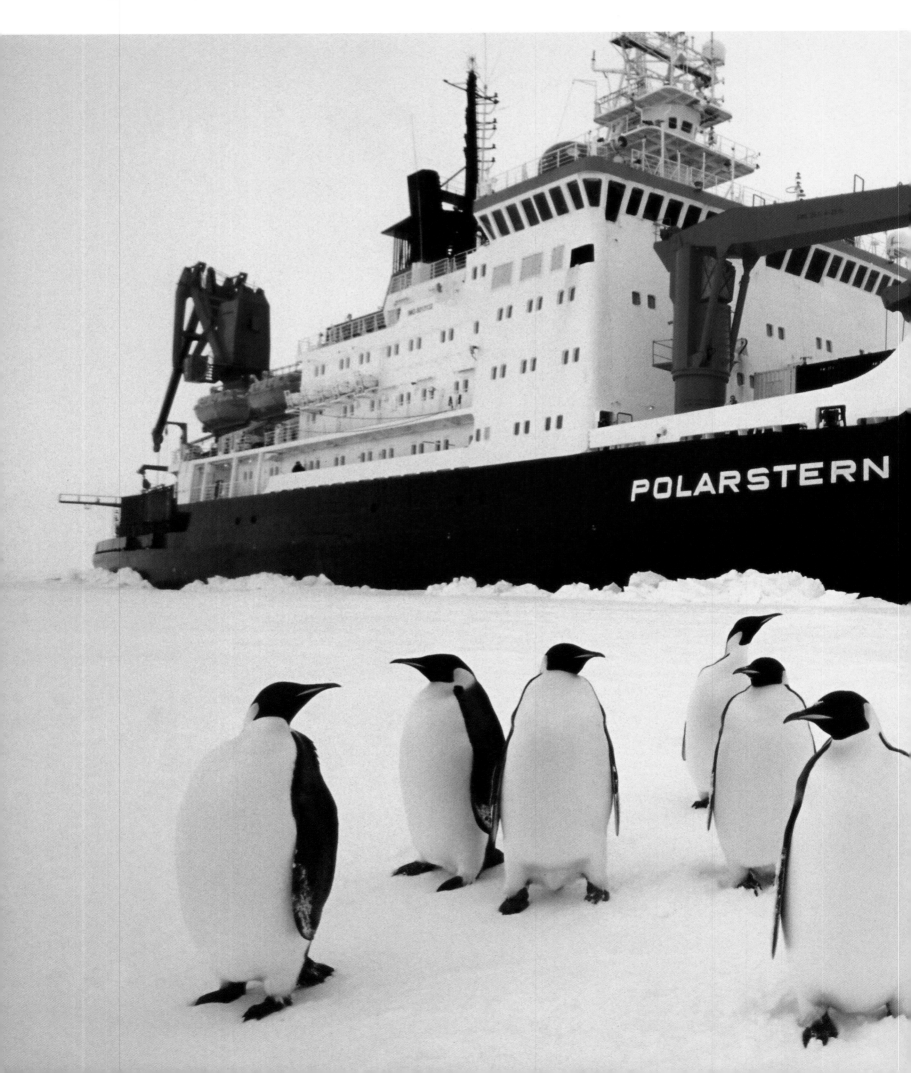

The icebreaker research ship,
Polarstern, *with Emperor penguins*
nearby, Weddell Sea, Antarctica.

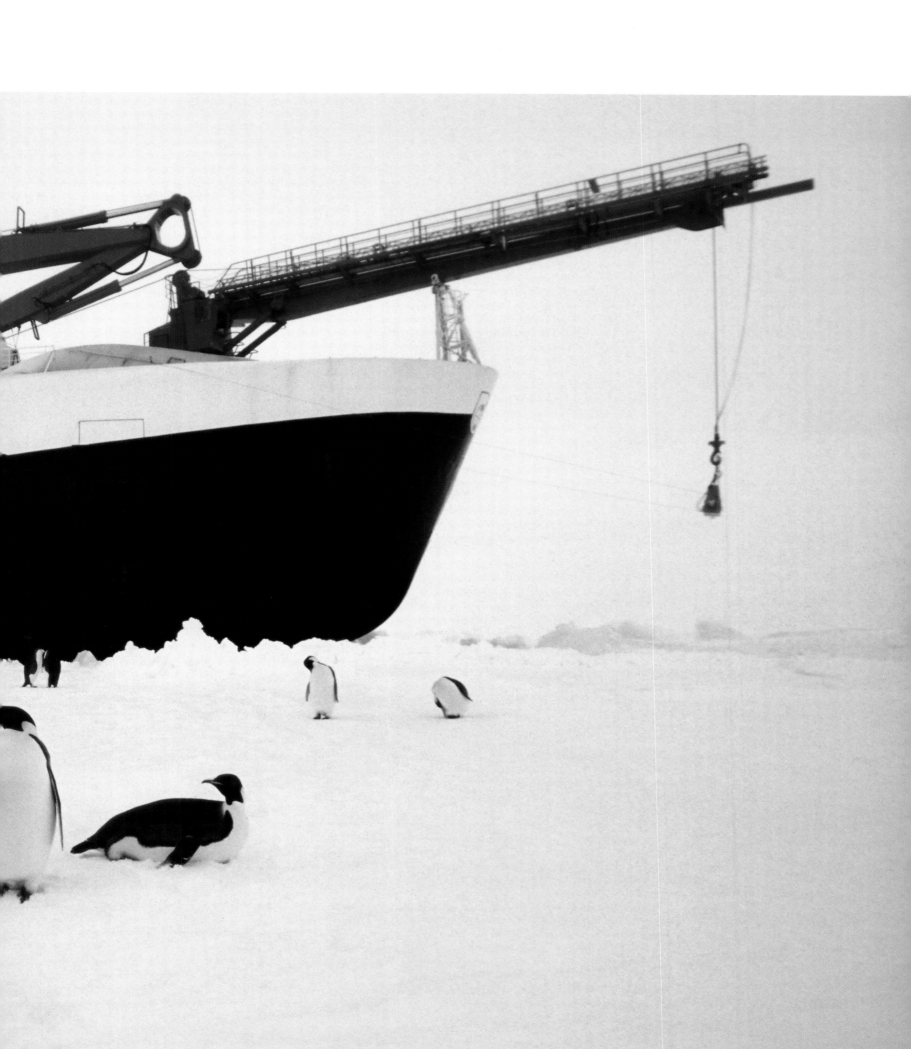

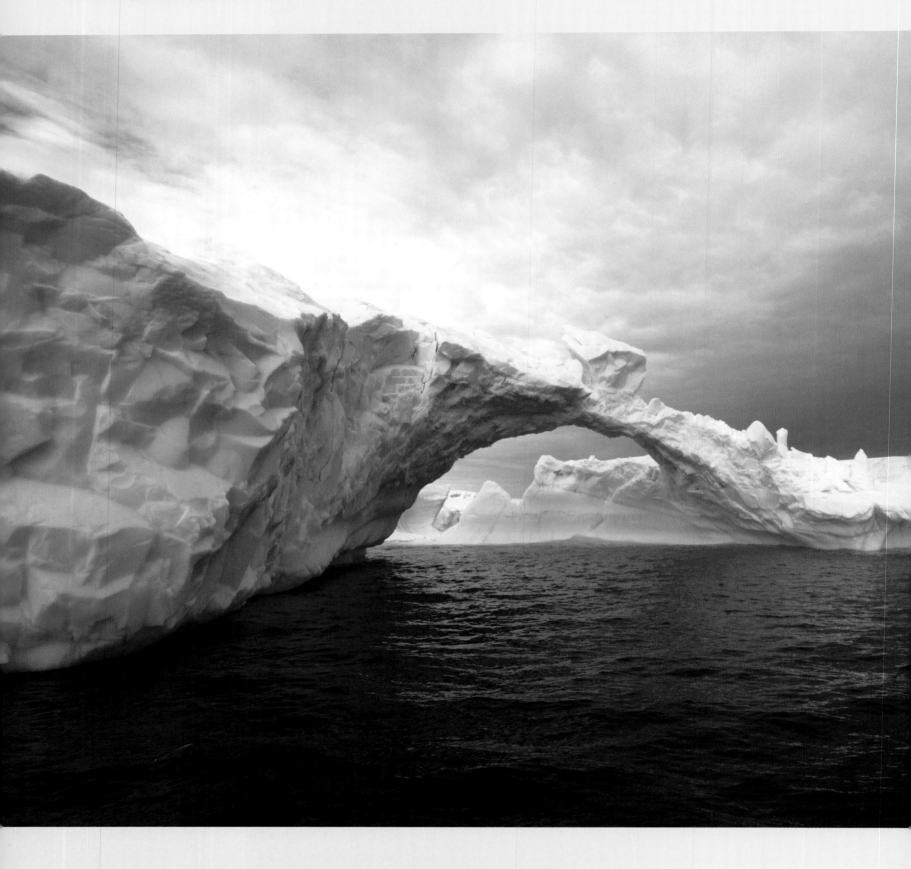

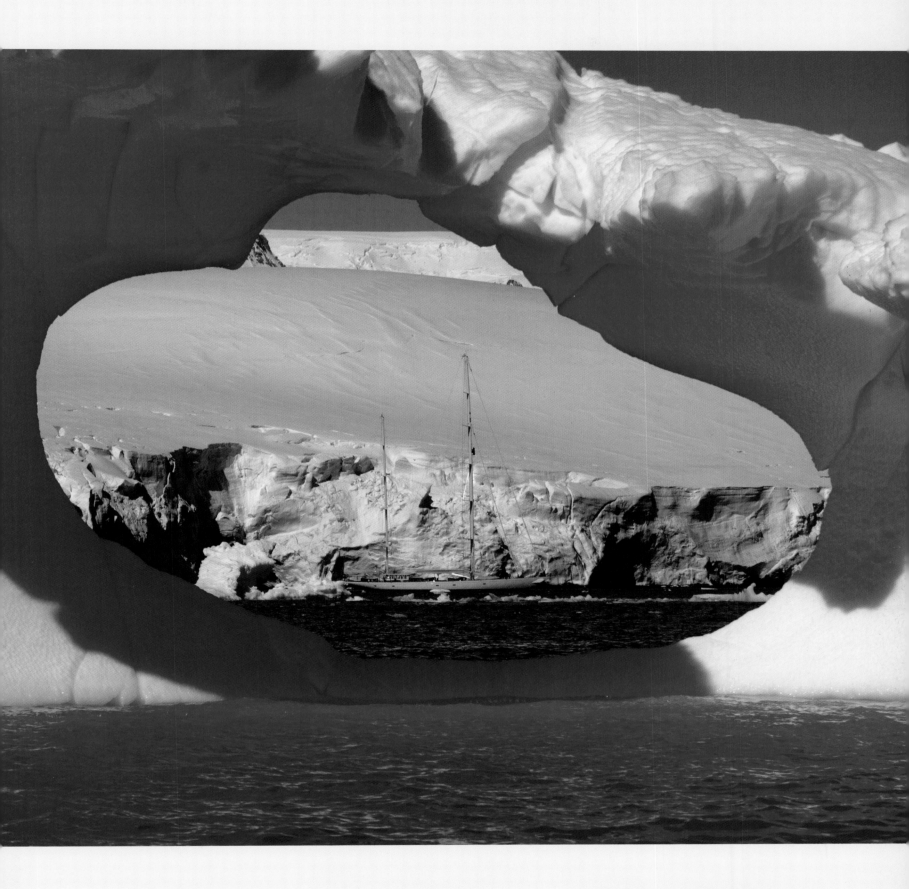

SY Adele, *a 180ft Hoek design, seen in the distance through an ice window, motoring in the Lemair Channel, Antarctic.*

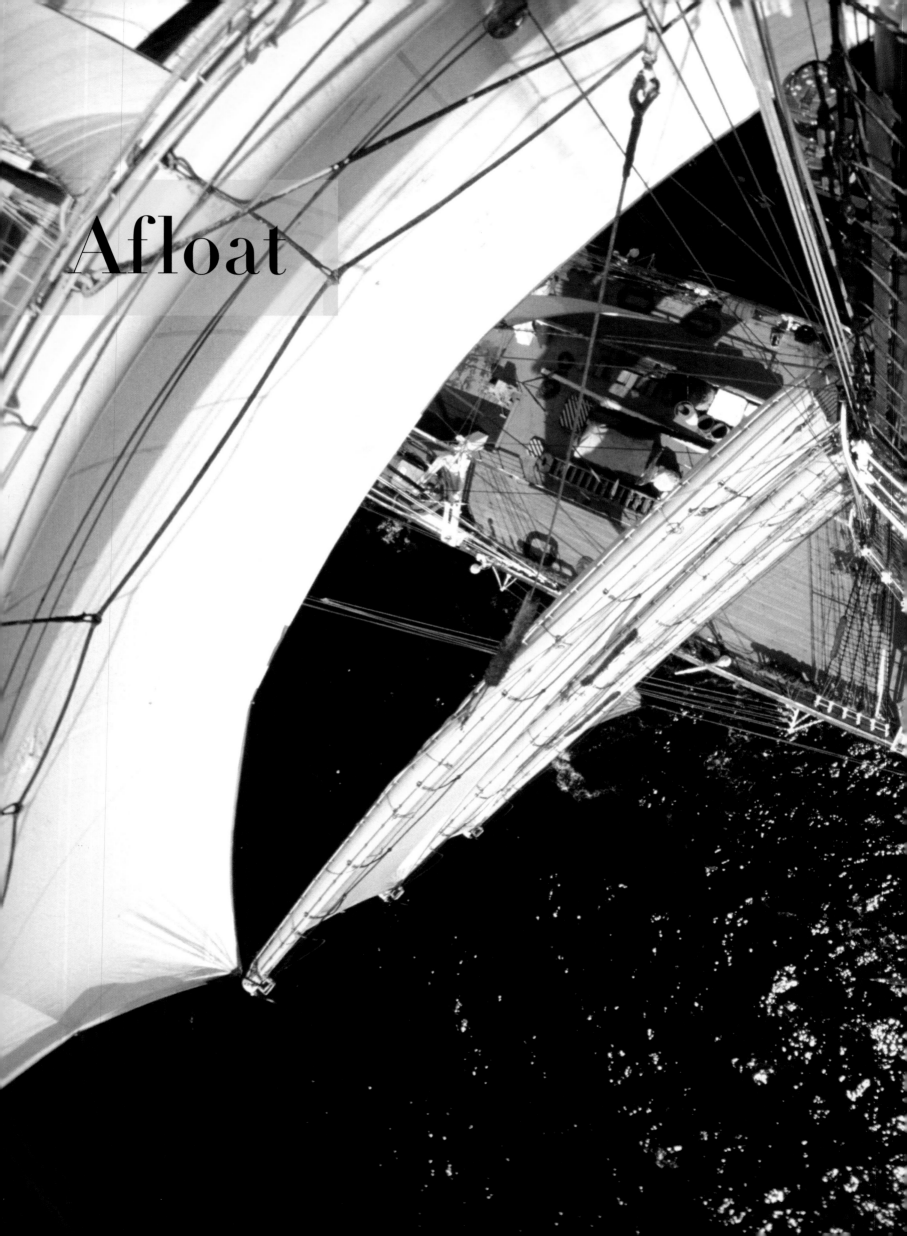

Afloat

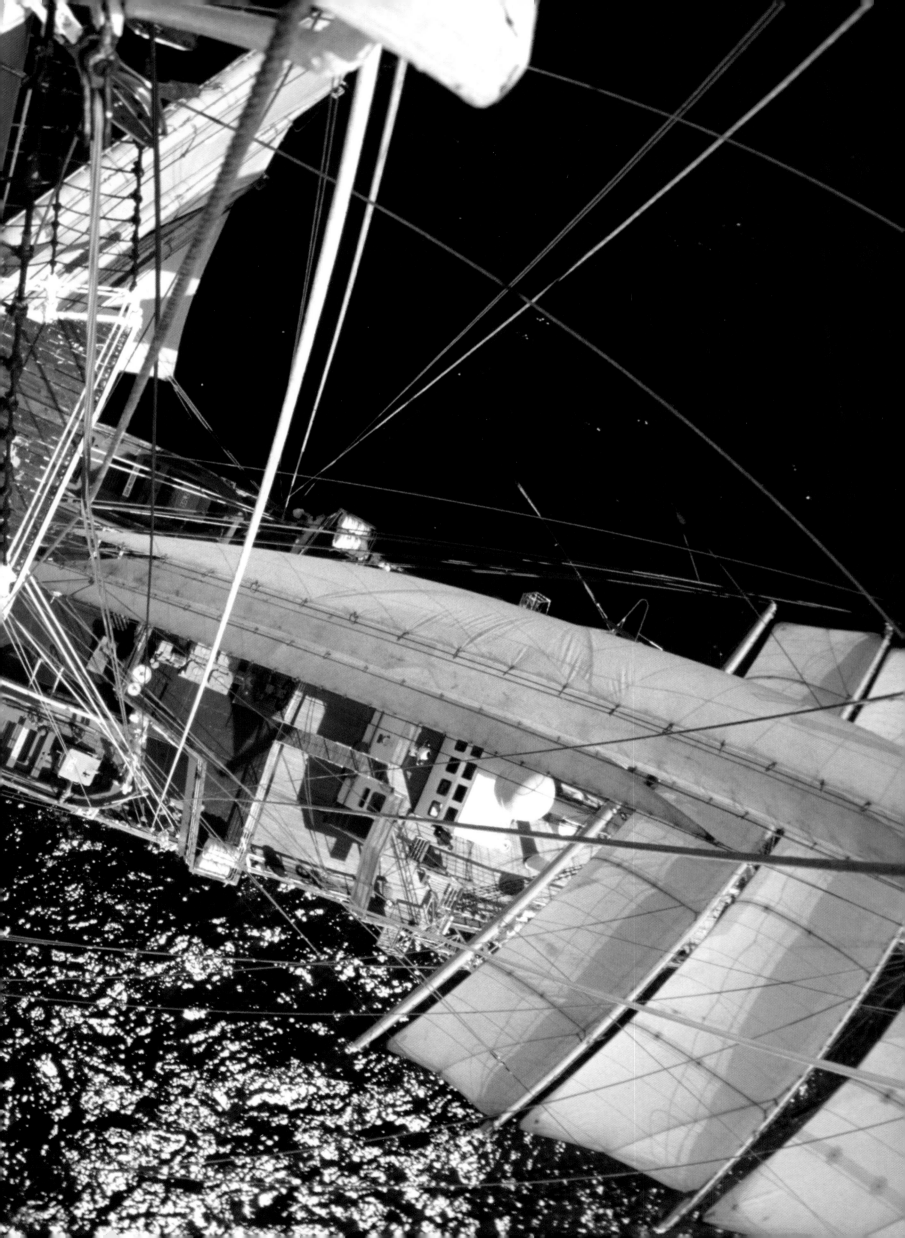

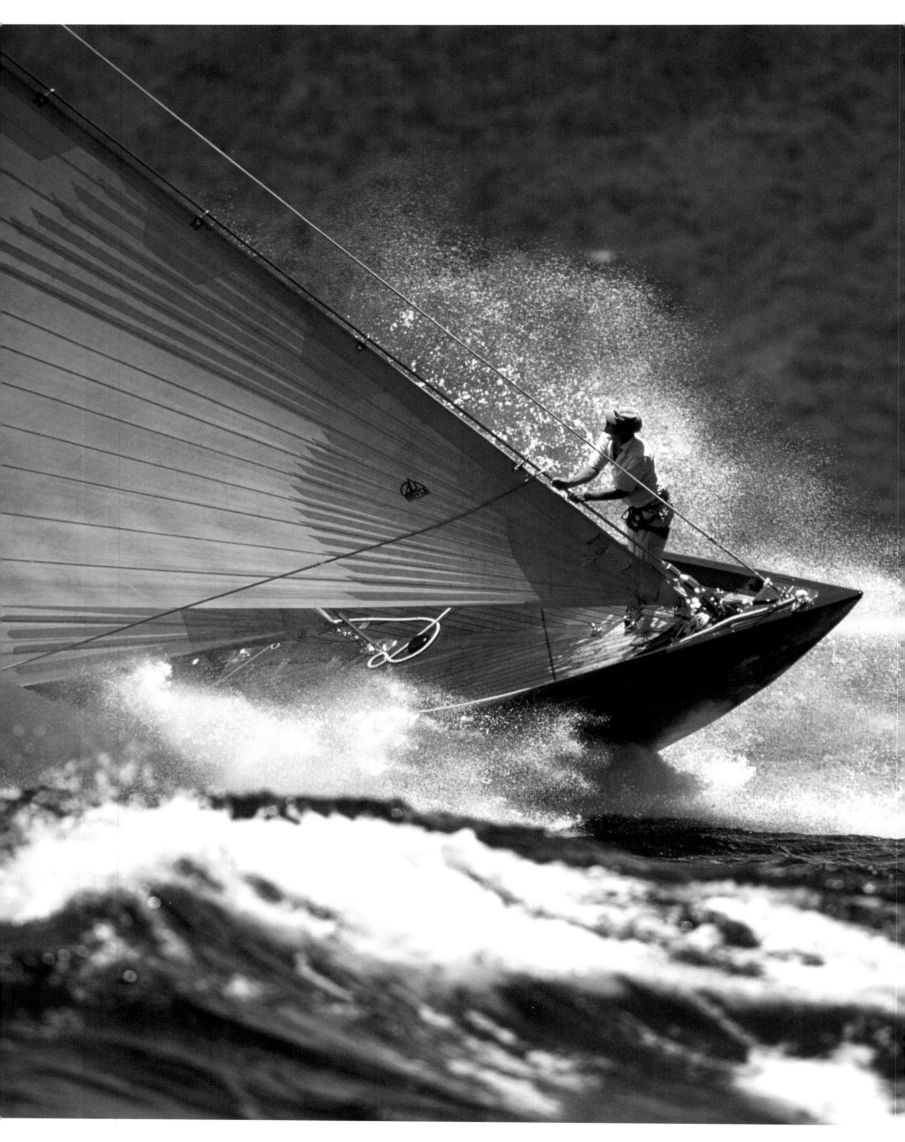

When boats go to work and play

For at least 7,000 years men and women have taken to the sea in all manner of craft – from simple rafts and dainty 'cockleshells', to spectacular square-riggers and mighty ocean liners. An extraordinary amount of skill and ingenuity has been exercised creating these vessels from materials as varied as balsa, bamboo, reed, steel, and even concrete. The result is the wonderful array of craft of every shape and size depicted in the following pages.

What these craft have in common is that they were all built using the latest technology and the best materials available at a particular time and place. Most primitive vessels were built to trade or to fish and, in order to be competitive, they needed to be built to the most advanced design of the day. And, because going to sea can be a dangerous business, only the best materials could be used in the construction of sea-going craft, whether for work or leisure. Not for nothing did sailors come up with the expression 'don't spoil the ship for a hap'orth of tar'.

This is why modern fishing boats use the latest electronic devices to scan the seabed, why cargo ship design is constantly evolving, and why submarines that have to remain immersed at sea for months at a time are fitted with nuclear power. It's

also why racing yachts are built of carbon fibre and fitted with hinged keels, while cruising yachts are built of fibreglass and fitted with fixed keels. It's design and technology fit for purpose.

Yet the wonderful, and perhaps surprising, thing about this drive for efficiency is that it almost always produces designs that are both supremely functional and beautiful to behold. Think of the *Cutty Sark*, built to be the fastest ship to fetch tea and wool from the other side of the world to the markets of Europe. Think of the Pacific proas, built with no other purpose than to hop from one island to the next, fishing or carrying cargo. Think of the Chinese junk, one of the great workhorses of the sea that is nevertheless appealing enough to feature on countless tourist postcards. Even today's warships and cargo ships have a certain imposing majesty – albeit little of the grace of their predecessors.

The following pages include yachts, fishing boats, lifeboats, cargo ships – and even a submarine. Some are more elegant than others. Yet they are all designed and built to cope with the most challenging environment nature has created: the sea. In their way, all fulfill the ultimate design objective of marrying form with function. Not, in most cases, because they need to look pretty, but simply because that is the most efficient shape they can possibly be. And, as several of these images demonstrate, the sea is a hard taskmaster, which will not tolerate failure. You don't get many second chances if your ship fails in an ocean gale in the middle of the Atlantic.

Previous pages: The view from the masthead of the Polish Tall Ship Dar Mlodziezy.

Left: The bowman on the J-Class yacht Velsheda *checks the sail trim during a race at the Antigua Classic Yacht Regatta.*

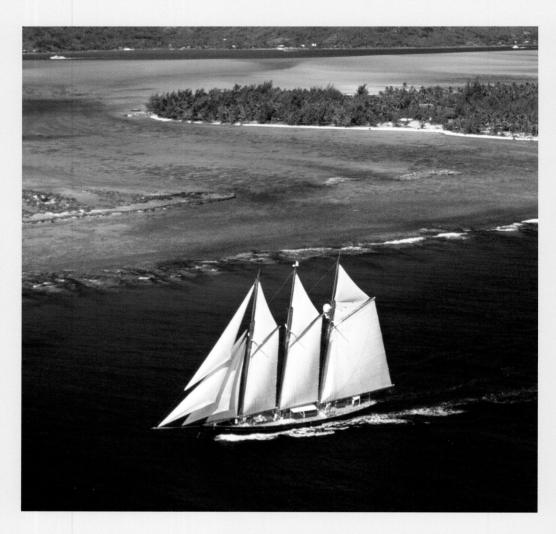

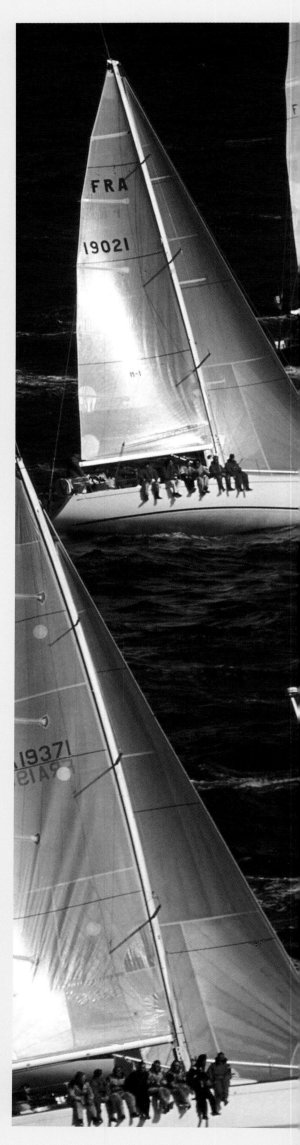

Above: The three-masted schooner **Shenandoah** *sailing along the northwestern barrier reef of Bora Bora, French Polynesia.*

Right: Regatta in the bay of Quiberon, Brittany.

Below: The Grand Parade at the Douarnenez Maritime Festival, Brittany.

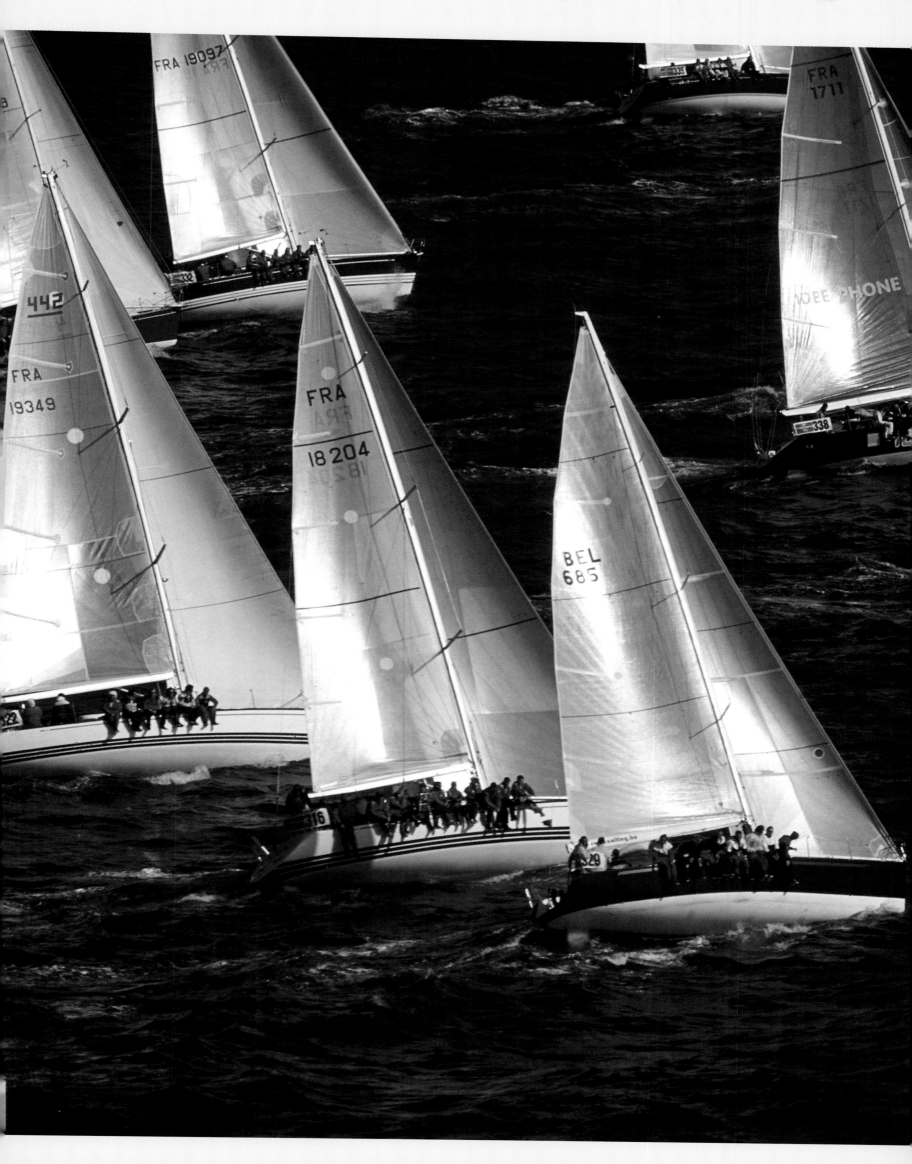

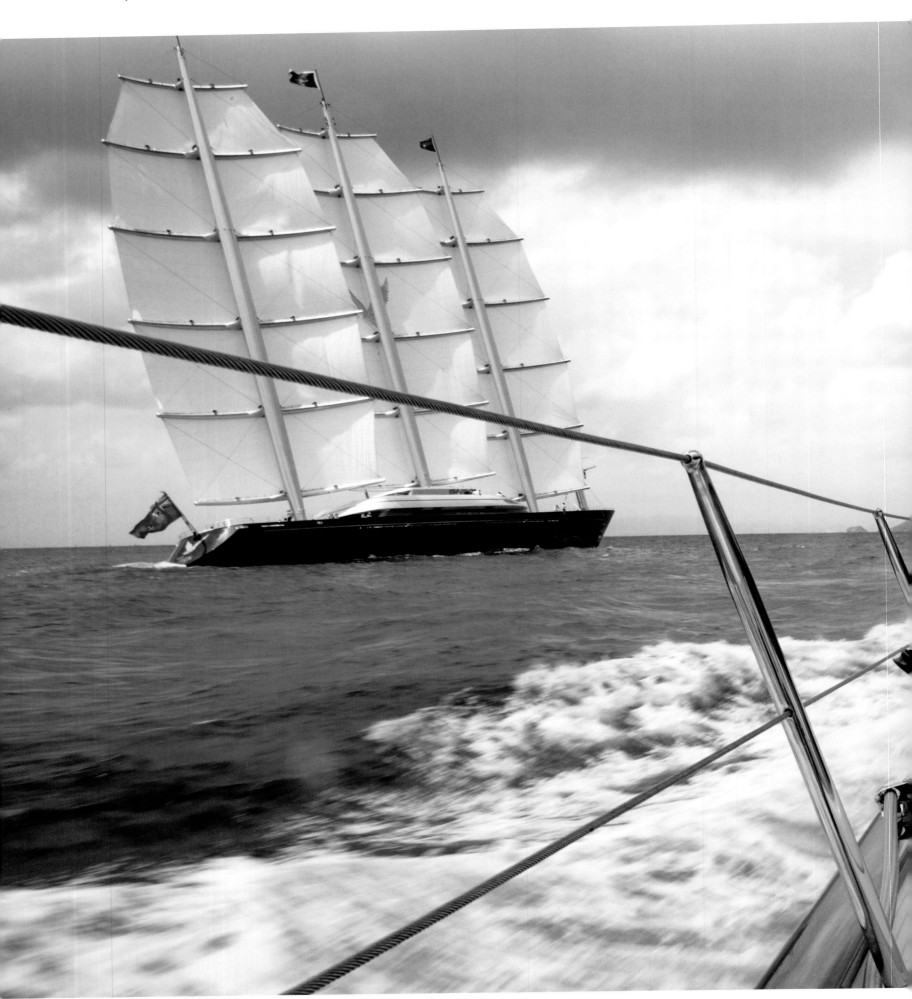

View from the deck of a neighbouring yacht of the megayacht Maltese Falcon *during the St Barth's Bucket Regatta, St Barthelemy, Caribbean.*

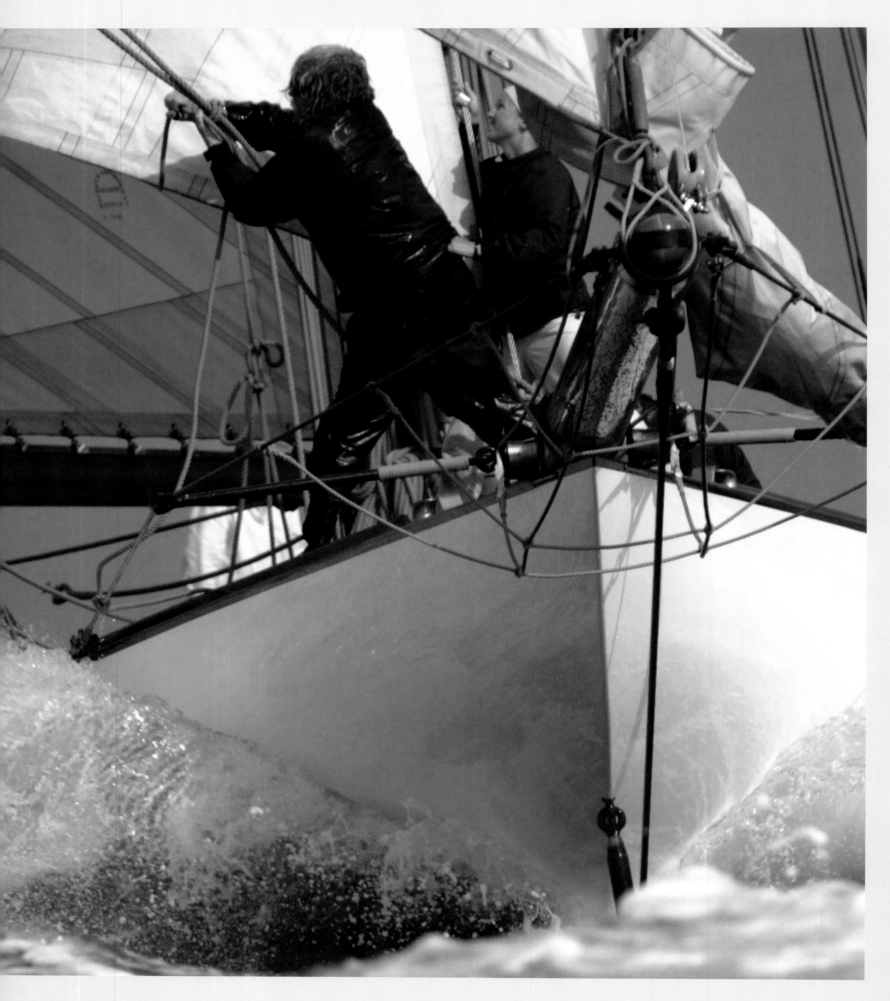

Sail change on the gaff cutter Mariquita
*during Les Voiles de Saint-Tropez,
France.*

Djuice Dragons *in tough conditions*
leaving Cape Town during the Volvo
Ocean Race 2001–2002.

Next pages: Jean Luc Neilas' 60ft
trimaran Belgacom *heeling.*

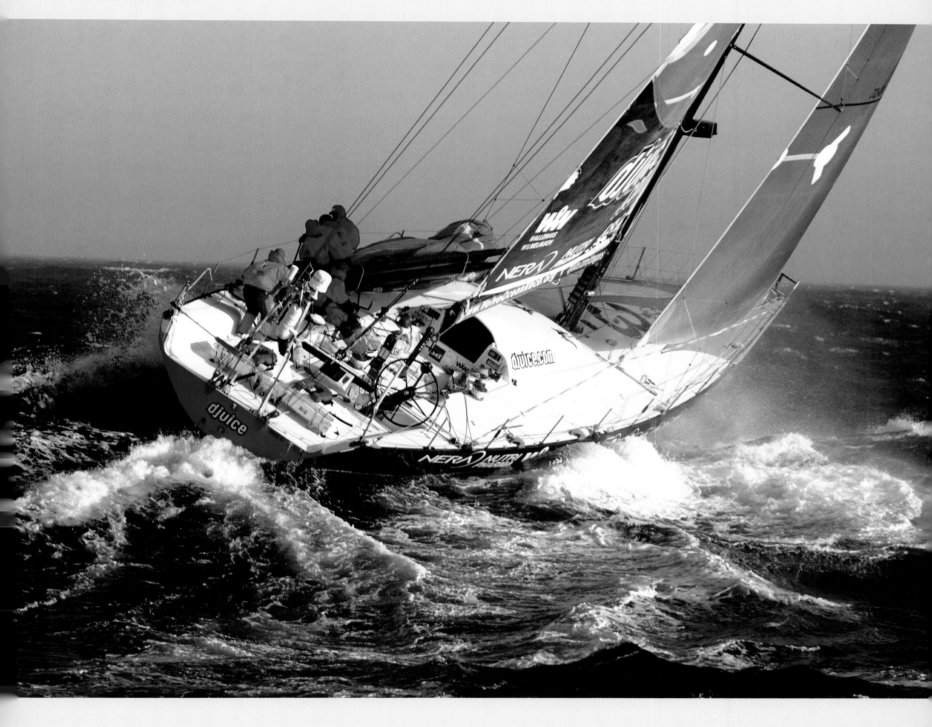

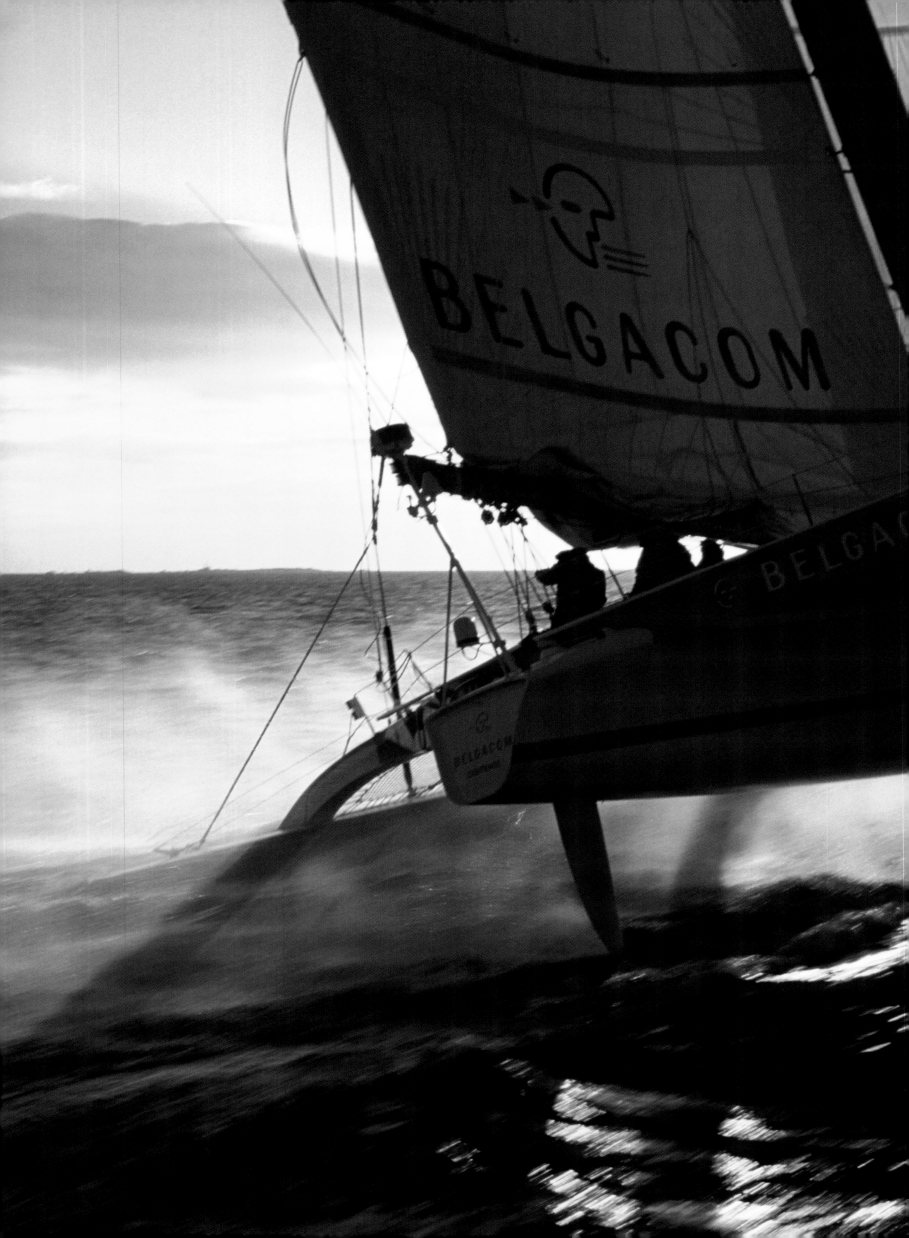

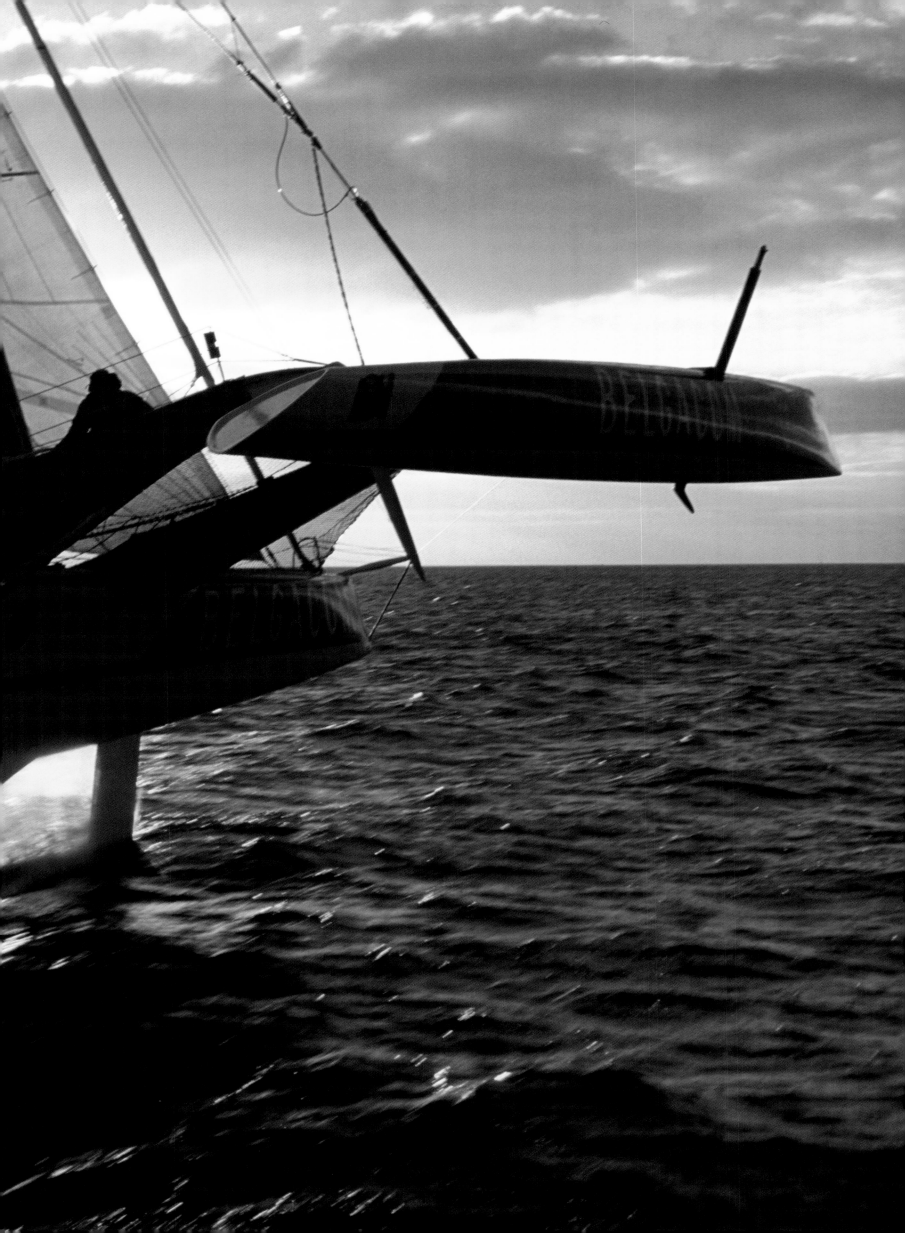

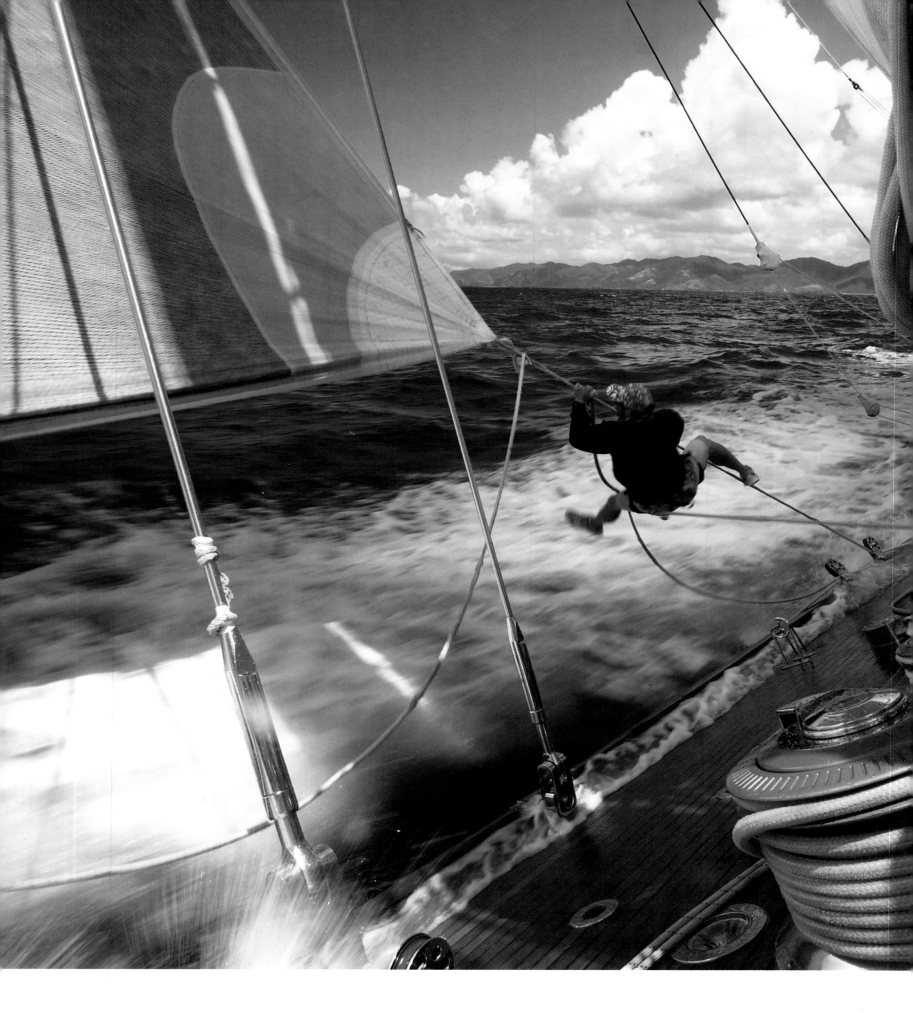

A crew member trips the spinnaker during a race aboard the J-Class yacht Velsheda *at the Antigua Classic Yacht Regatta.*

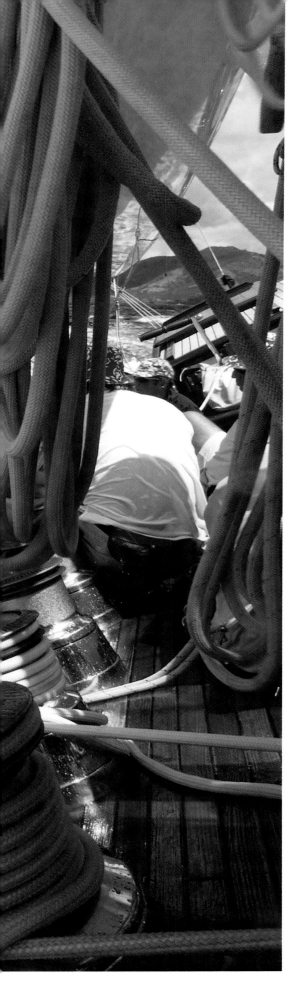

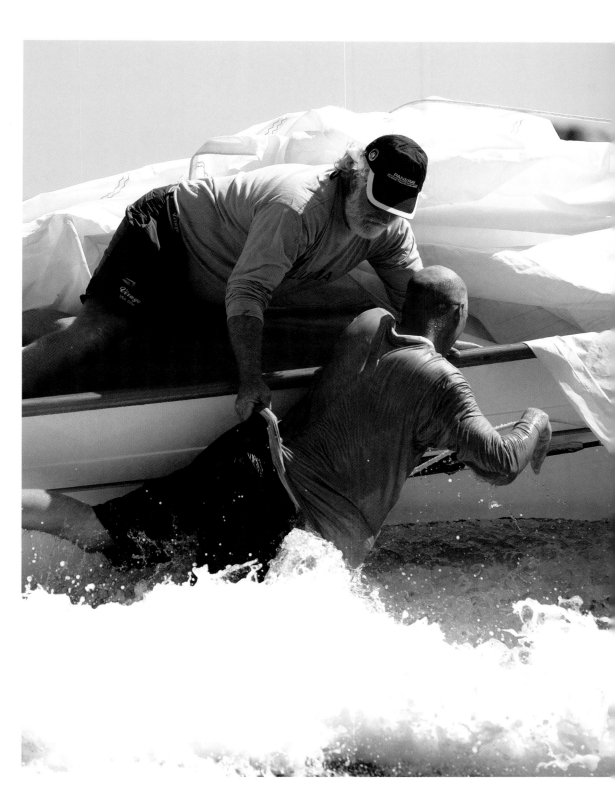

The bowman of the Bermudan yawl
Lucia *falls overboard during racing at*
the Panerai Classics Regatta, Sardinia.

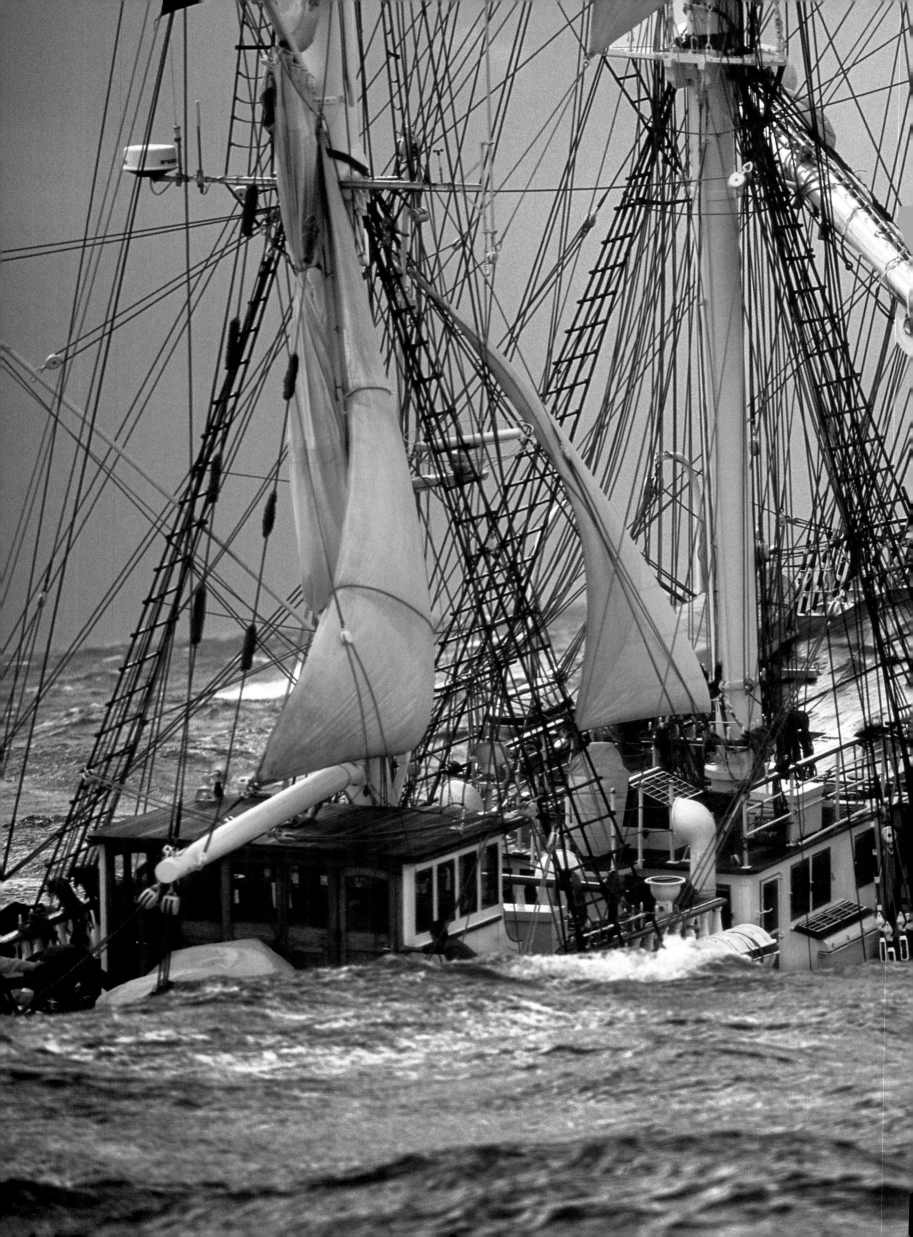

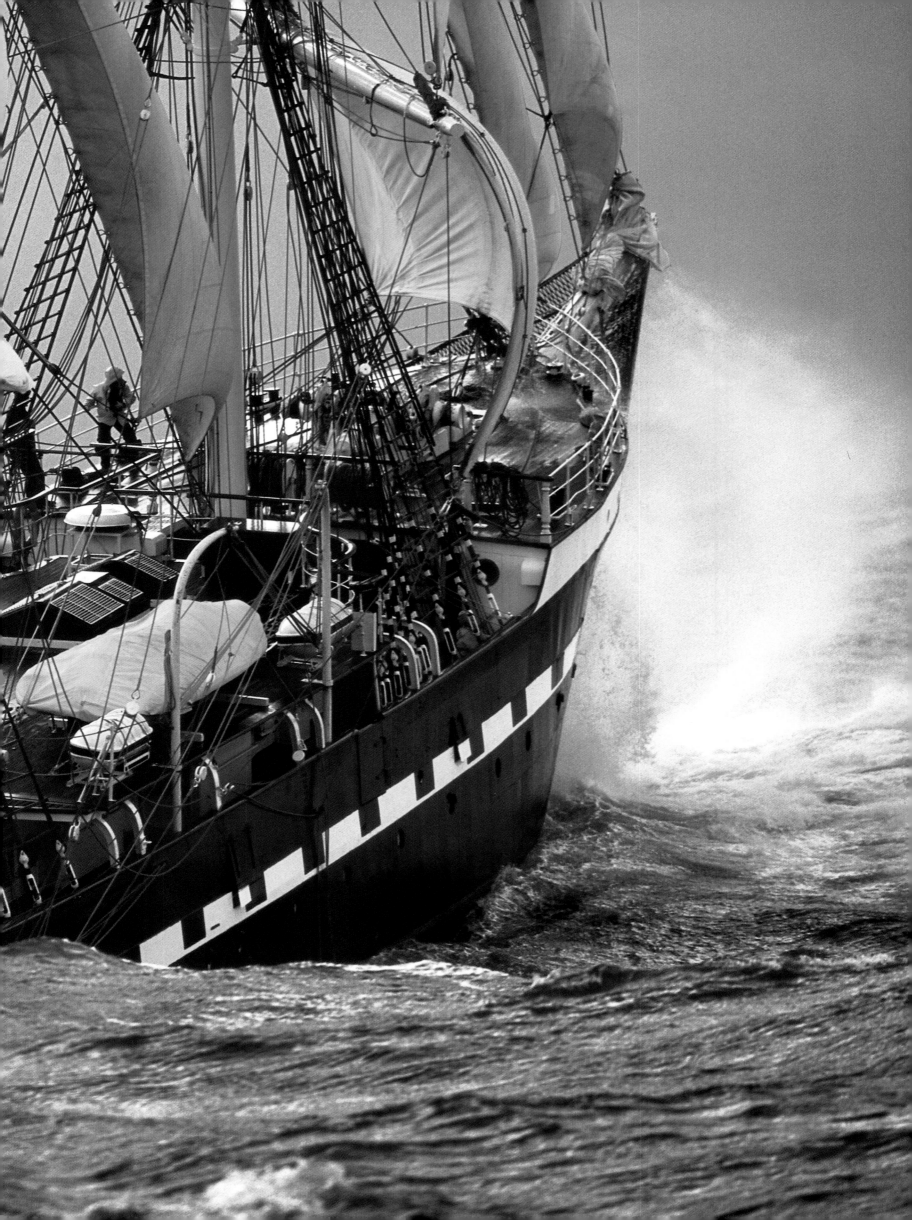

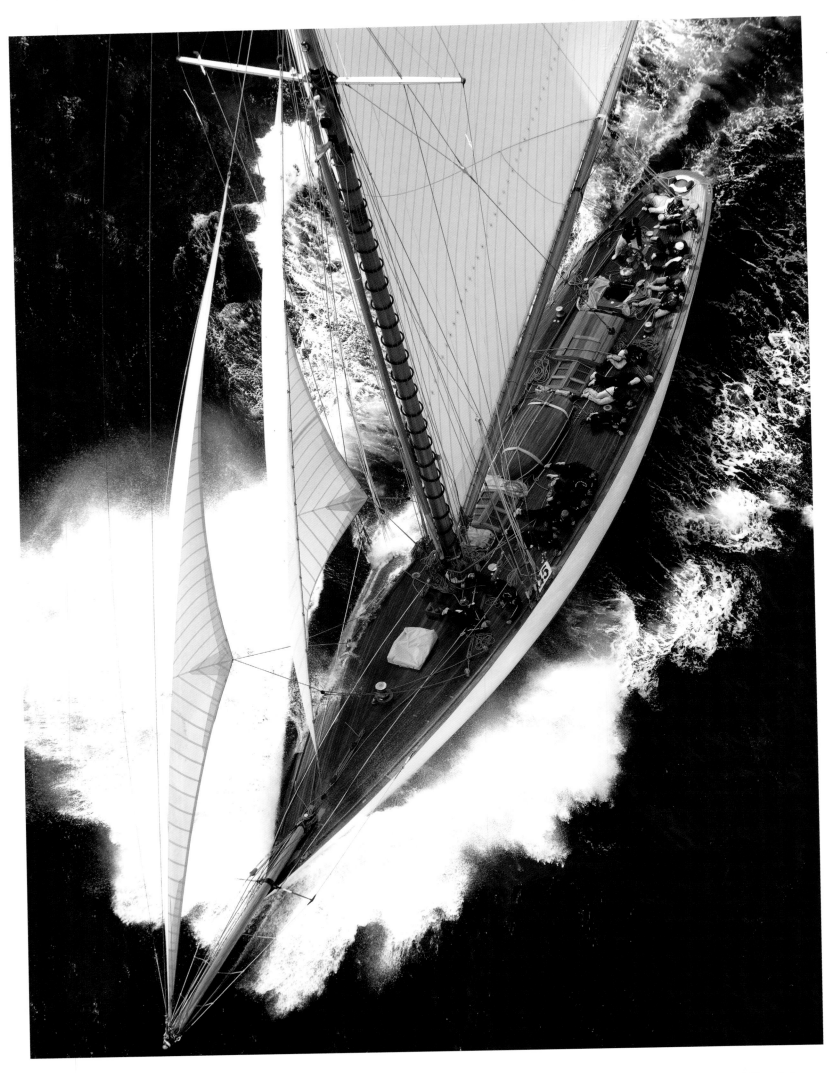

Previous pages: The three-masted tall ship Belem *in rough seas.*

Above: The gaff cutter Mariquita *sailing at Les Voiles de Saint-Tropez Regatta, France.*

Right: J Class yachts Astra *and* Candida *racing at Les Voiles de Saint-Tropez, France.*

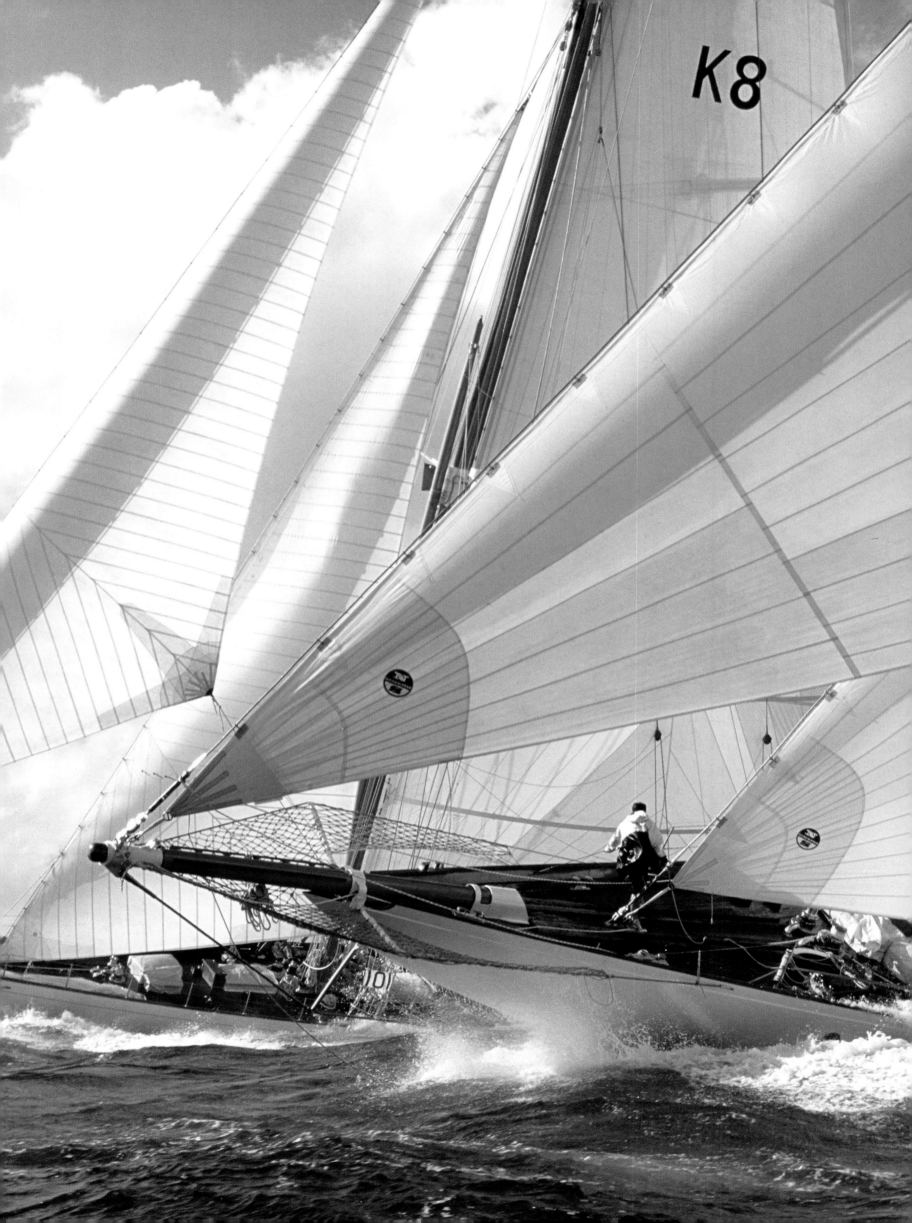

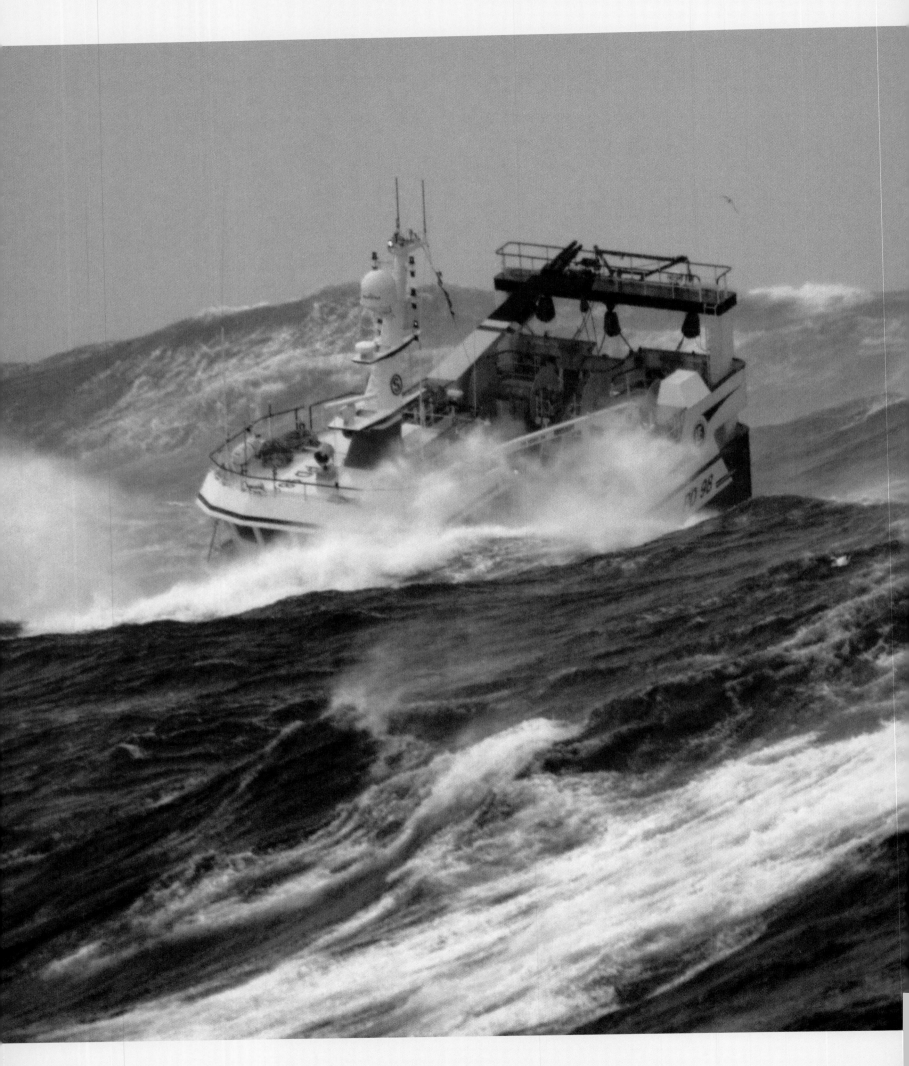

Fishing vessel in heavy weather, North Sea.

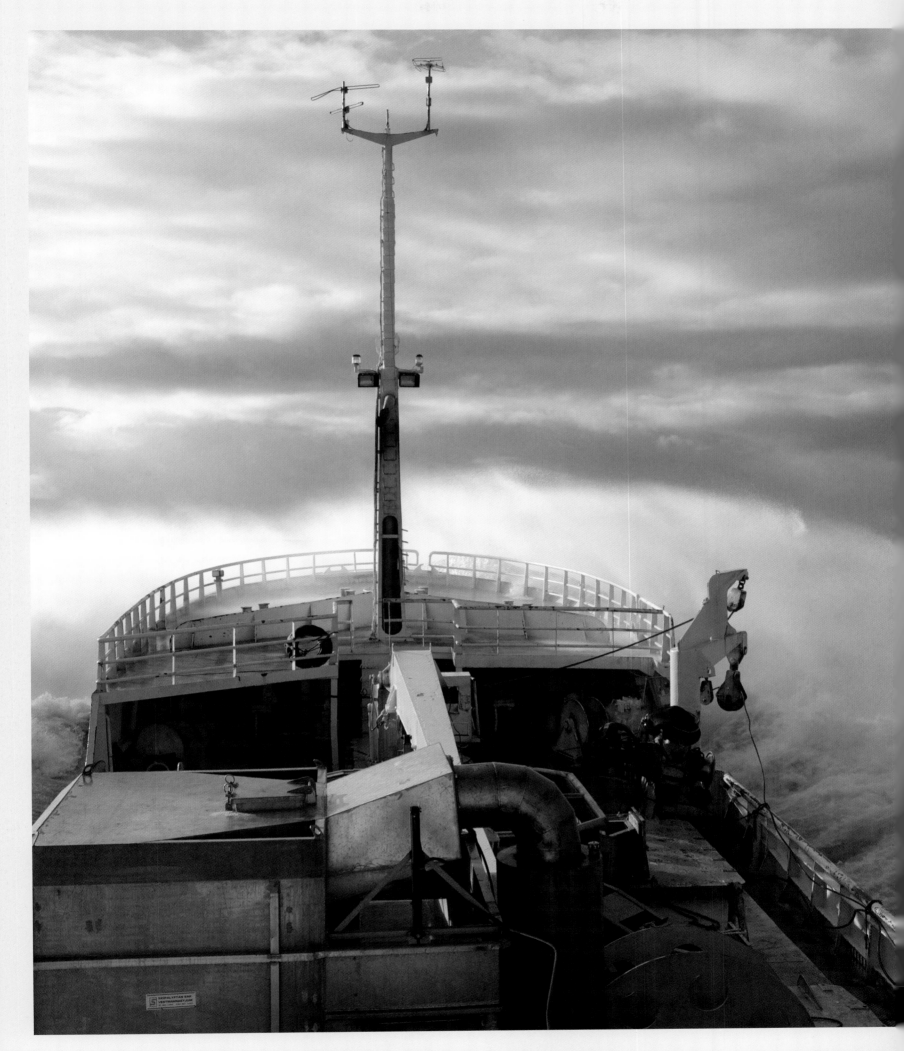

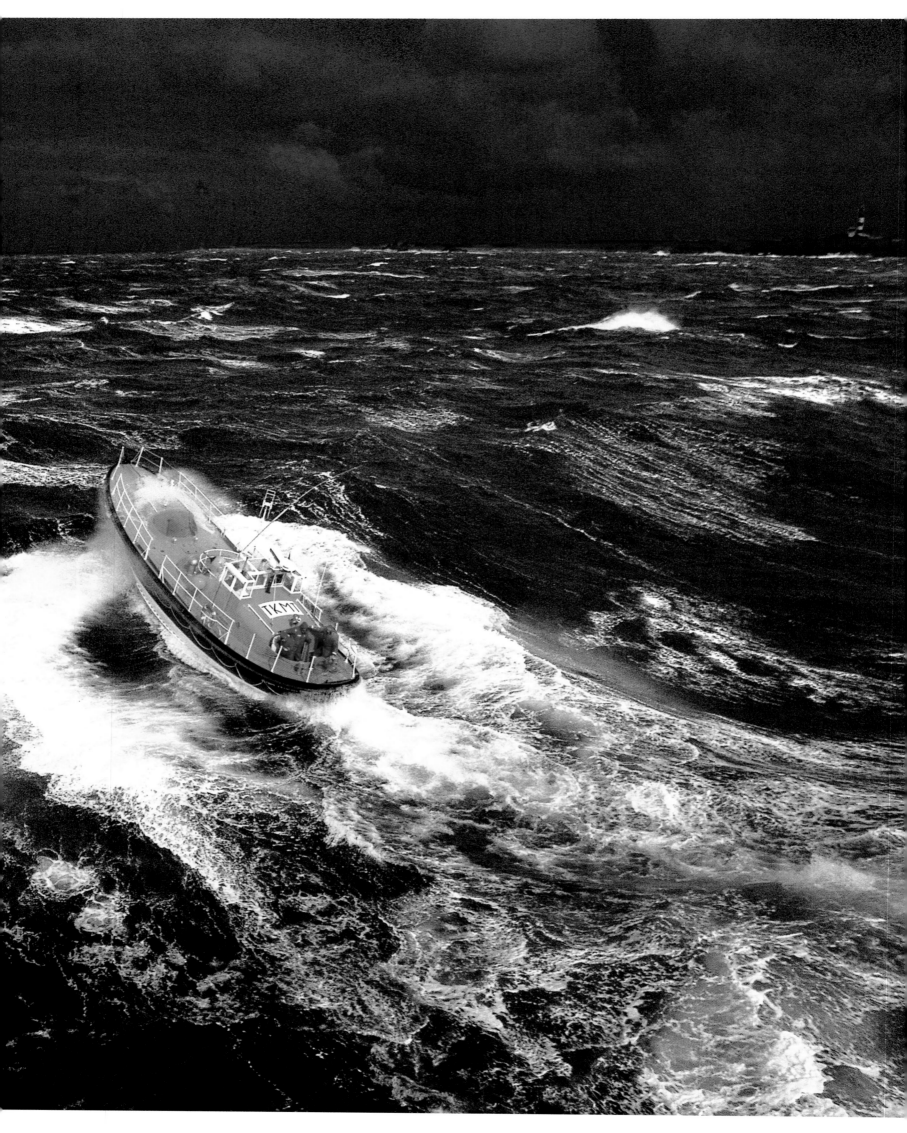

Opposite: Lifeboat in a storm off Ouessant Island, Finistère, with Le Créac'h lighthouse in the distance, Brittany.

Military helicopter flying above a submarine in the Iroise Sea off Finistère, Brittany.

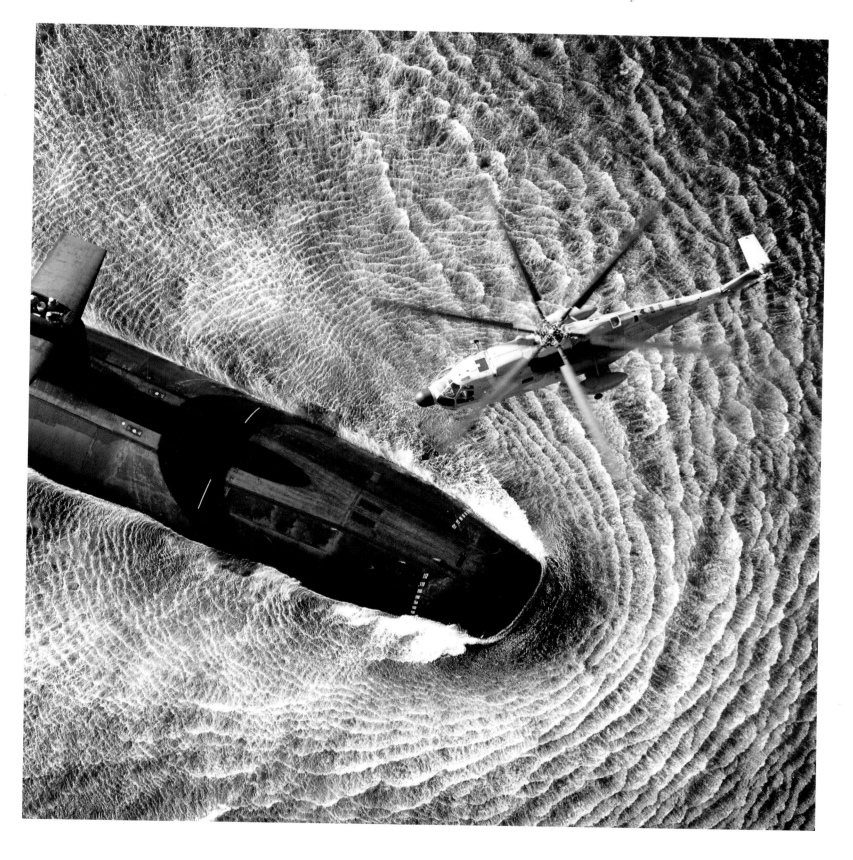

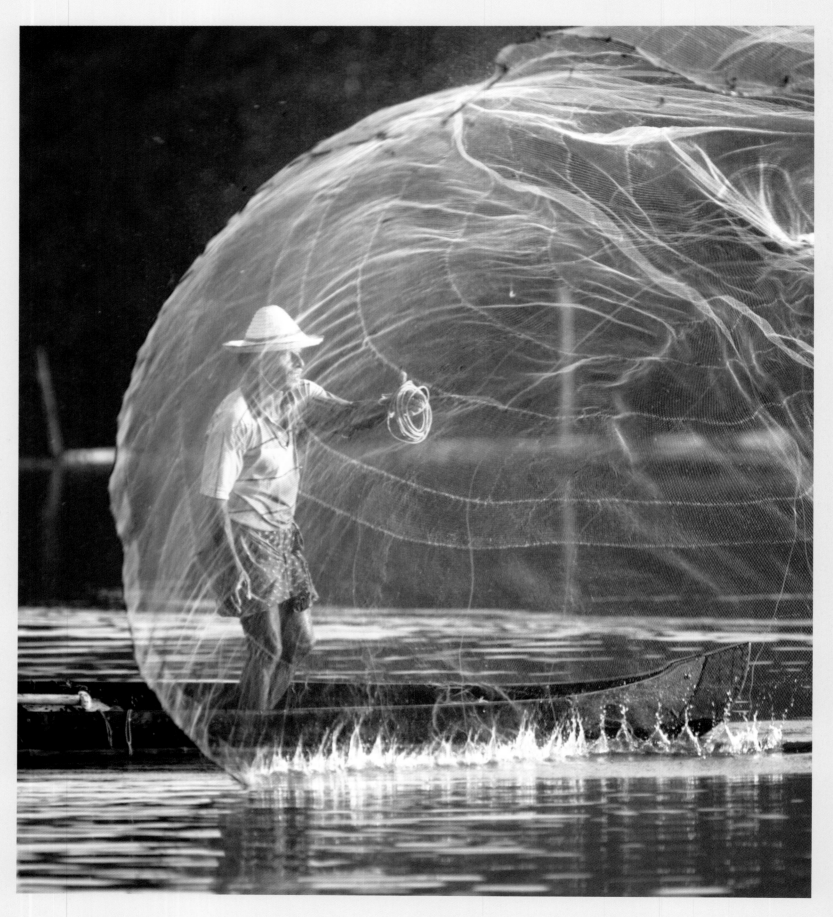

Above: A man casting a fishing net from a small boat in the Kerala Backwaters, India.

Right: A jangada at sunset, returning to the beach after a fishing trip, Ceara Beach, Brazil.

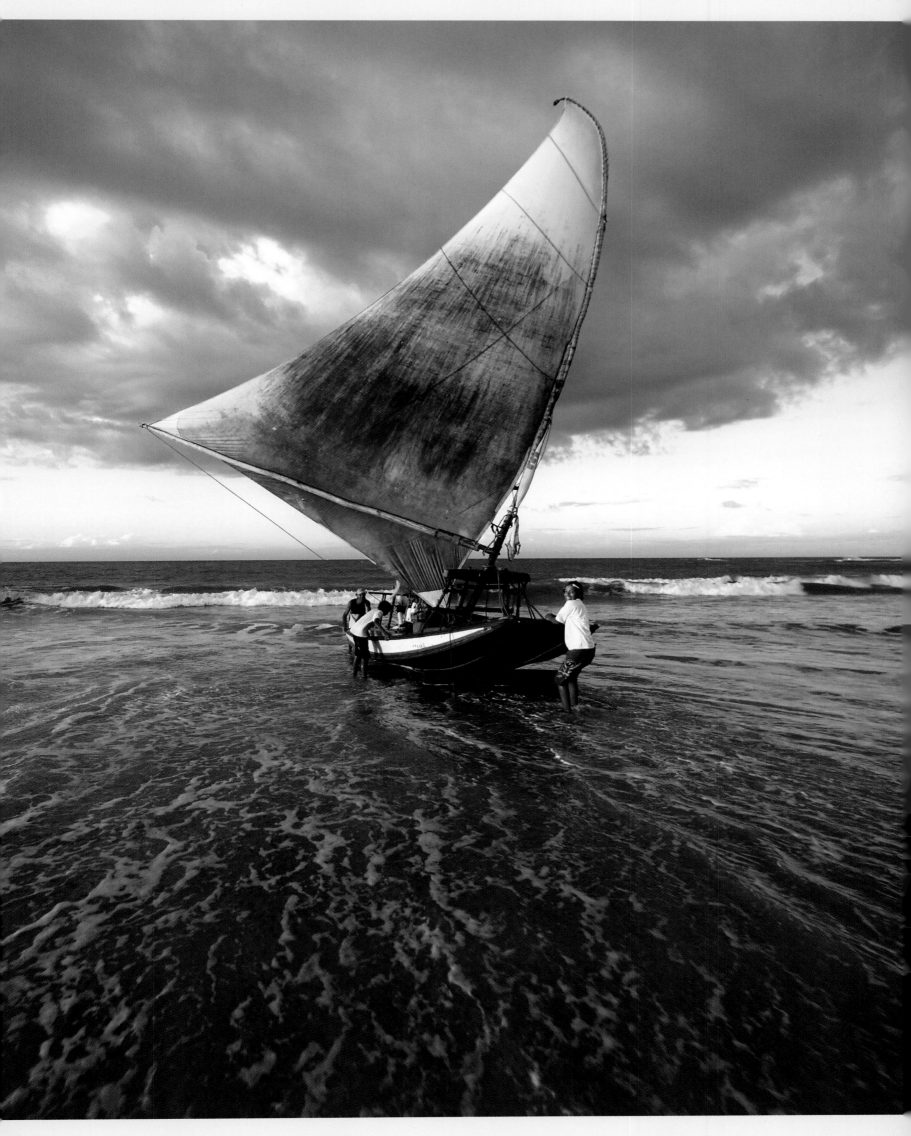

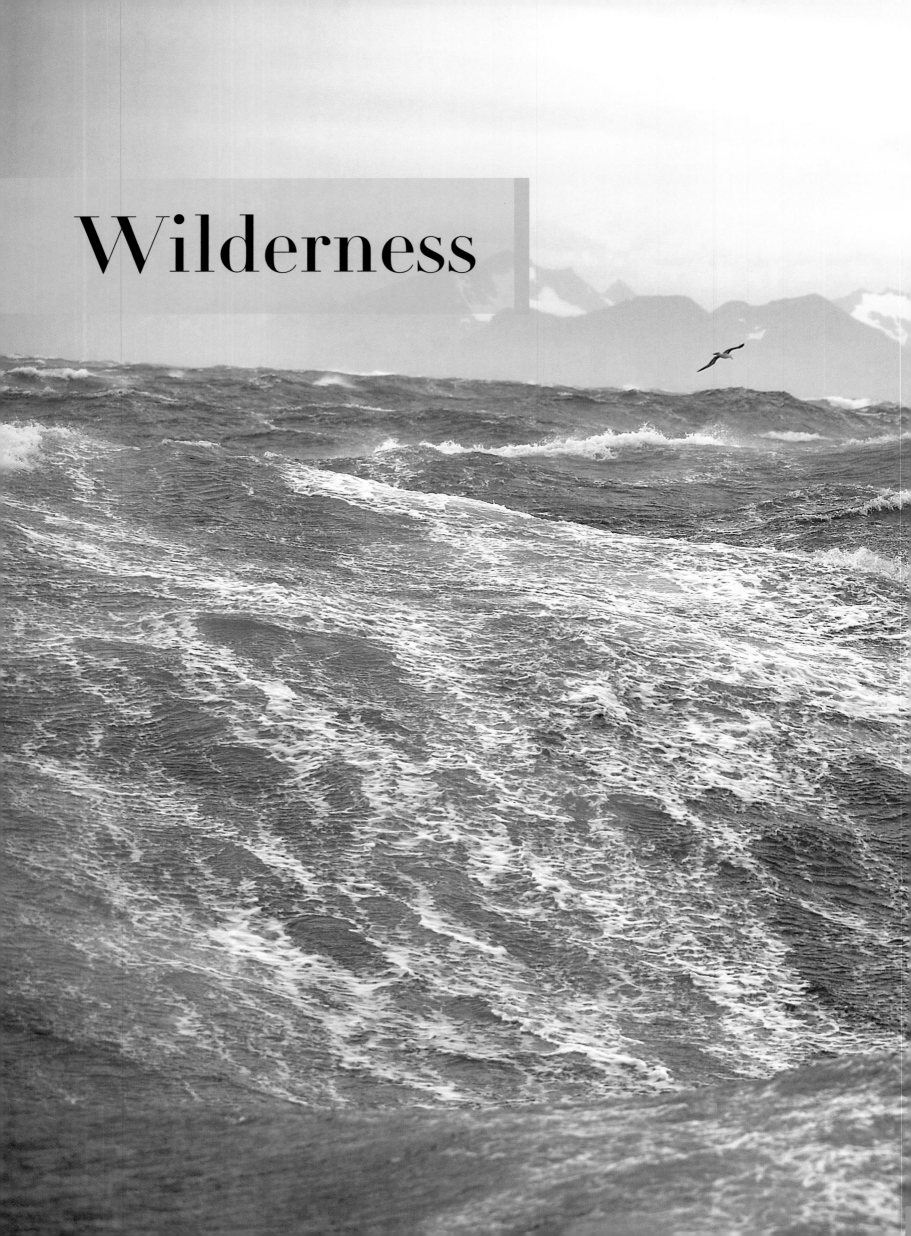

Wilderness

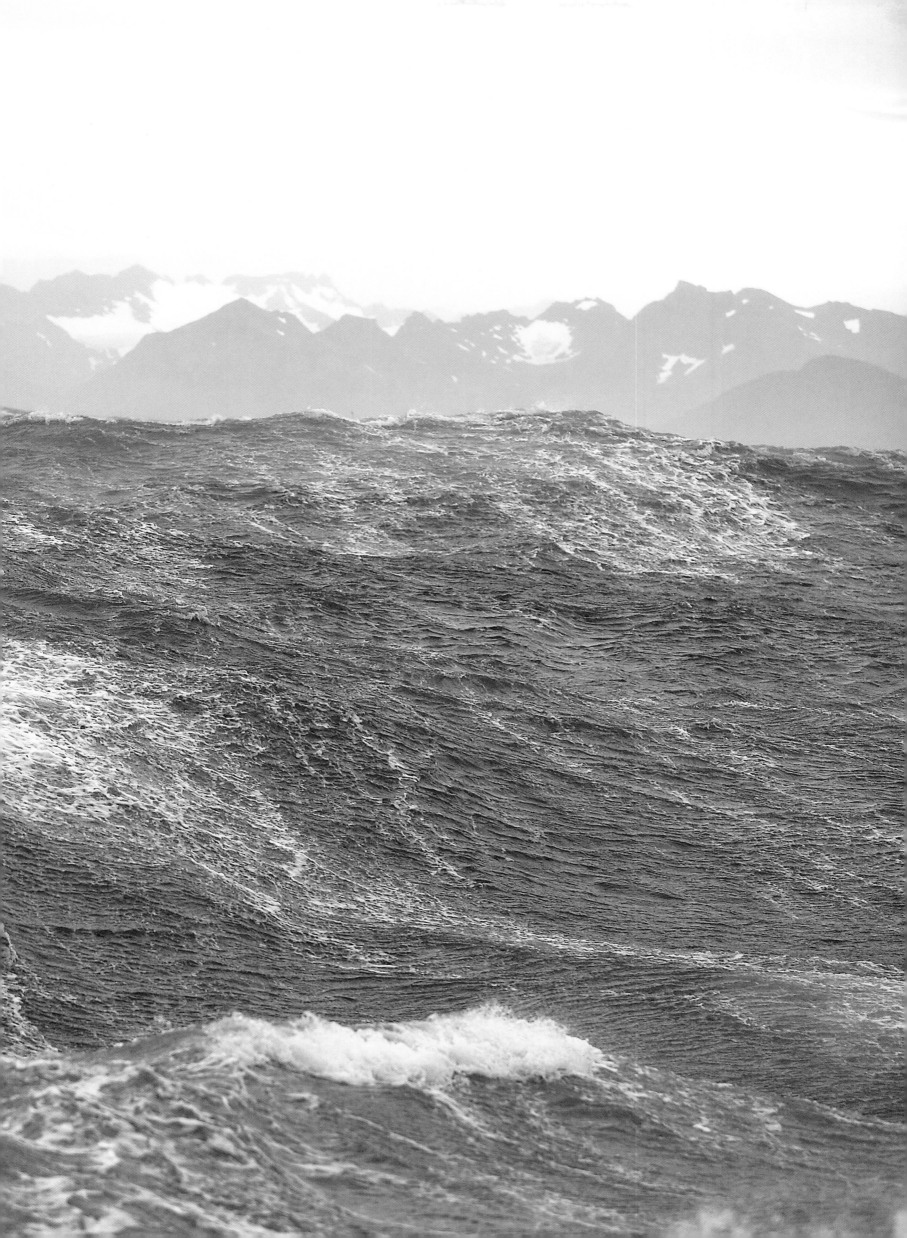

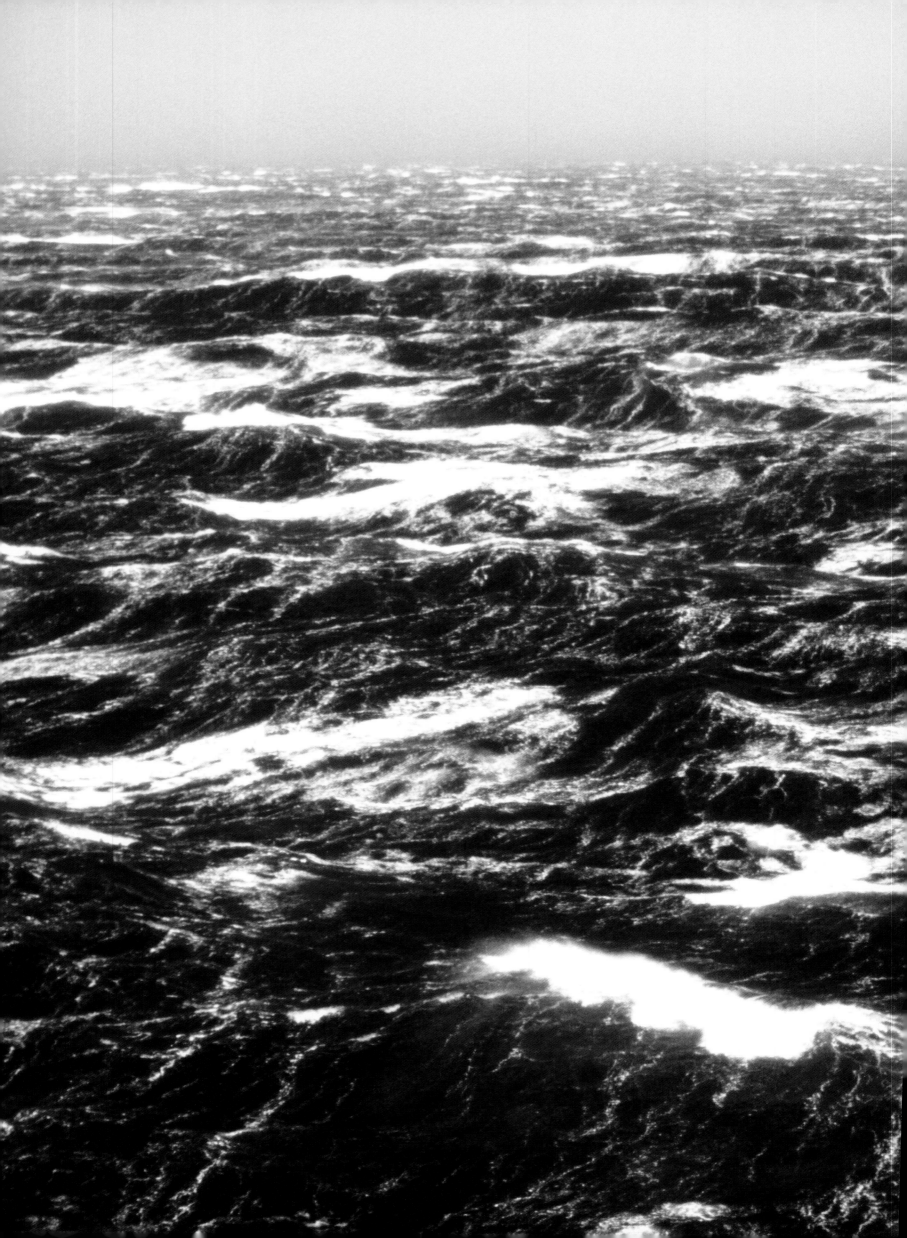

Oceans, waves and the elements

'Below the 40th Latitude, there is no law; below the 50th, there is no God.' This is how sailors described the notoriously dangerous waters which formed the southernmost part of the trade route from Australia to Europe, via the dreaded Cape Horn. And they had good reason to be wary. For even in the summer months, gales in the Southern Ocean can blow for weeks on end, and waves up to 60ft high run unobstructed around the world. No wonder sailors dubbed these waters the Roaring Forties and the Furious Fifties.

An added danger was that, in order to shorten the 5,000-mile voyage, the skippers pushed their ships as far south as they dared – because the closer to the poles you travel, the smaller the circumference of the earth, and the quicker you get from A to B. The trouble was, the further south they ventured, the greater the risk of collision with 'growlers' – great lumps of ice detached from Antarctic icebergs, which lay semi-submerged and could easily sink a vessel. Further south still lay the Screaming Sixties, where no sensible sailor would venture.

The world is now a smaller place, and true wilderness is harder and harder to find. When Magellan set off to sail around the world in 1519, it took his crew three years to complete the voyage (he himself never made it, being killed by natives on a beach in the Philippines). Three hundred years

Previous pages: An Albatross flying over large waves in typical Southern Ocean conditions off northern South Georgia.

Left: Force 12 in the Roaring Forties, near the Magellan Strait, South America. The wave height is between 12 and 15 metres.

later, the great tea clippers rushed around the world in under 200 days to deliver their precious cargo to the markets of Europe. More recently, a French sailor and his crew completed the same voyage on a high-tech catamaran in just 48 days. Even the great oceans of the world are no obstacle to the never-ending quest for speed.

Yet the Southern Ocean still holds a special place in our collective imagination. It's a place of extraordinary beauty, where the only signs of life you're likely to see are the occasional albatross and even more occasional whale. It's a place where nature retains the upper hand, and where mankind is forced to be humble. And it's a place that keeps us in touch with a more elemental part of ourselves, which we all recognise and yet rarely have a chance to connect with.

By its very nature, this wilderness should make an ideal sanctuary for wildlife. And there are various international treaties intended to protect the area's seals and whales, as well as limiting the amount of fishing allowed. Sadly, however, despite the ban on commercial whaling, Japanese fishing boats continue to hunt for whales under the guise of scientific research, and there's evidence that an increasing number of ships are fishing in the area too. Every year more tourists visit nearby Antarctica, bringing all the associated risks to the environment. Despite the dire warnings of our forefathers, for the sake of the world's last great wilderness, it may be time to bring the law below the 40th Latitude. God can follow in his own time.

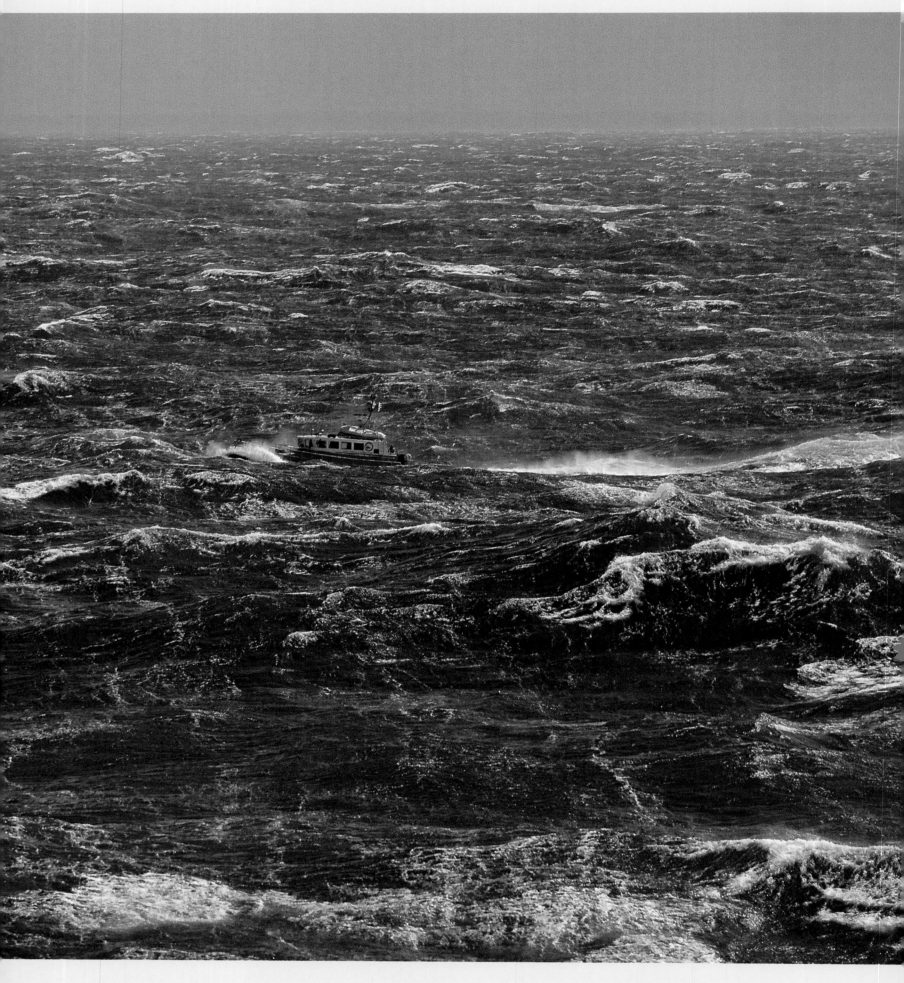

*Lifeboat in heavy seas off Finistère,
Brittany.*

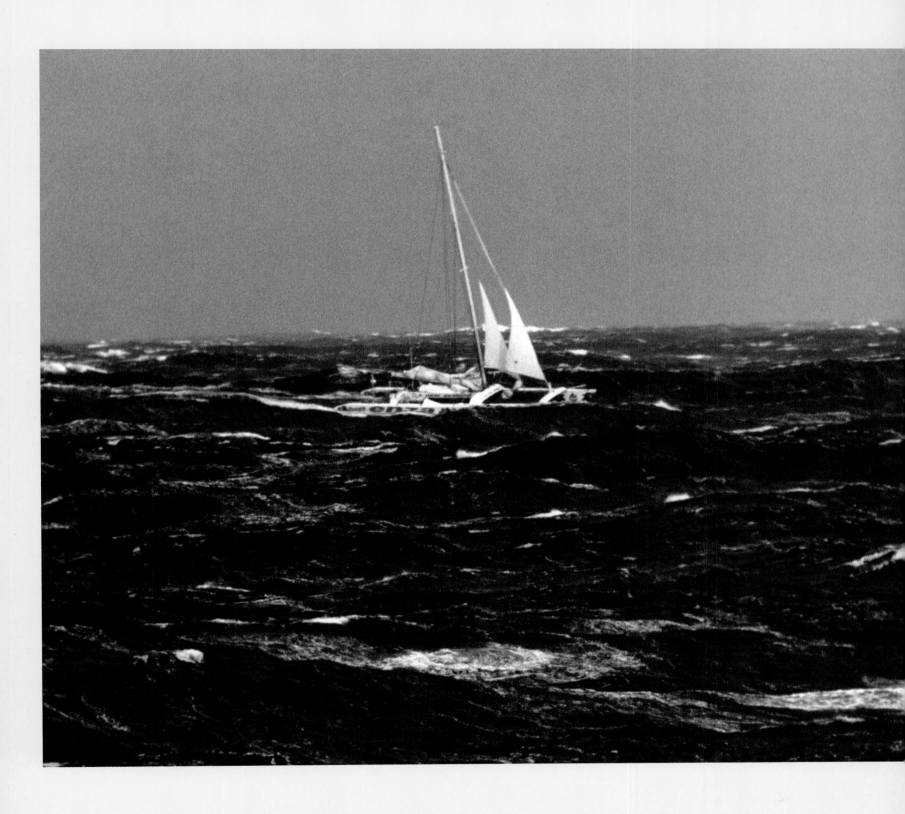

The catamaran Enza *60 miles from Ushant Island, under storm jib, and towing a coiled chain to avoid pitchpoling in the steep running waves.*

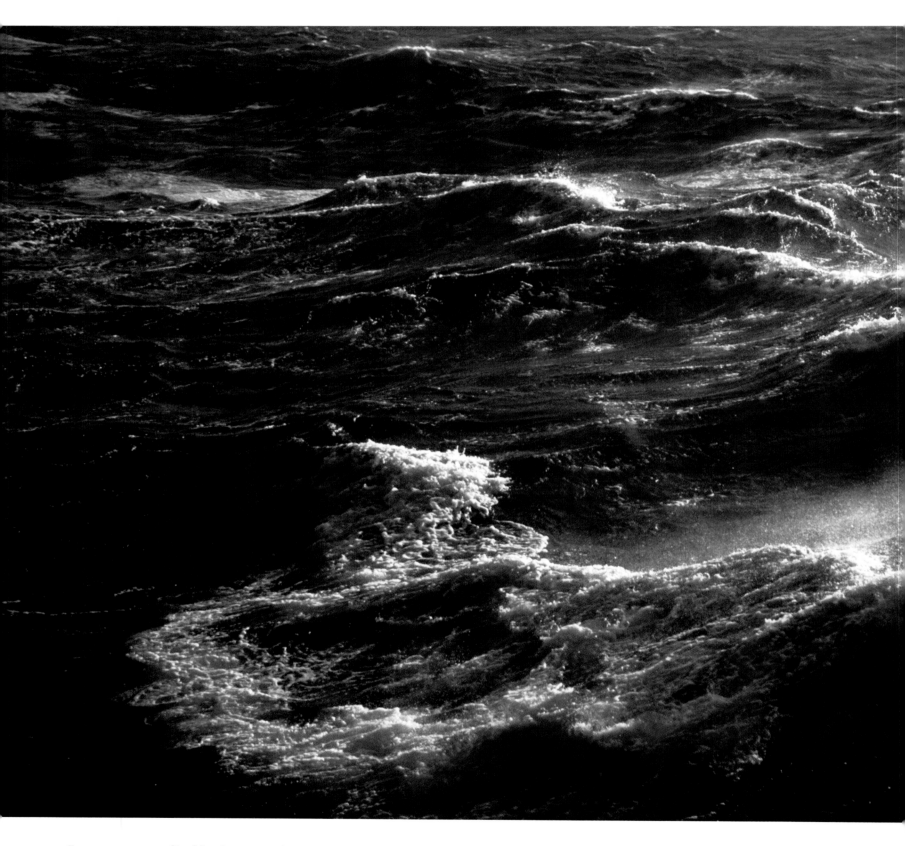

Strong nortwesterlies blowing around
Ushant Island, Brittany.

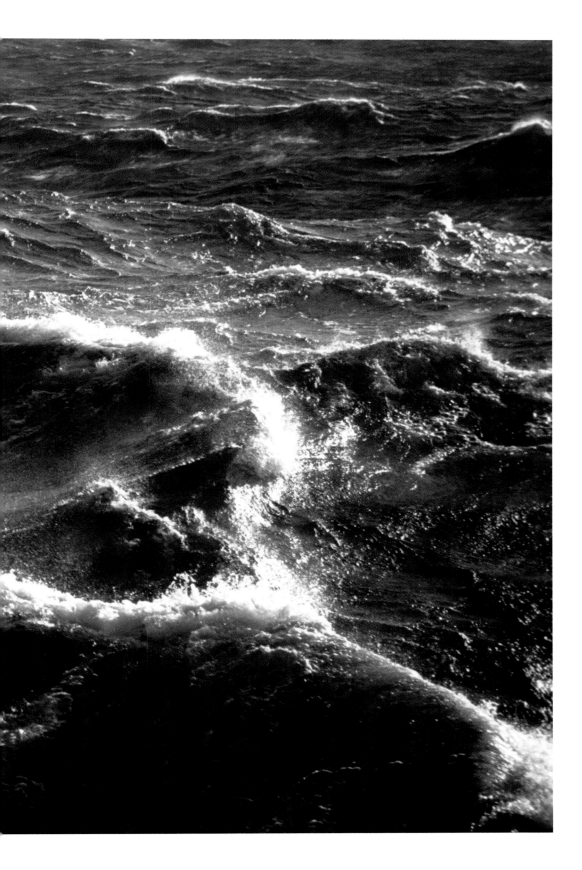

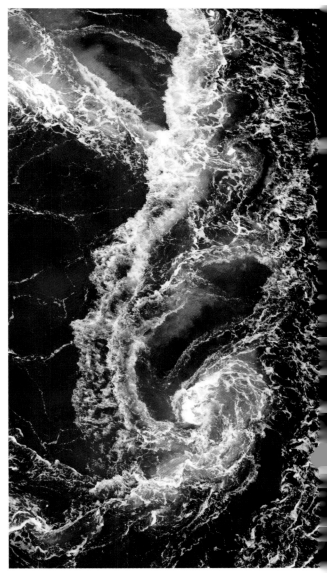

A whirlpool at Saltstraumen, Bodö, Norway.

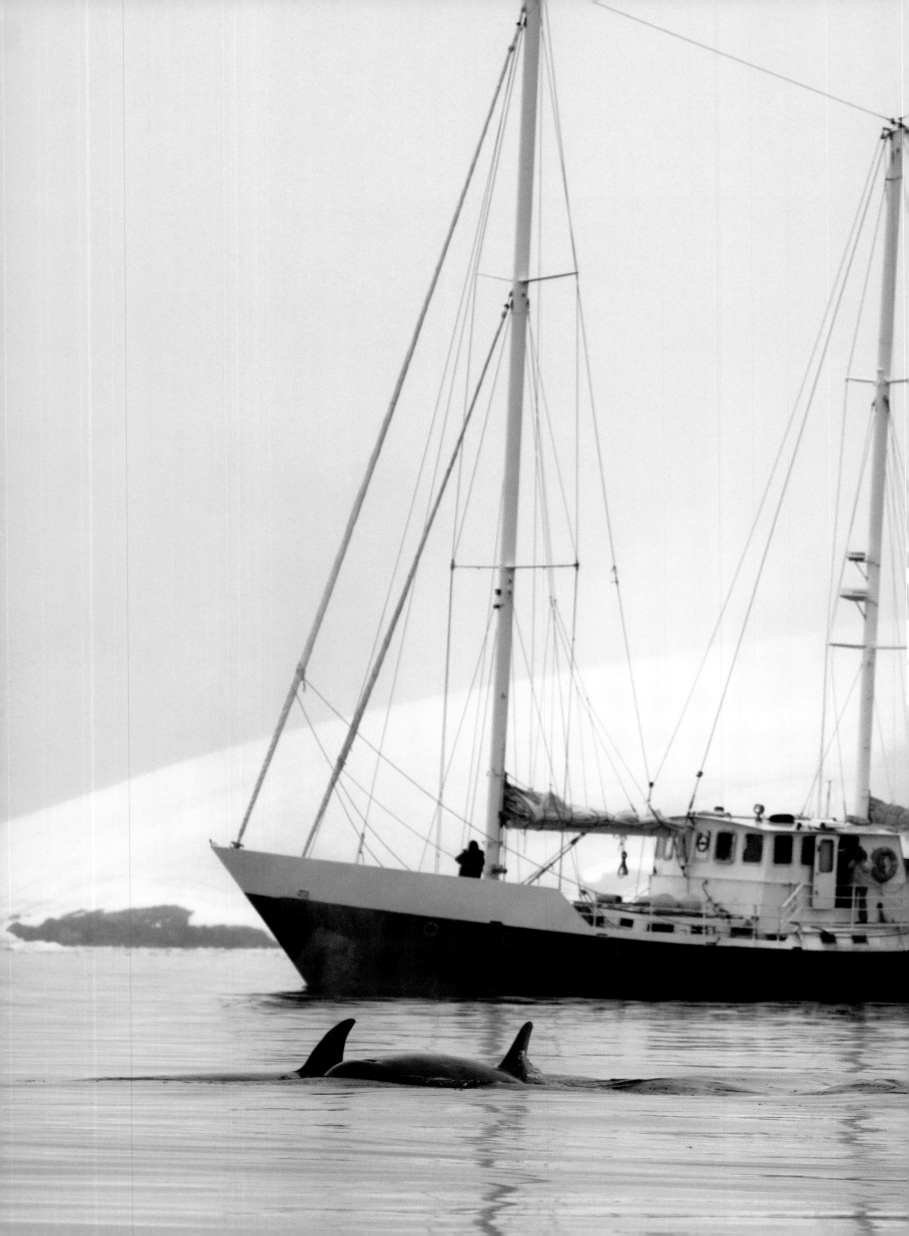

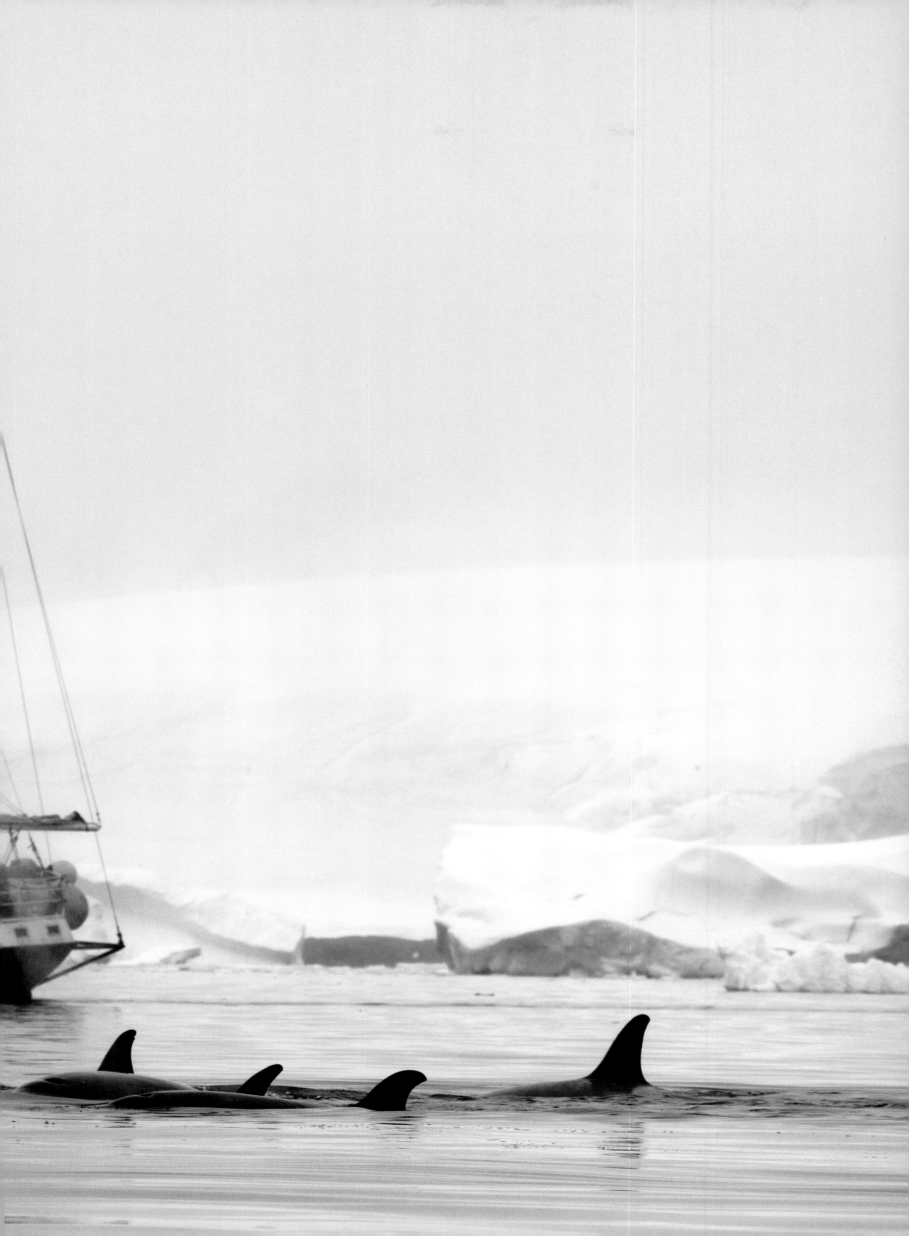

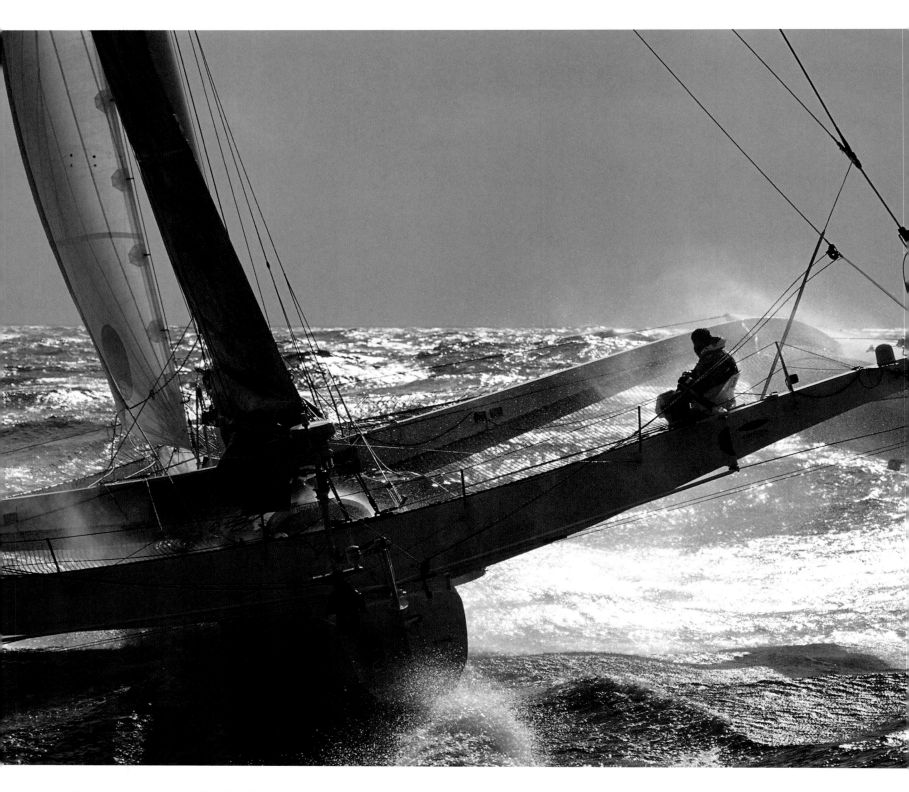

Rexona *practising sailing for the Route
du Rhum Race, Port la Foret, France.*

*Previous pages: A pod of Killer whales
travelling beside a boat in waters off the
western Antarctic Peninsula.*

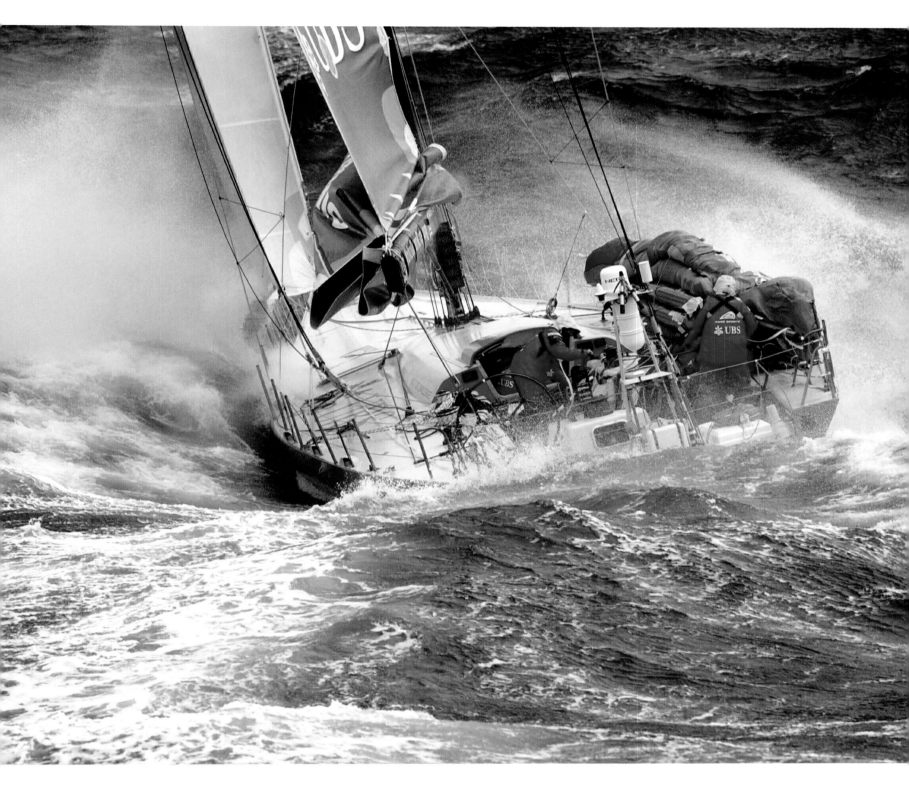

Amer Sport Too battles towards Hobart
on Leg 3 of the Volvo Ocean Race.

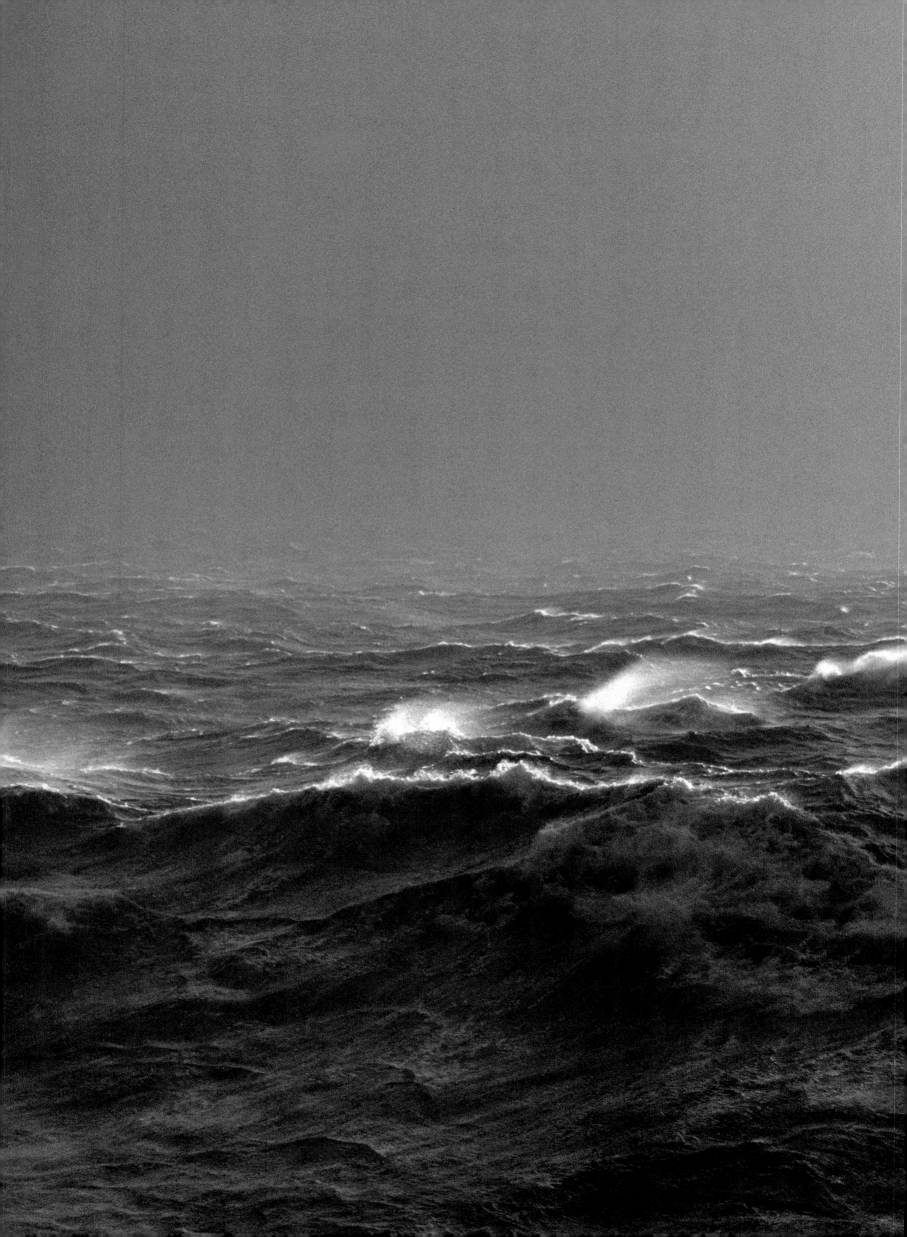

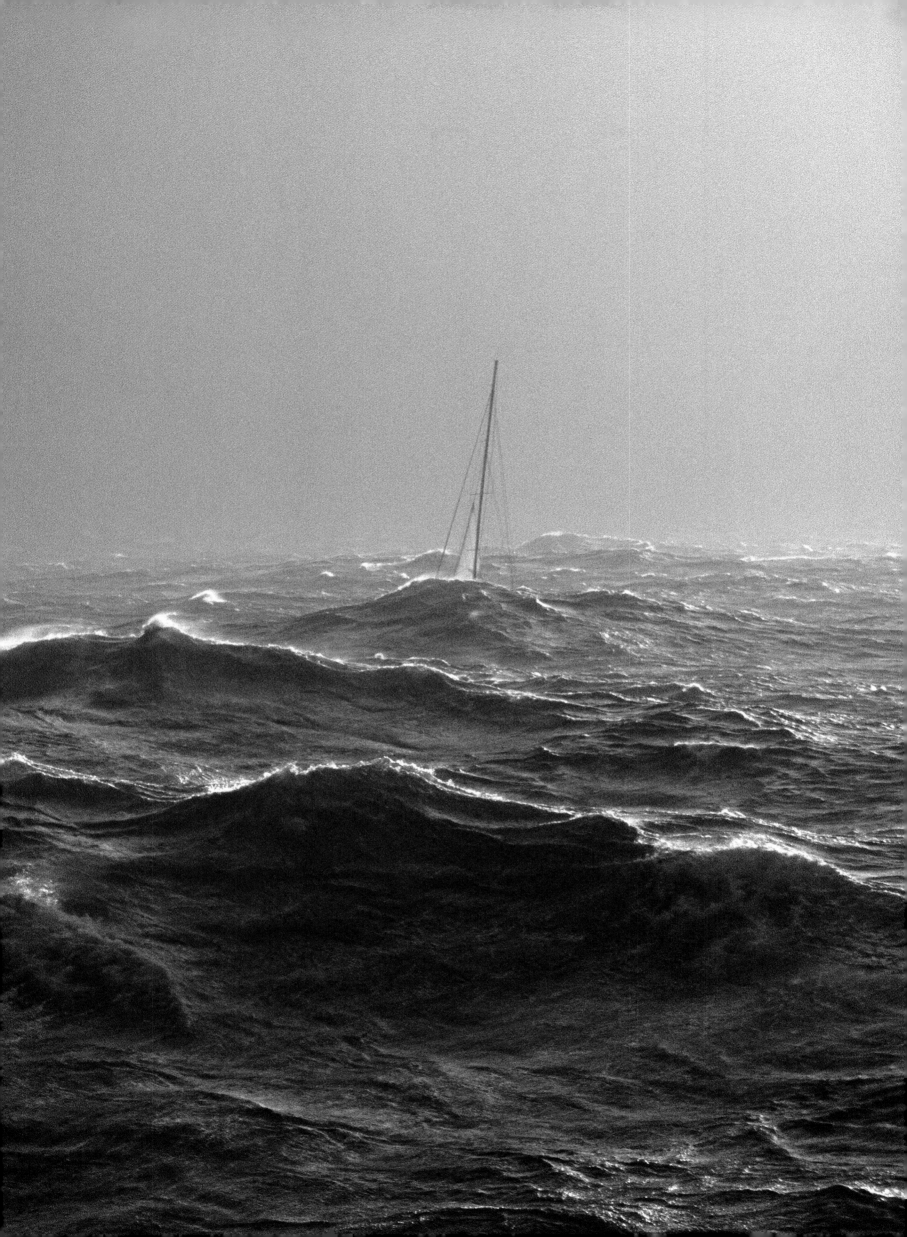

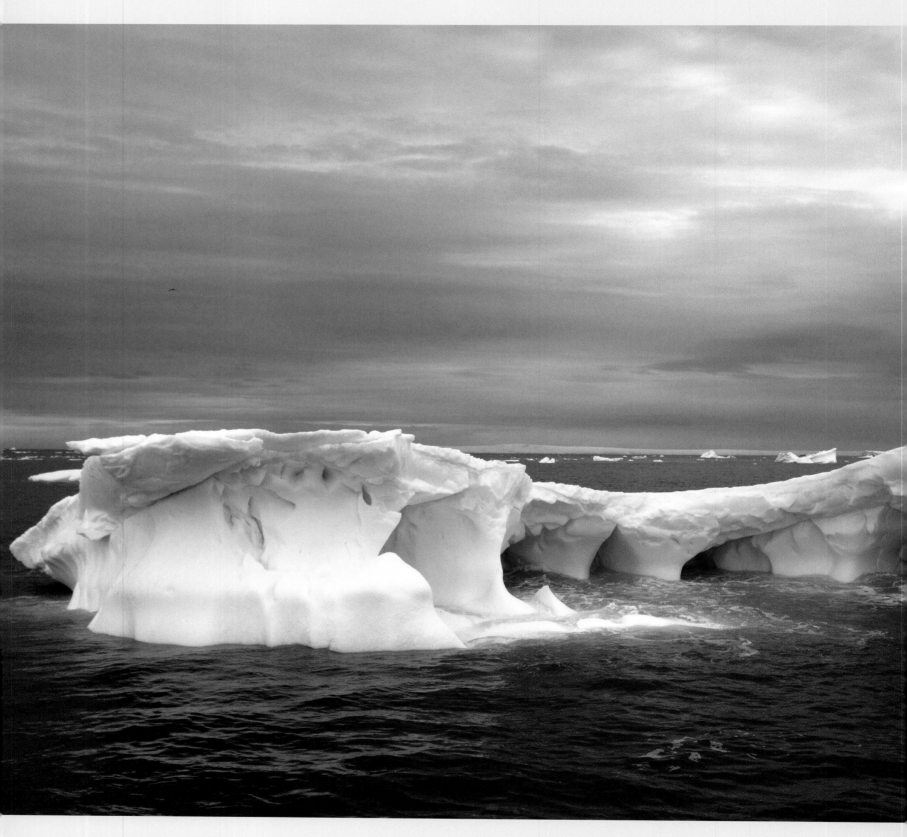

Previous pages: A yacht battles 45-knot winds in the English Channel.

Above and right: Arched icebergs floating off the western Antarctic peninsula, Southern Ocean. Whittled into shape by decades of Southern Ocean storms, these 'ice sculptures' can drift around the coast for many seasons, before floating out to sea.

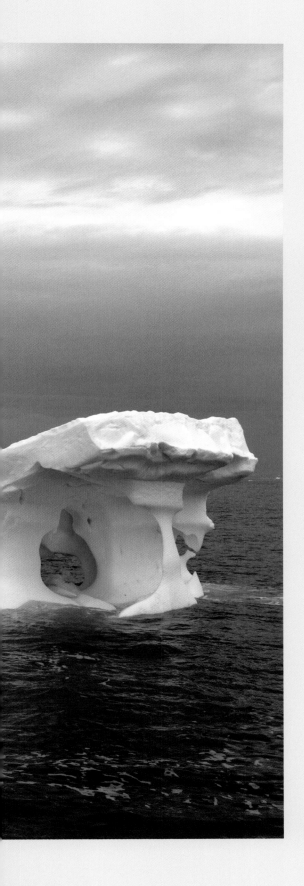

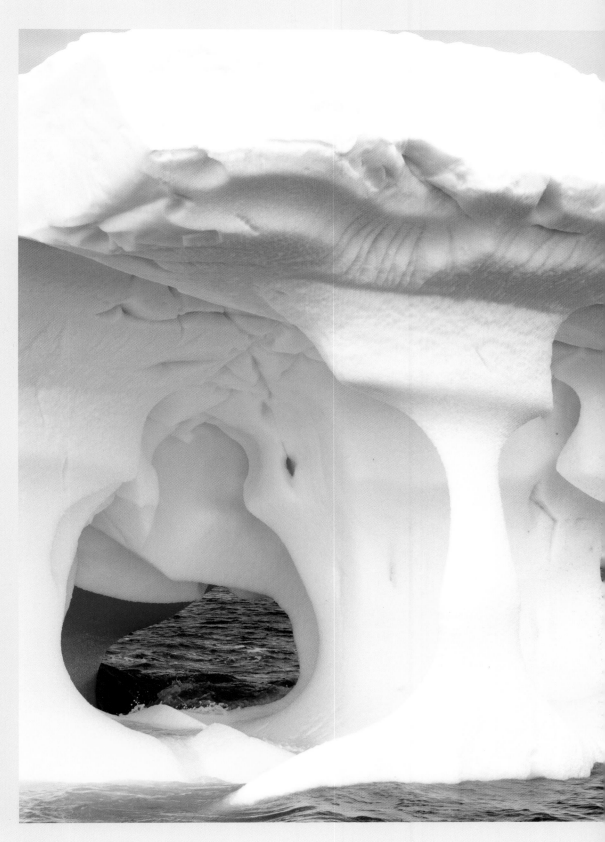

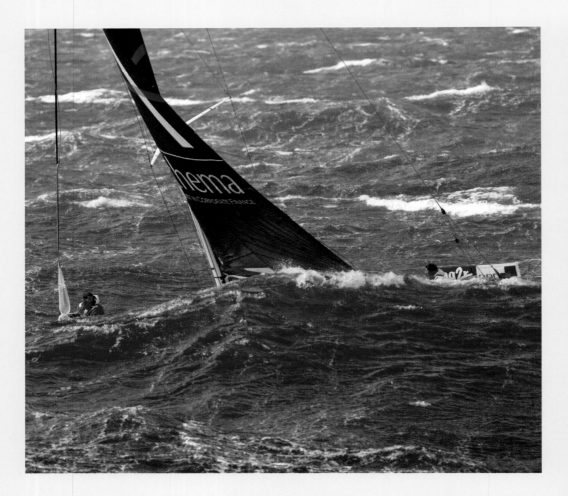

Above: Erwan Tabarly aboard the Figaro yacht Athema.

Right: The first sight of South Georgia from a boat window, Southern Ocean, Antarctica.

Below: A Black-browed albatross in flight over the Southern Ocean.

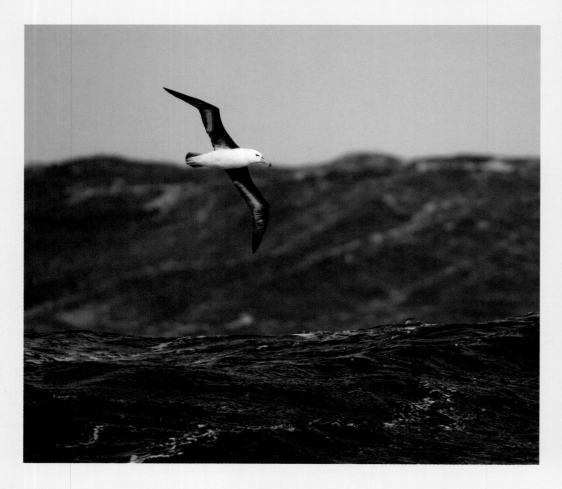

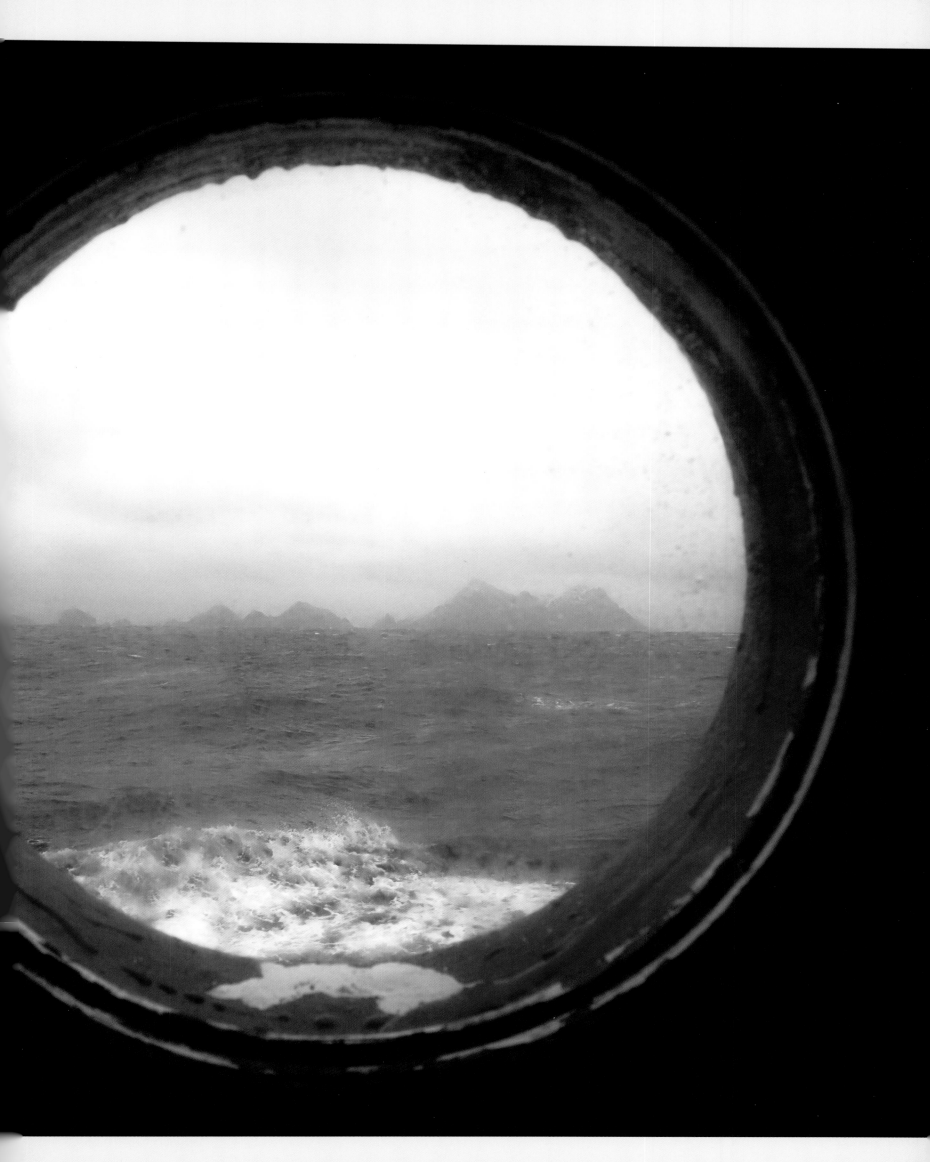

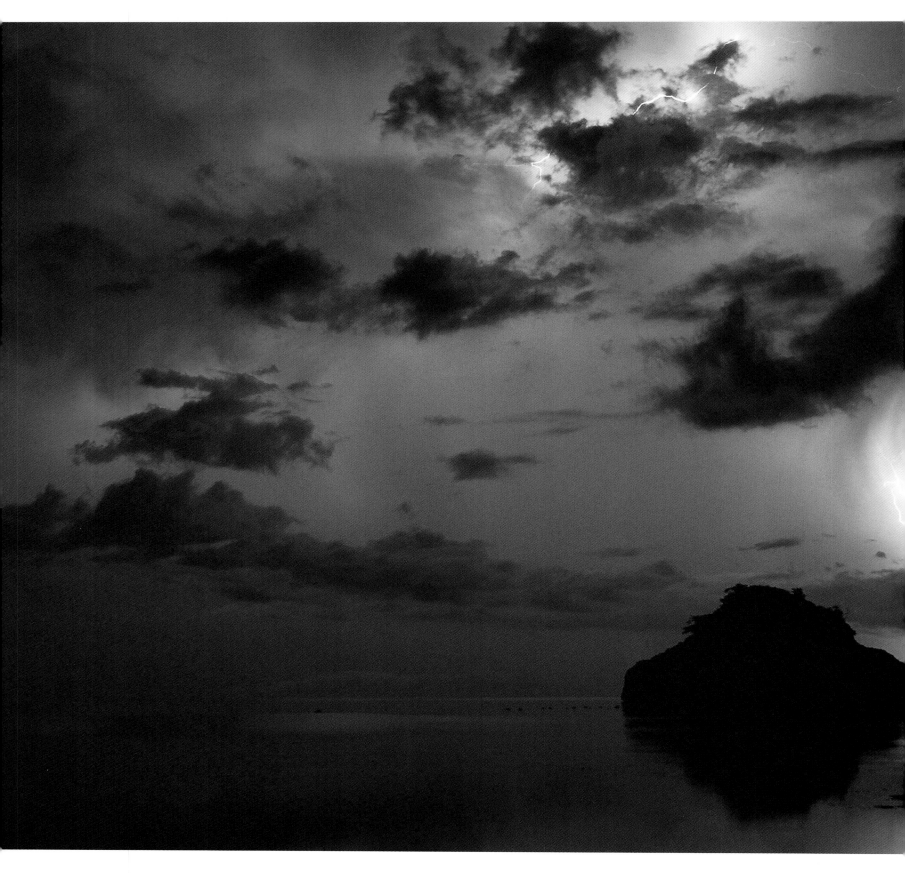

Lightning and thunderstorm over Sulu-sulawesi seas, Indo-Pacific ocean.

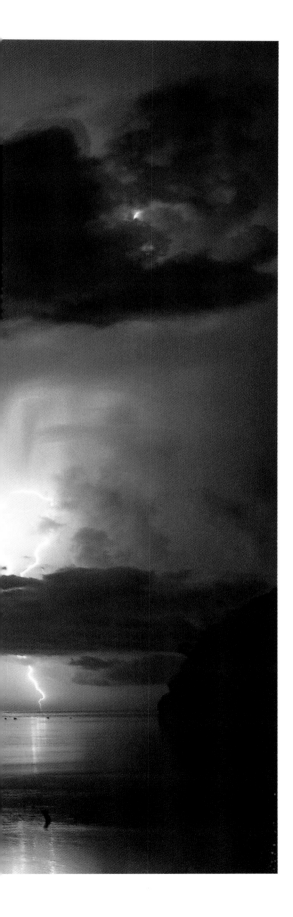

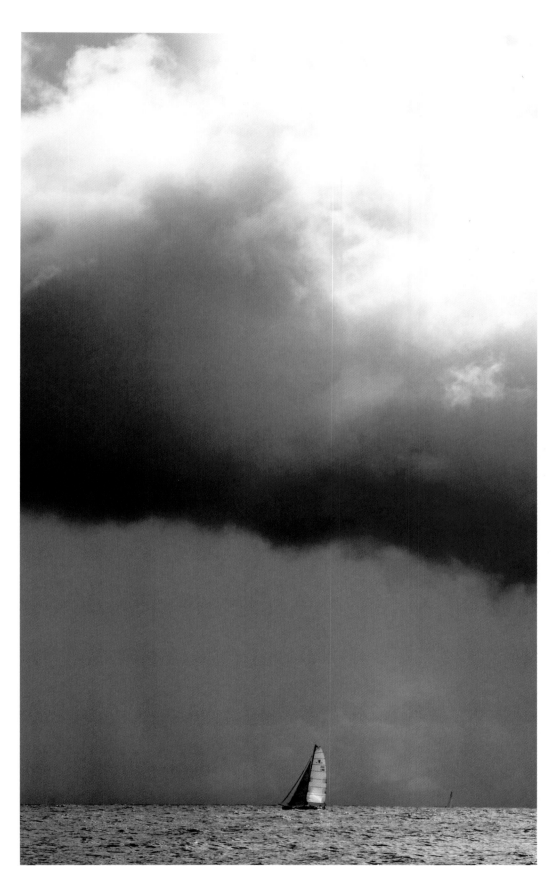

*A small boat is engulfed by a heavy
squall during a race in the Grenada
Sailing Festival, Caribbean.*

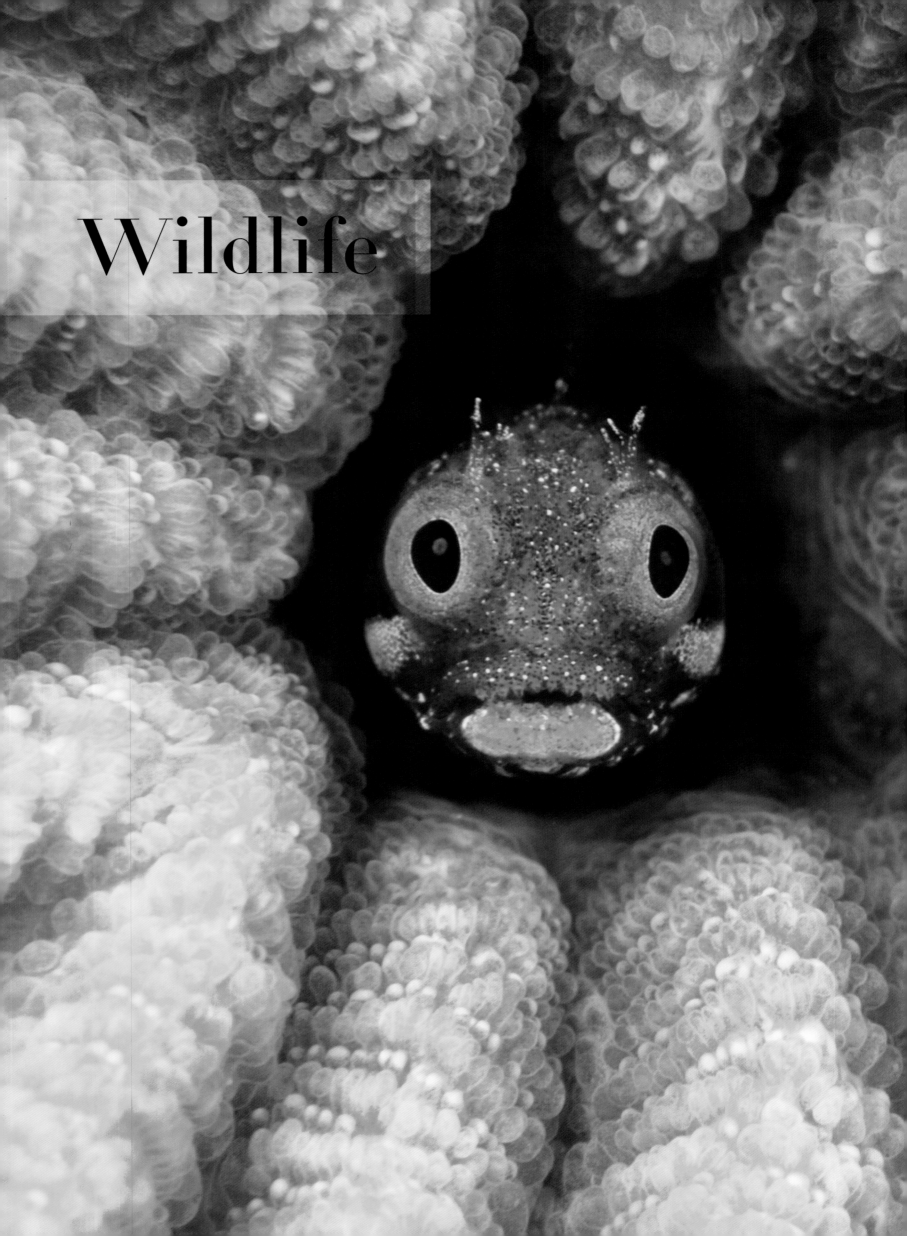

Wildlife

The sea alive

A squid that flashes a light at its prey, a transparent sea cucumber, a fish with a 'fishing rod' attached to its head – and don't even mention outsize jellyfish and gargantuan octopuses. The sea is full of strange and wonderful creatures. Scientists have already catalogued 120,000 different species, and they reckon there are at least another 750,000 yet to be discovered. But what's astonishing isn't so much the number of species as the extraordinary variety. Whilst one fish grows very, very long, another is a flat as a pancake; yet another is so fat that it's not much more than a ball of lard.

The outcomes are sometimes comical, such as the wretched male Kroyer deep sea angler fish, reduced to little more than a small appendage on the female's lower anatomy. Others are extraordinarily beautiful, such as the multi-coloured peacock mantis shrimp. Still others, such as the fierce-looking fangtooths, look quite terrifying, though in reality they present little danger to human beings.

There are wonders to behold above water too. Seabirds come in every shape and size, from dainty kittiwakes to the giant albatrosses of the Southern Ocean, which grow a wingspan of up to 12ft and can travel 550 miles a day. For comic value, there are penguins and bright-billed puffins, which still survive in great numbers in the cold waters of the north. And let's not forget the mammals of the ocean, from lovable seals and dolphins to mighty whales – still the largest animals on this planet, weighing in at up to 170 tons.

Yet, despite this amazing diversity, the study of marine biology lags far behind its dry land equivalent. Simply gathering sufficient specimens has proven a major logistical problem which has set the science back decades, if not centuries. Indeed, until the invention of the so-called 'bathysphere' in 1934, scientists had to base their theories about life in the deep almost exclusively on what they could collect in nets and dredges. Even now, their ability to 'see' the habitat they are describing is severely restricted by its sheer inaccessibility.

These difficulties have created a strange divide in our understanding of the world: we are fantastically well-informed about life above water but, as soon as we leave the shallows of the inter-tidal zone, our knowledge becomes positively medieval. Little wonder that people grumble about sending rockets to outer space to carry out scientific research, when there's so much about our own planet that we don't understand. It's no exaggeration to say we know more about the surface of the moon that we do about what's going on at the bottom of the sea.

Motion shot of blue and gold Fusilier fish, near Phil's Reef, Tufi, Papua New Guinea.

Previous pages: Spinyhead blenny in hard coral, Bonaire, Caribbean.

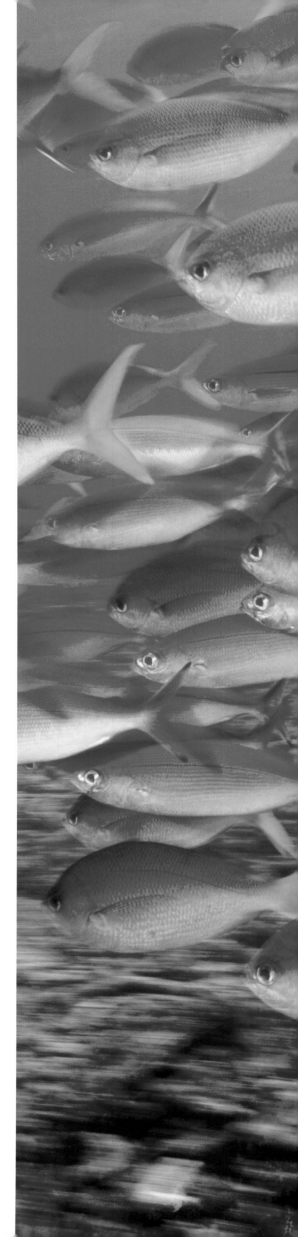

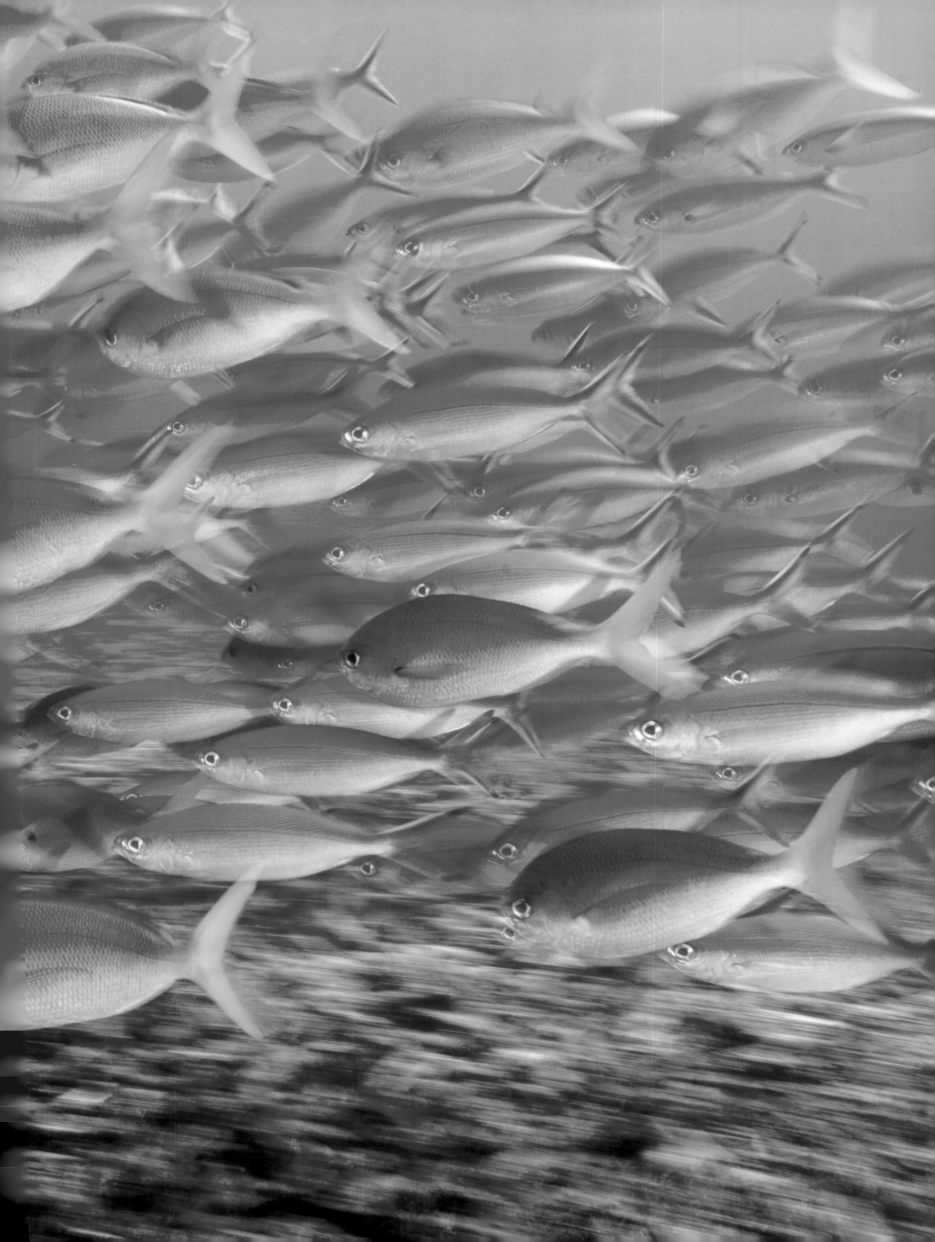

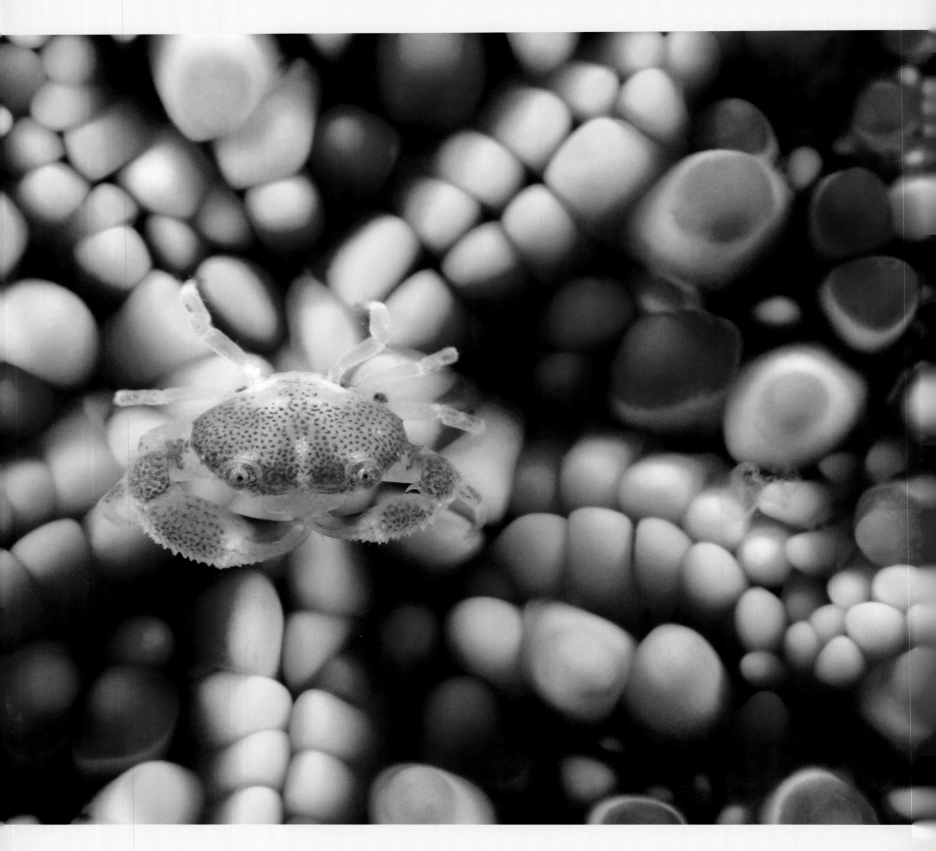

*A juvenile Guard crab on a cushion
starfish, Hawaii.*

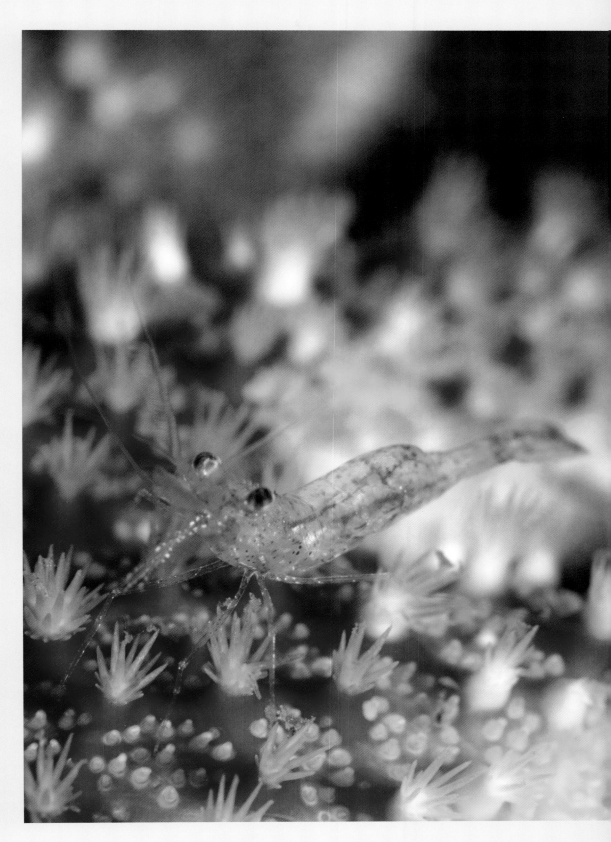

Close up of a common red sunstar with a shrimp on it, Moere coastline, Norway.

Close-up of the lips of a Giant clam, in Palau, Micronesia.

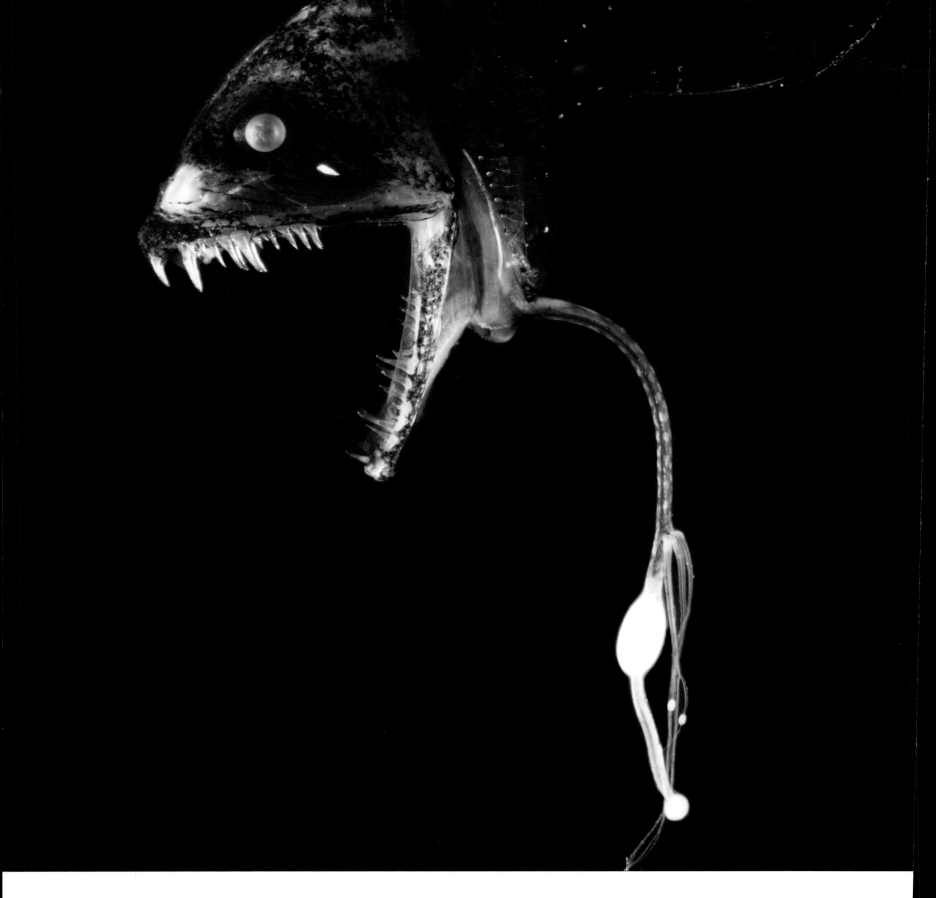

A deep sea Dragonfish, with bioluminescent lure, from between 498–805m, Mid-Atlantic Ridge, North Atlantic Ocean.

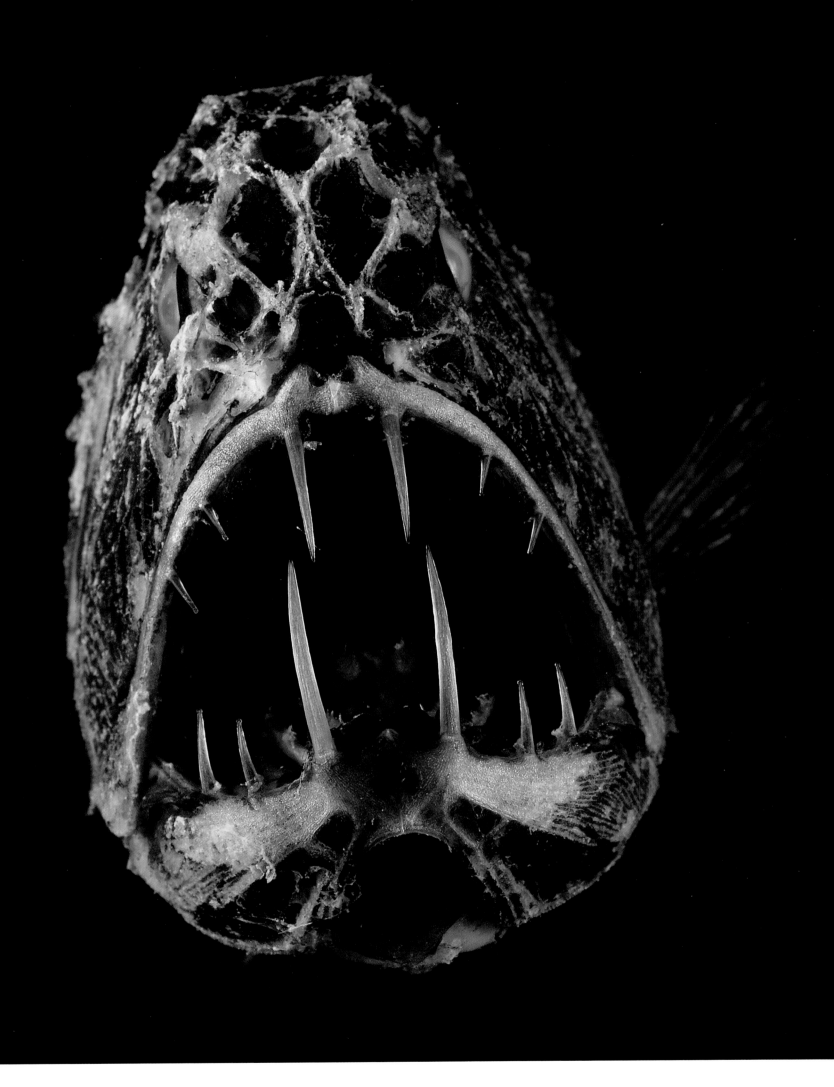

*A Fangtooth bathypelagic fish,
deep Atlantic Ocean.*

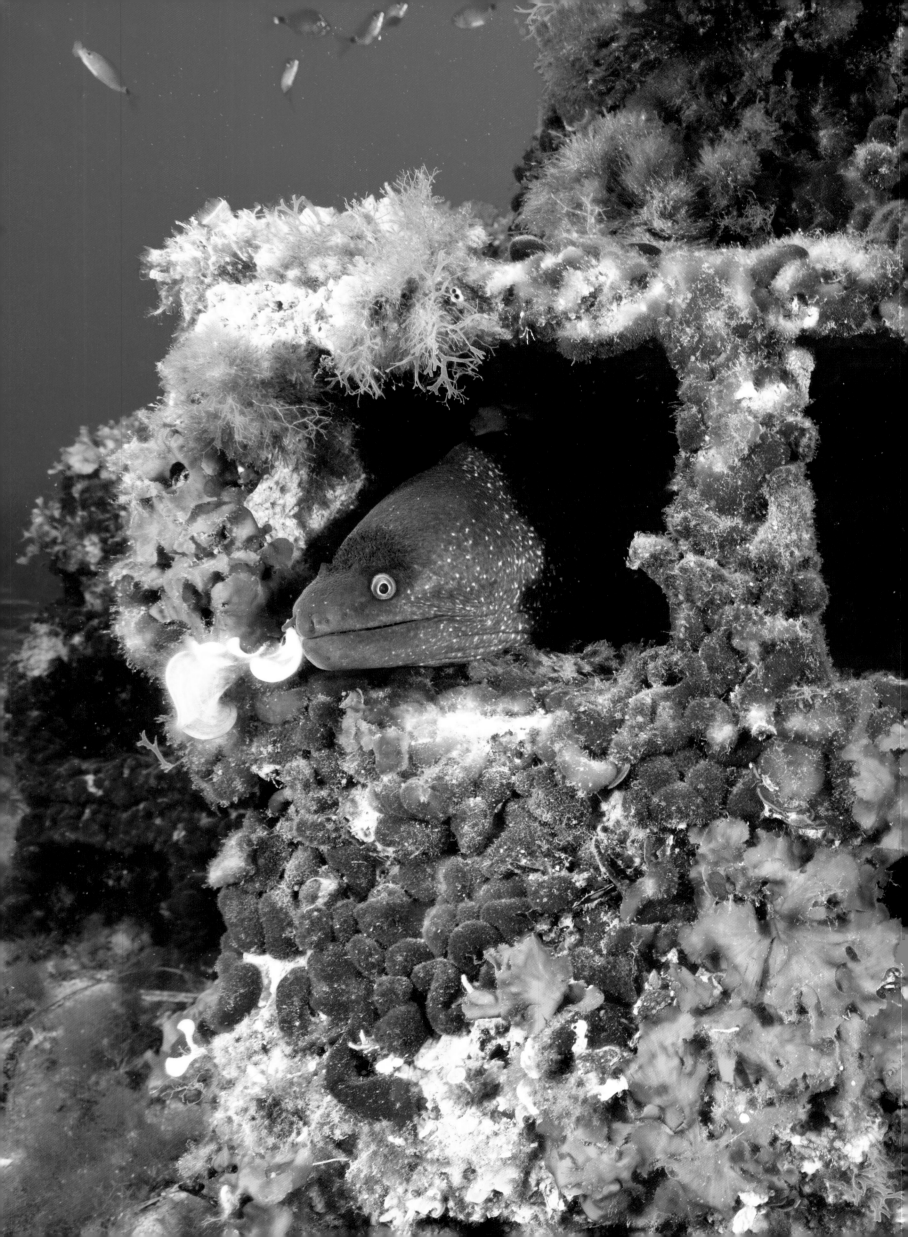

Opposite: A Moray eel looks out
of a hole in the artificial reef,
Larvotto Marine Reserve, Monaco,
Mediterranean Sea.

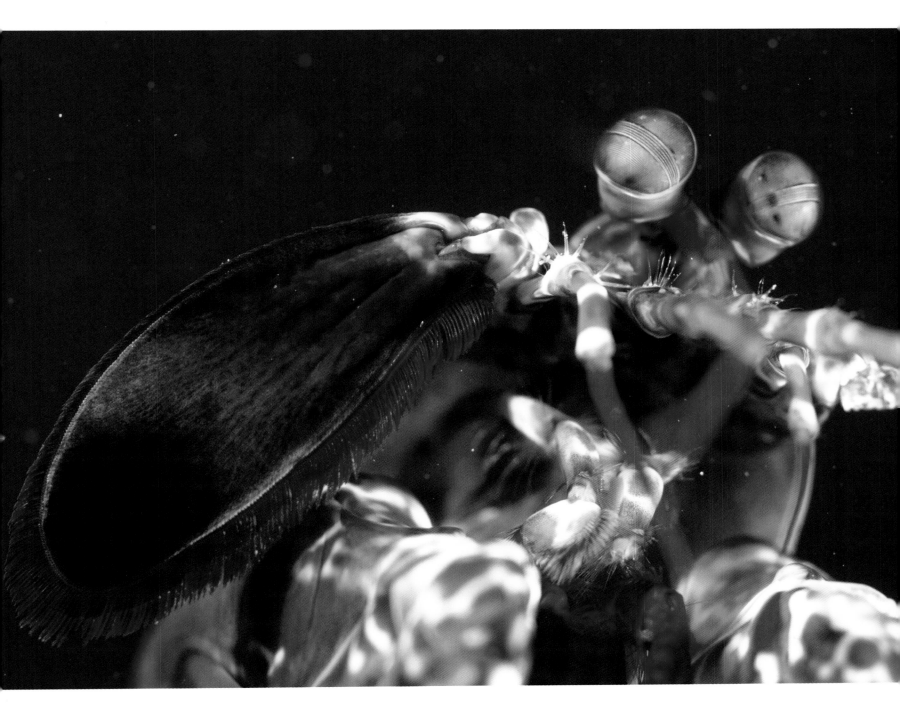

Close up of the face, antennae and
mouthparts of a large male Peacock
mantis shrimp, Lembeh Straits, Sulawesi,
Indonesia.

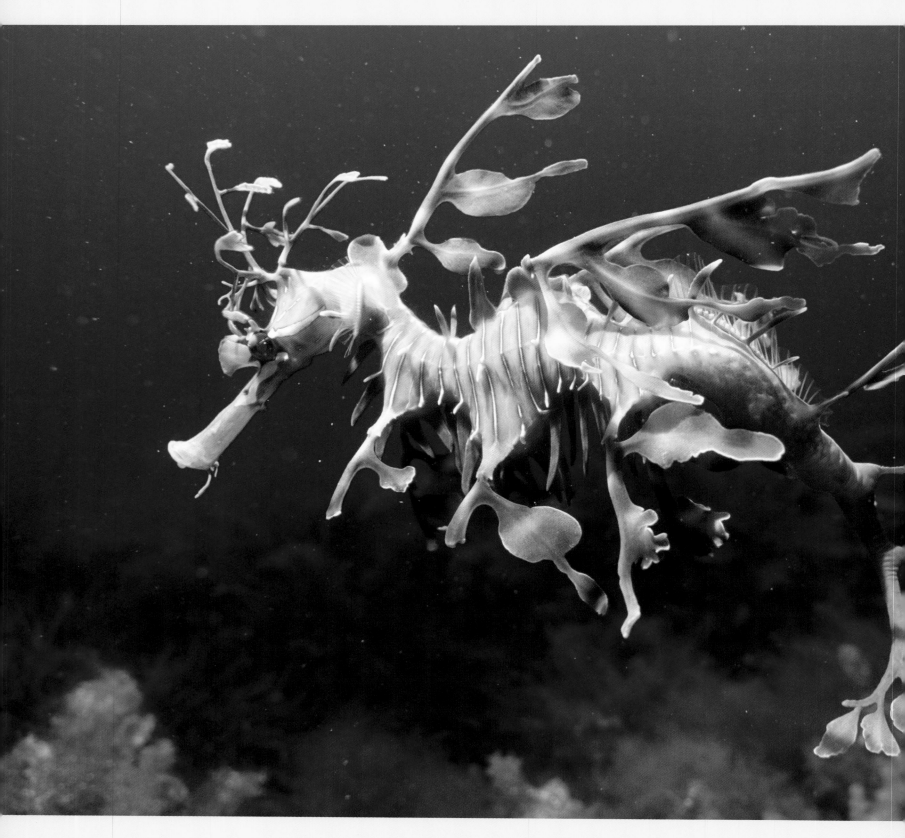

Male Leafy seadragon, Australia. The
leaf-like protrusions provide camouflage,
and it can also change colour to blend in
with its surroundings.

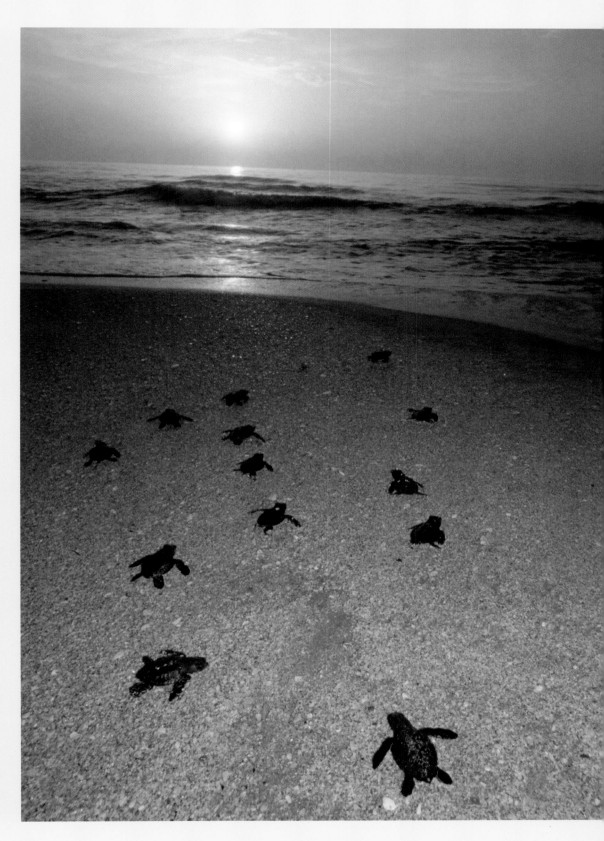

Kemp's ridley turtle hatchlings head for the sea after release from protected nests, Rancho Nuevo, Gulf of Mexico.

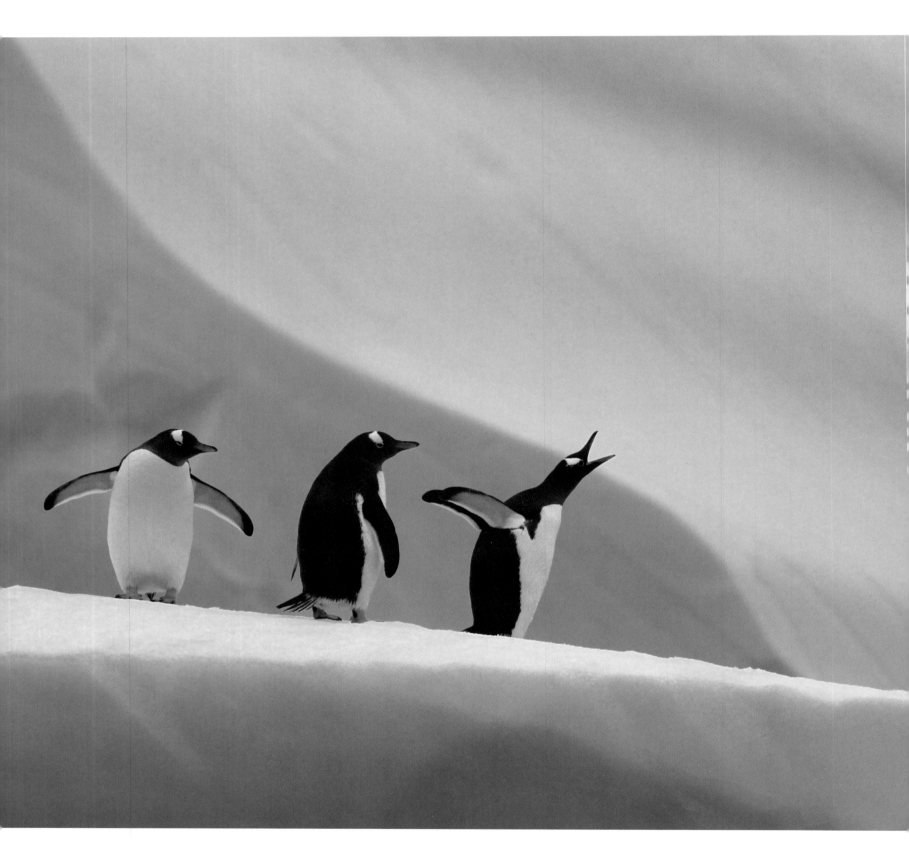

A group of Gentoo penguins on an iceberg, with one calling. Mikkelsen Harbour, Antarctic.

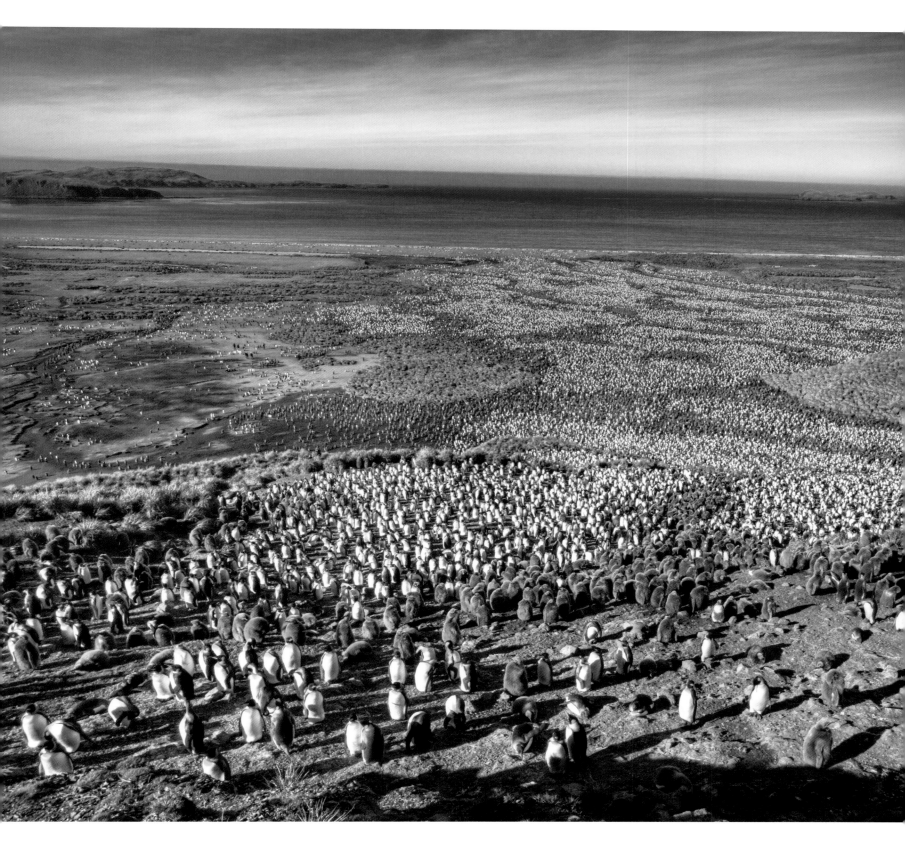

Huge colony of King penguins. The white birds are adults, and the brown birds are chicks. Salisbury Plain, South Georgia.

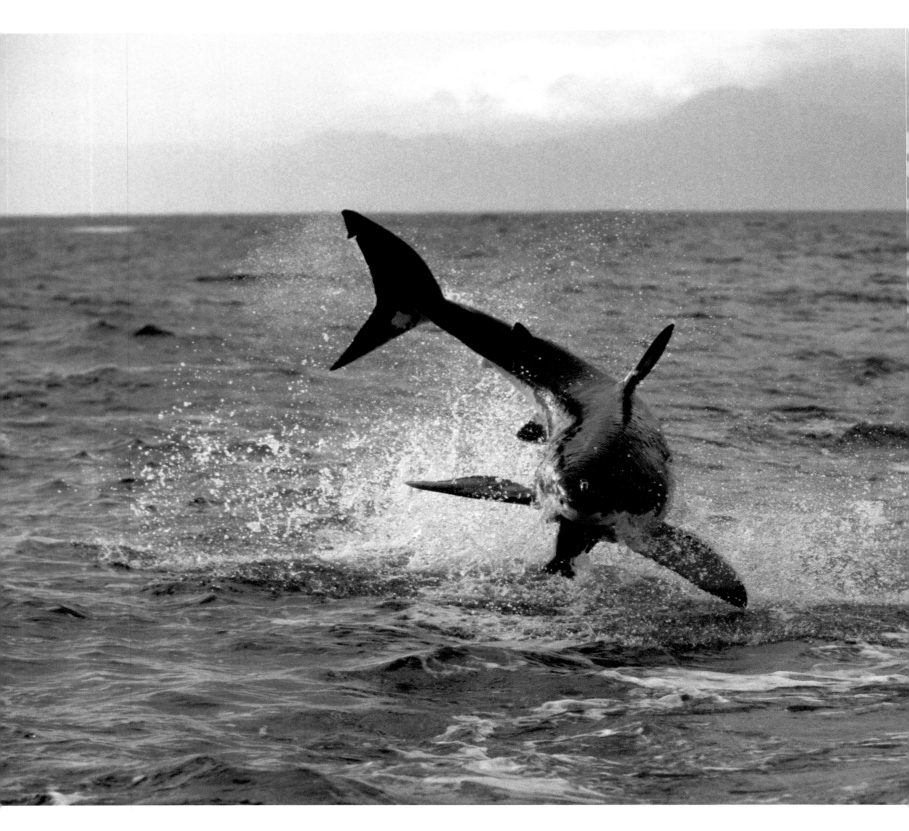

*A Great white shark breaching to catch a
seal decoy, South Africa.*

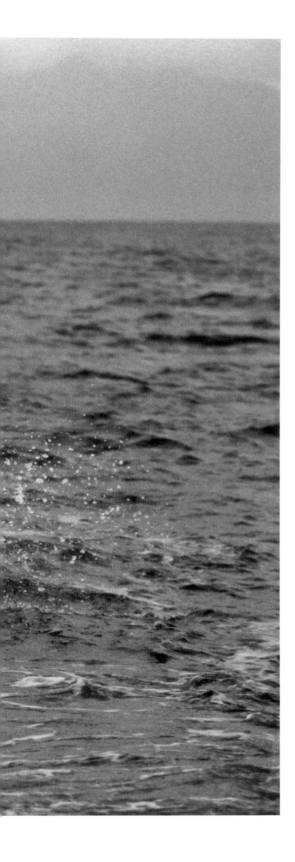

Blue whale surfacing, Channel Islands
National Park, California, Pacific.

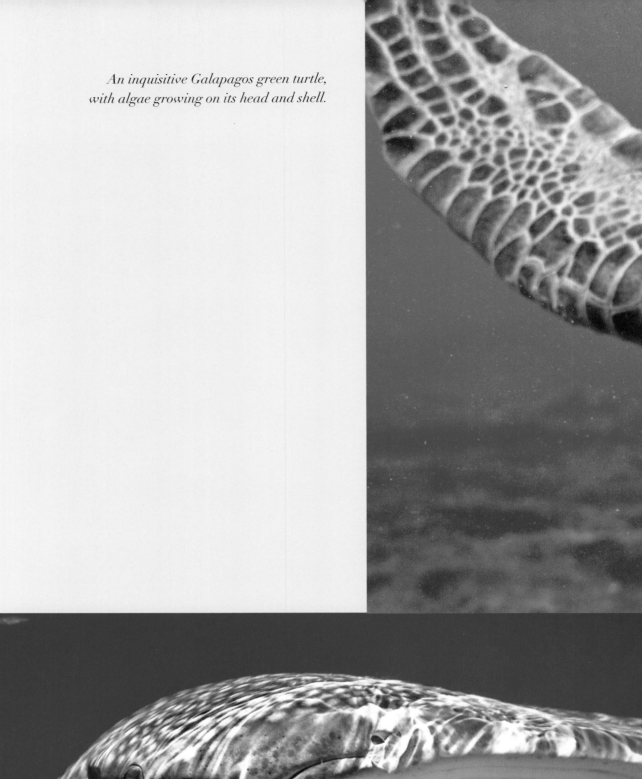

An inquisitive Galapagos green turtle, with algae growing on its head and shell.

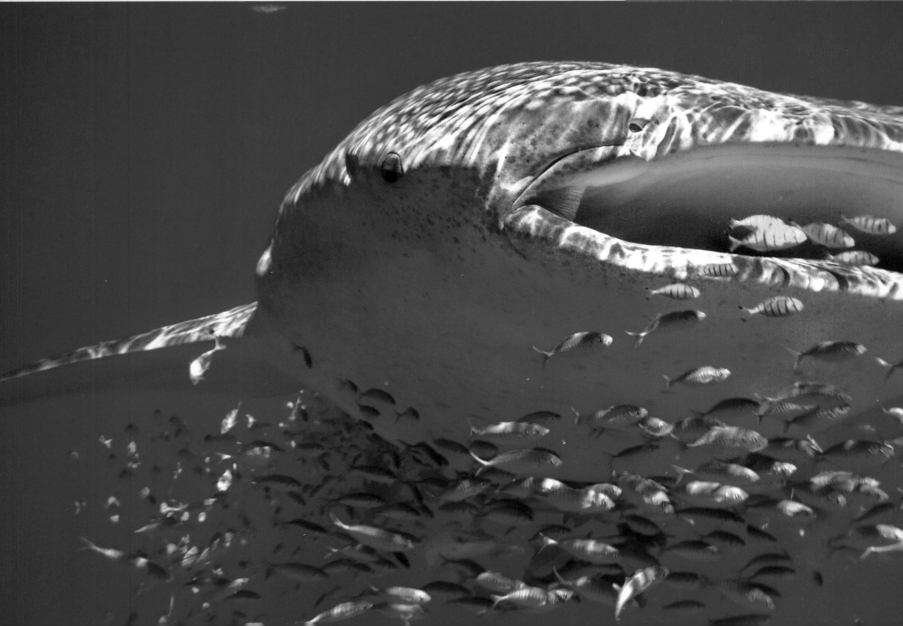

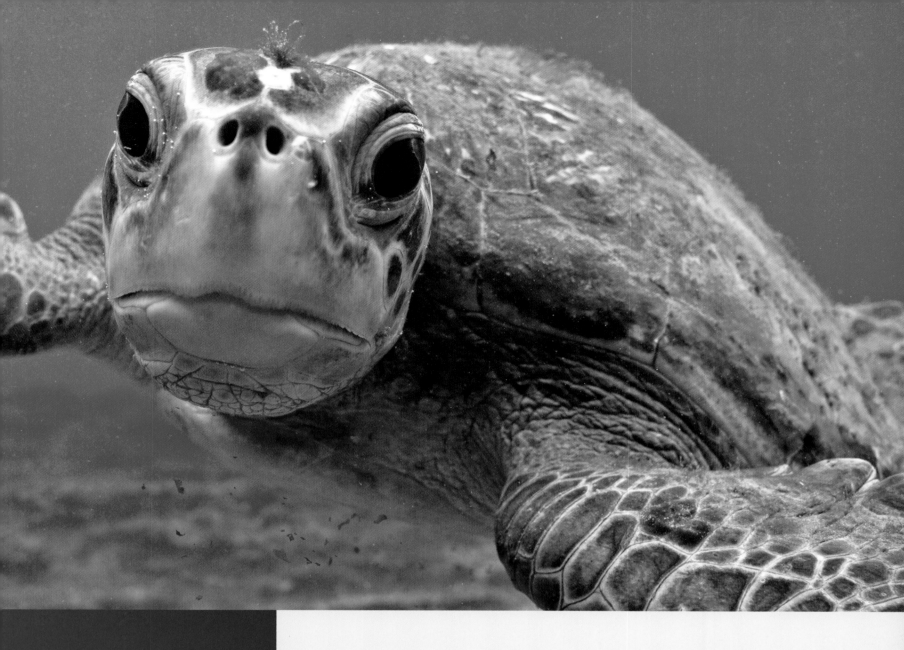

A Whale shark filter feeding, surrounded
by other smaller fish, Ningaloo Reef,
Western Australia.

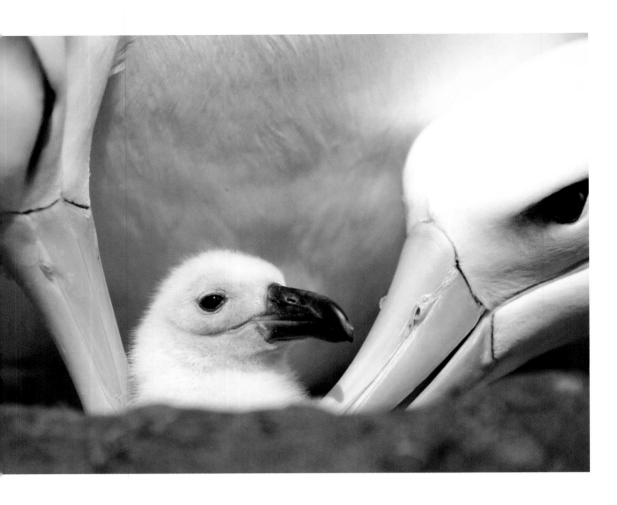

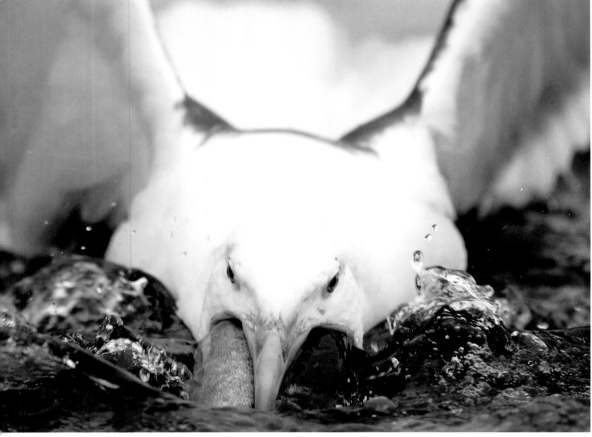

Top: Black browed albatross parents tending their chick, Falkland Islands.

Above: Greater black backed gull swallowing a large fish, Flatanger, Nord-Trøndelag, Norway.

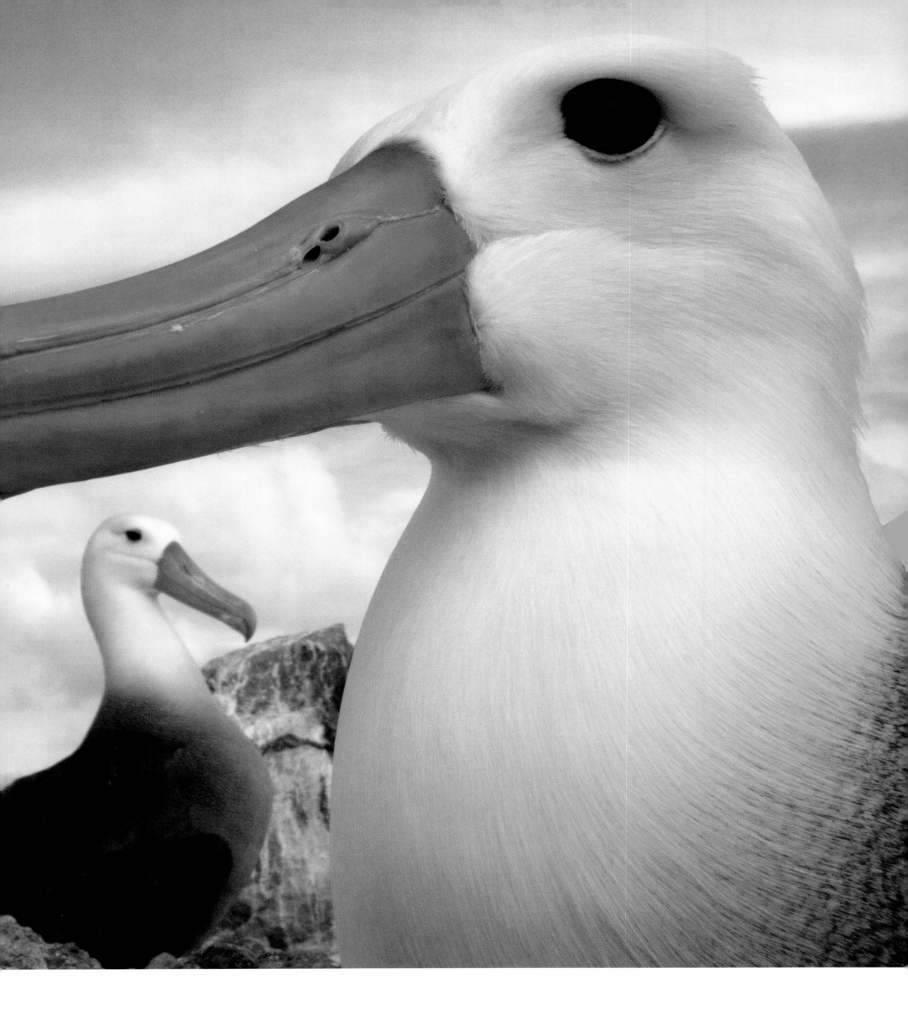

Waved albatross at Punta Cevallos,
Española Island, Galapagos Islands.

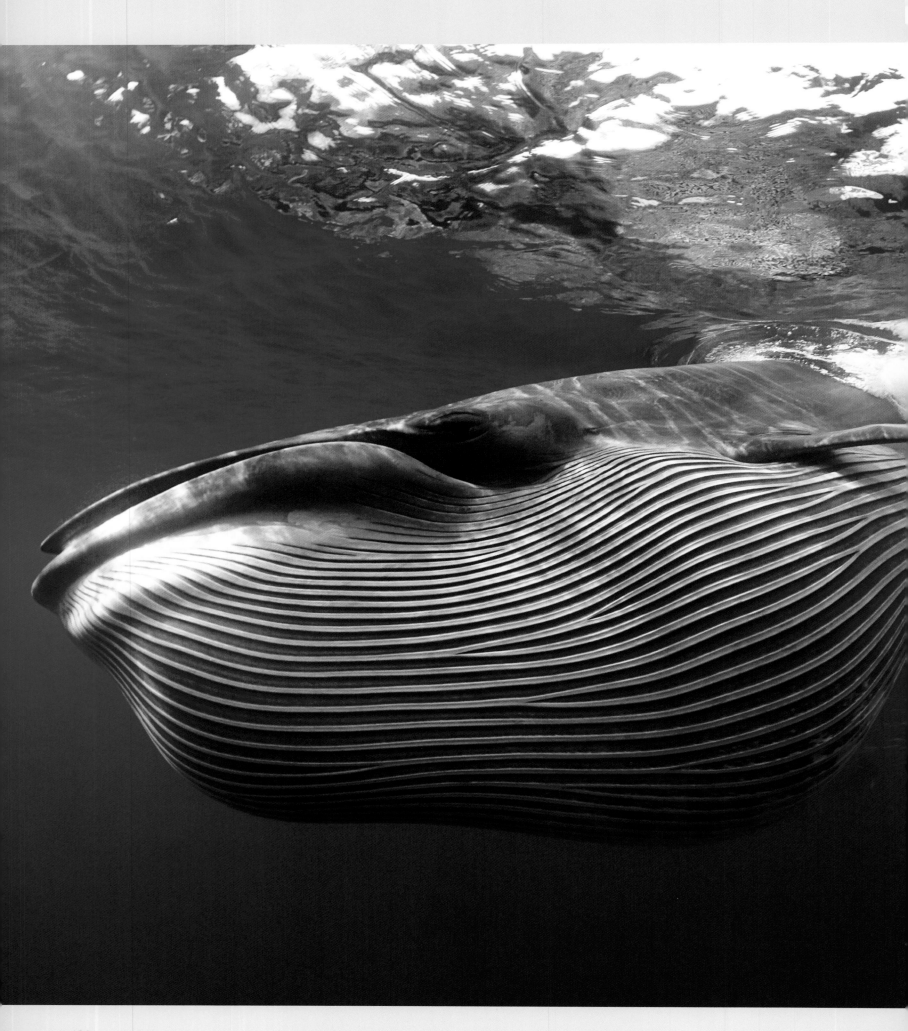

A Bryde's whale with throat pleats
expanded after feeding on a baitball of
sardines off Baja California, Mexico.

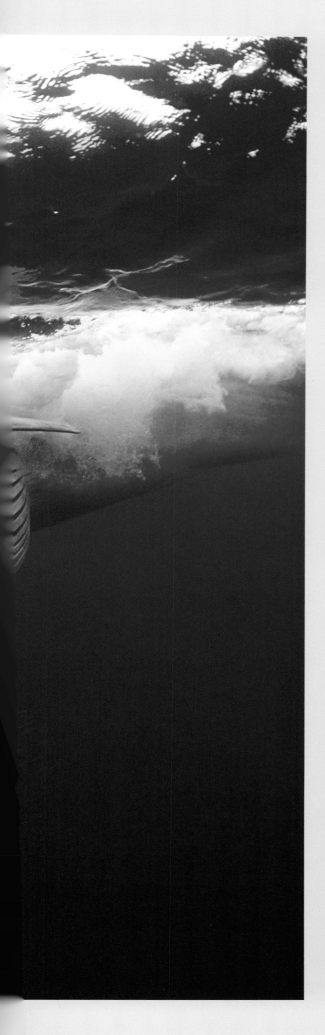

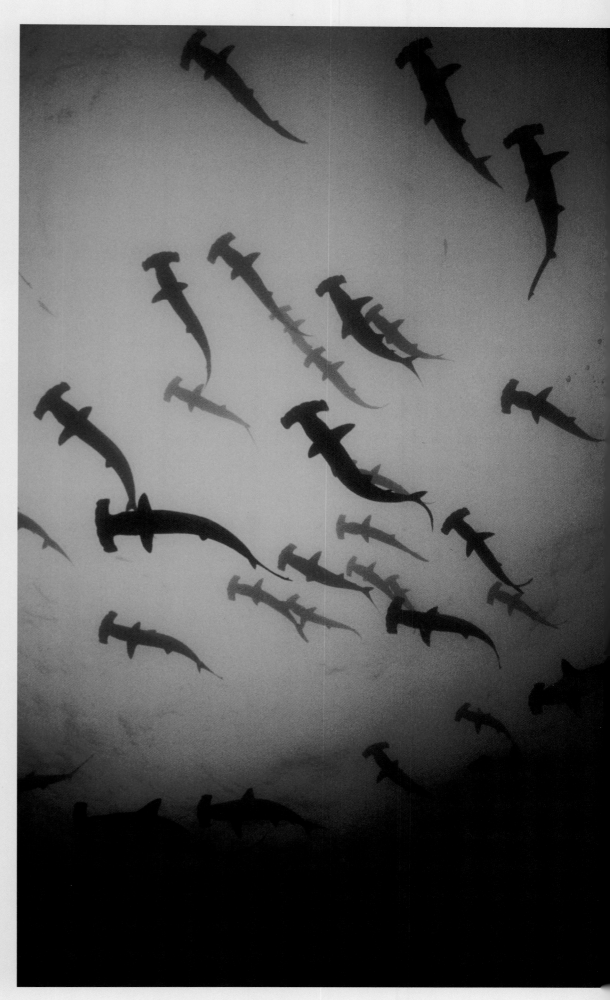

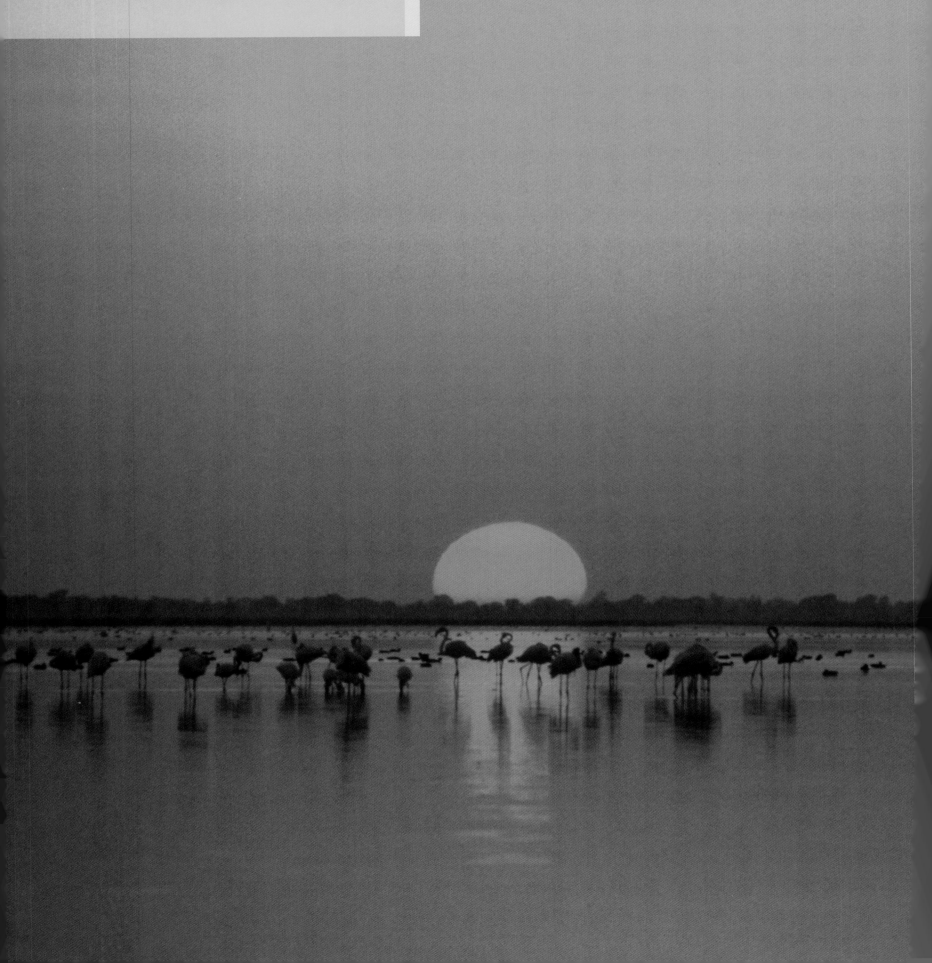

Paradise

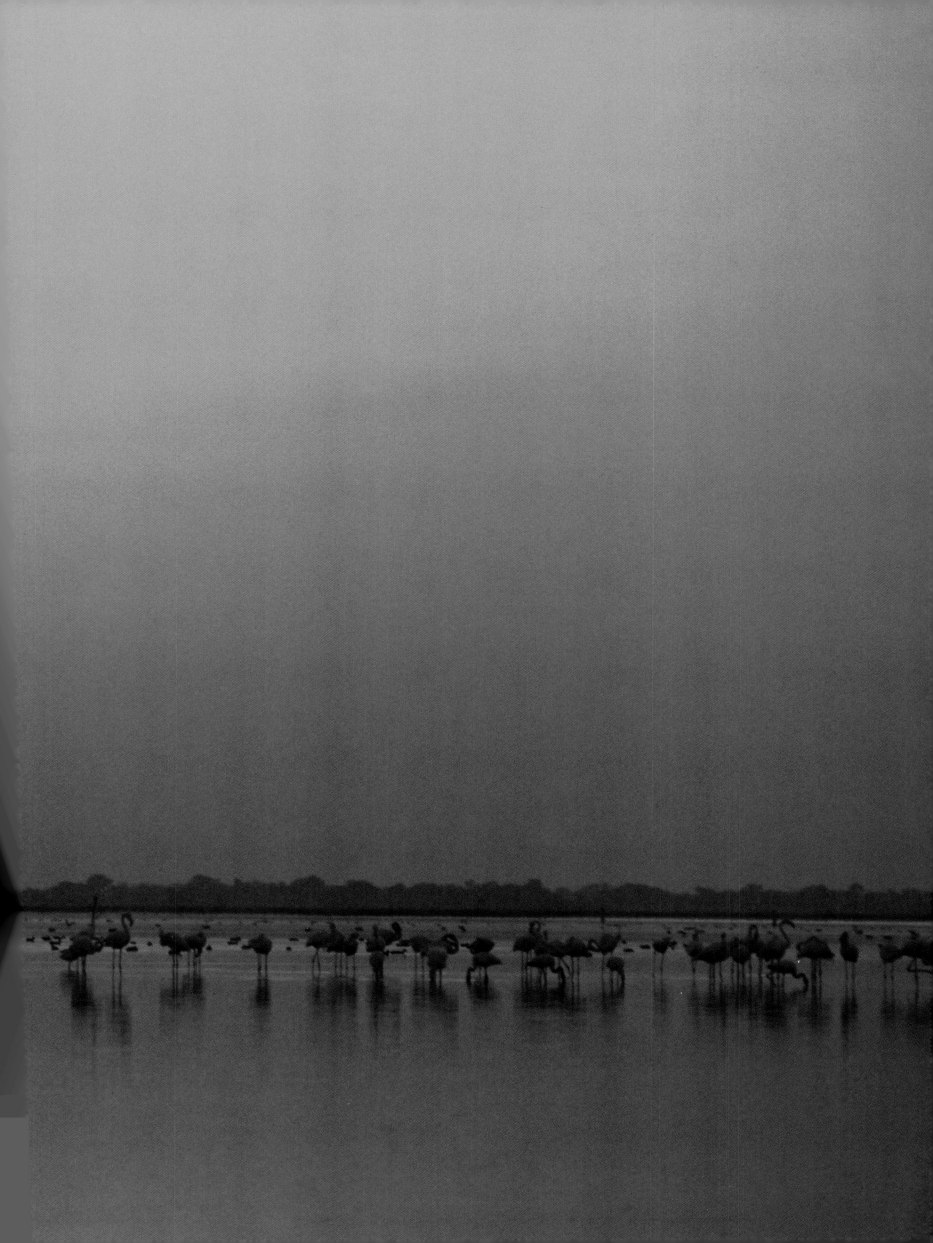

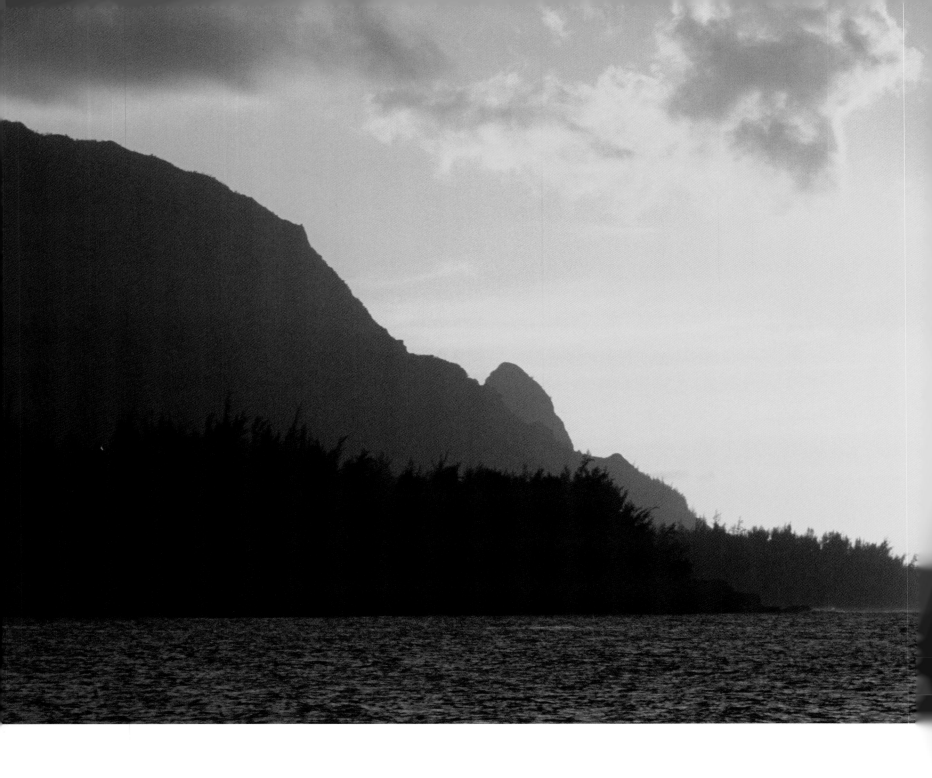

Tropical dreams

Paradise. We all know what paradise looks like, don't we? For most of us, it is a sandy beach fringed with palm trees, with a crystal clear sea lapping at the shore, fish swimming lazily amongst the corals, and the sun beating down on our shoulders. Smartly-dressed waiters mix cocktails at the bar, while goodtime music plays on the radio. We slumber on a mattress as the scent of grilled fish wafts over from the barbecue. Life is good.

But paradise was not always thus. The word originally referred to a walled garden or, more specifically, the great parks created by the noble families of Persia. Later, it was used in certain versions of the Bible to describe the Garden of Eden, and from there the word found its way into the English language. The notion of paradise on earth would remain closely linked to gardens for many centuries to come.

But the benefits of sun, sea and sand were certainly appreciated

by people before the modern era. The Romans travelled on holiday to Greece, Sicily and Egypt, and are said to have produced the first tourist guide, listing the available inns, complete with easy-to-follow ratings symbols. They also built holiday homes around the Bay of Naples, and the area acquired a reputation as a kind of proto-typical tourist resort. Even now, the Bay is a popular destination – though likening it to paradise might be a tad fanciful.

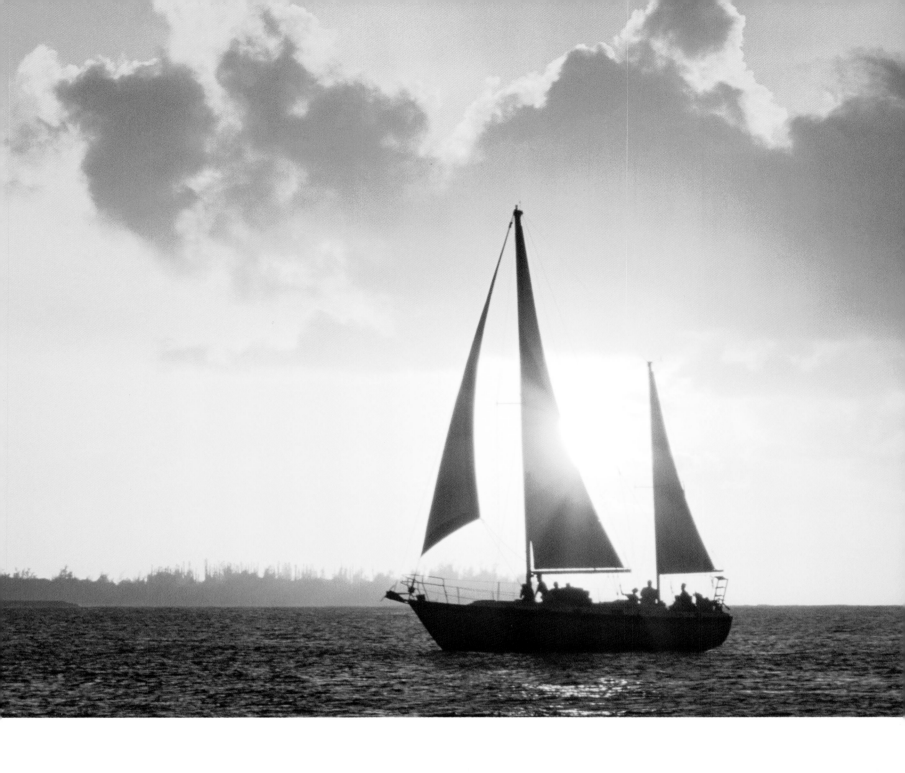

Tourism took a dip in the Middles Ages, and it wasn't until the advent of the Grand Tour in the 17th Century that travel for pleasure became fashionable again. Seaside 'spa' resorts developed throughout Europe from the beginning of the 18th Century, and the concept was exported to the Caribbean as early as 1751, when the 19-year-old George Washington and his ailing brother visited Barbados specifically for its health-giving climate. A few years later, the first tourist hotel opened on the island of Nevis, and soon counted Horatio Nelson and the poet Samuel Taylor Coleridge among its guests. Already, the lure of idyllic beaches and warm seas was beginning to supplant the agrarian concept of paradise in the western imagination.

But the biggest development in our quest for a water-borne nirvana was the arrival of cheap overseas flights following World War II. By the mid-1950s, most of the Caribbean islands were building hotels as fast as they could fill them. Top of the list of attractions were the islands' unsullied beaches and limpid waters; cocktails and massages were optional extras. By the end of the century, an annual overseas holiday was almost regarded as a basic human right, and paradise would never be the same again.

Above: A yacht sailing through the sunset in Hanali Bay, Kavai, Hawaii.

Previous pages: Flamingos wading in the lake at Nal Sarovar Bird Sanctuary, Gujarat, India.

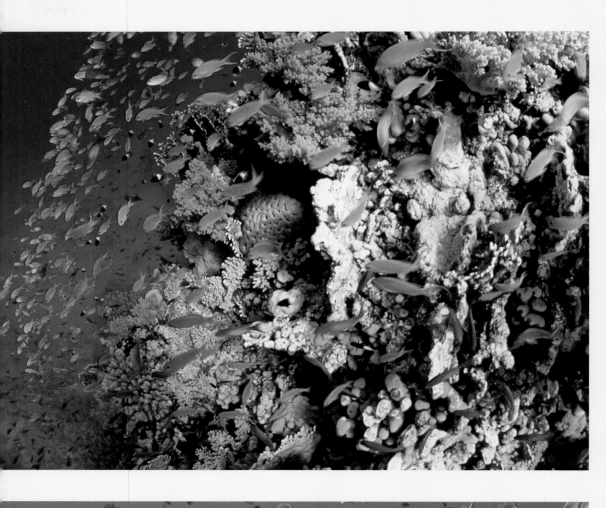

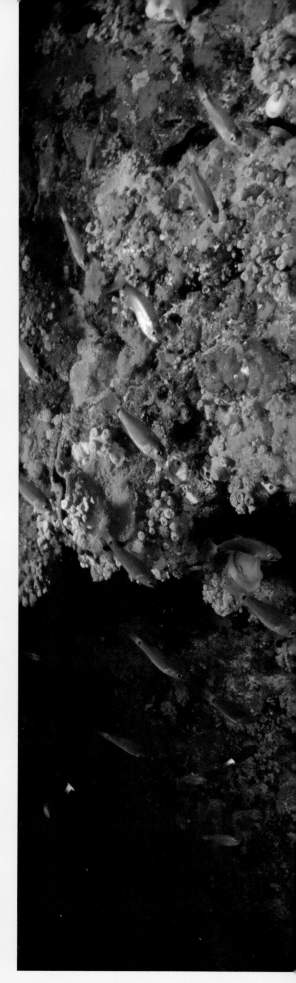

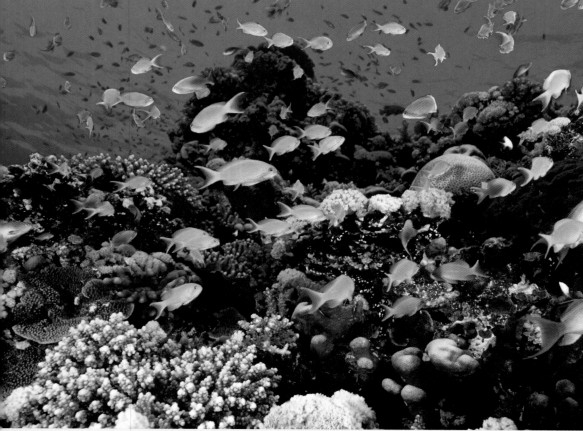

Top: Anthias on a coral reef, Red Sea.

Above: Anthias on a coral reef, Farasan Islands, Saudi Arabia.

Juvenile schooling fish on a coral reef, Indo-Pacific.

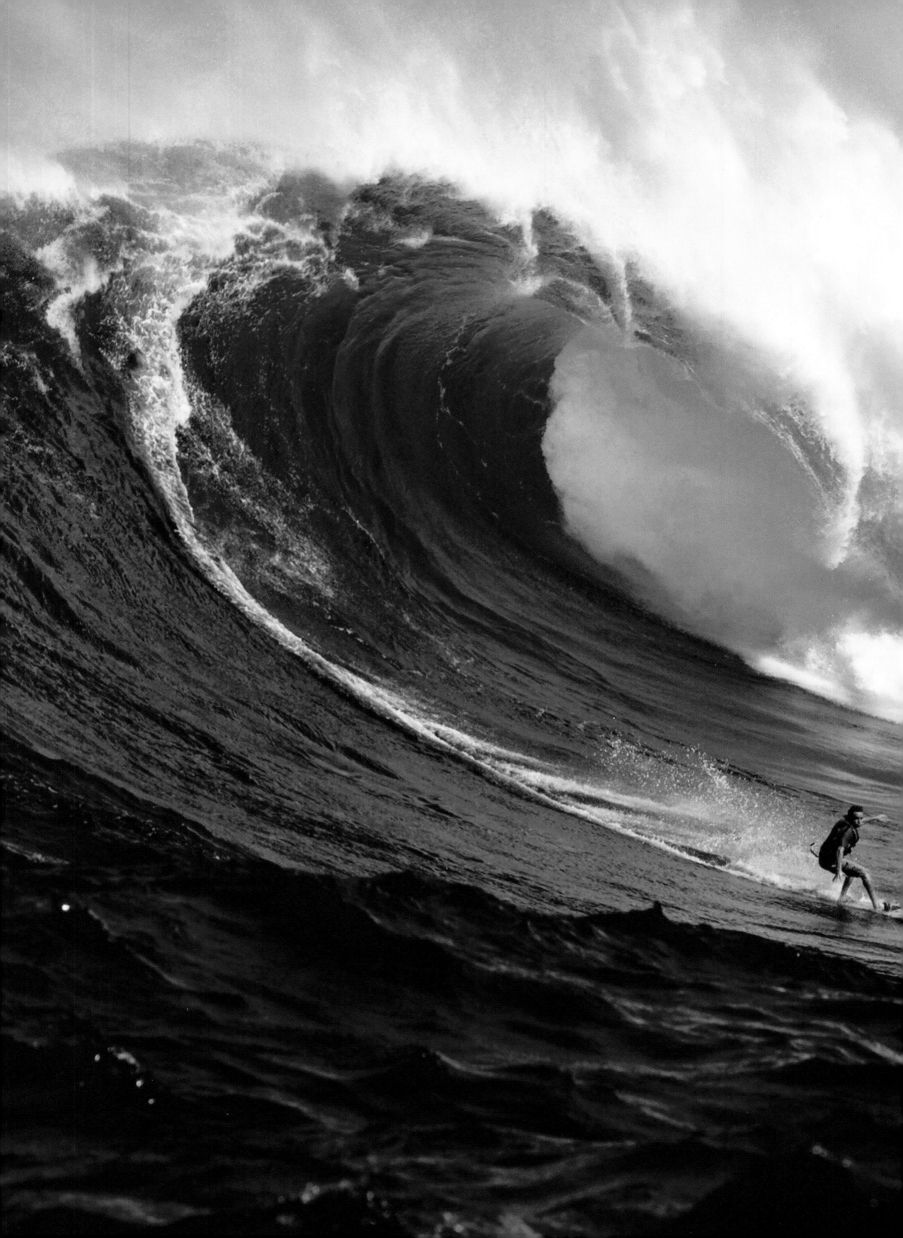

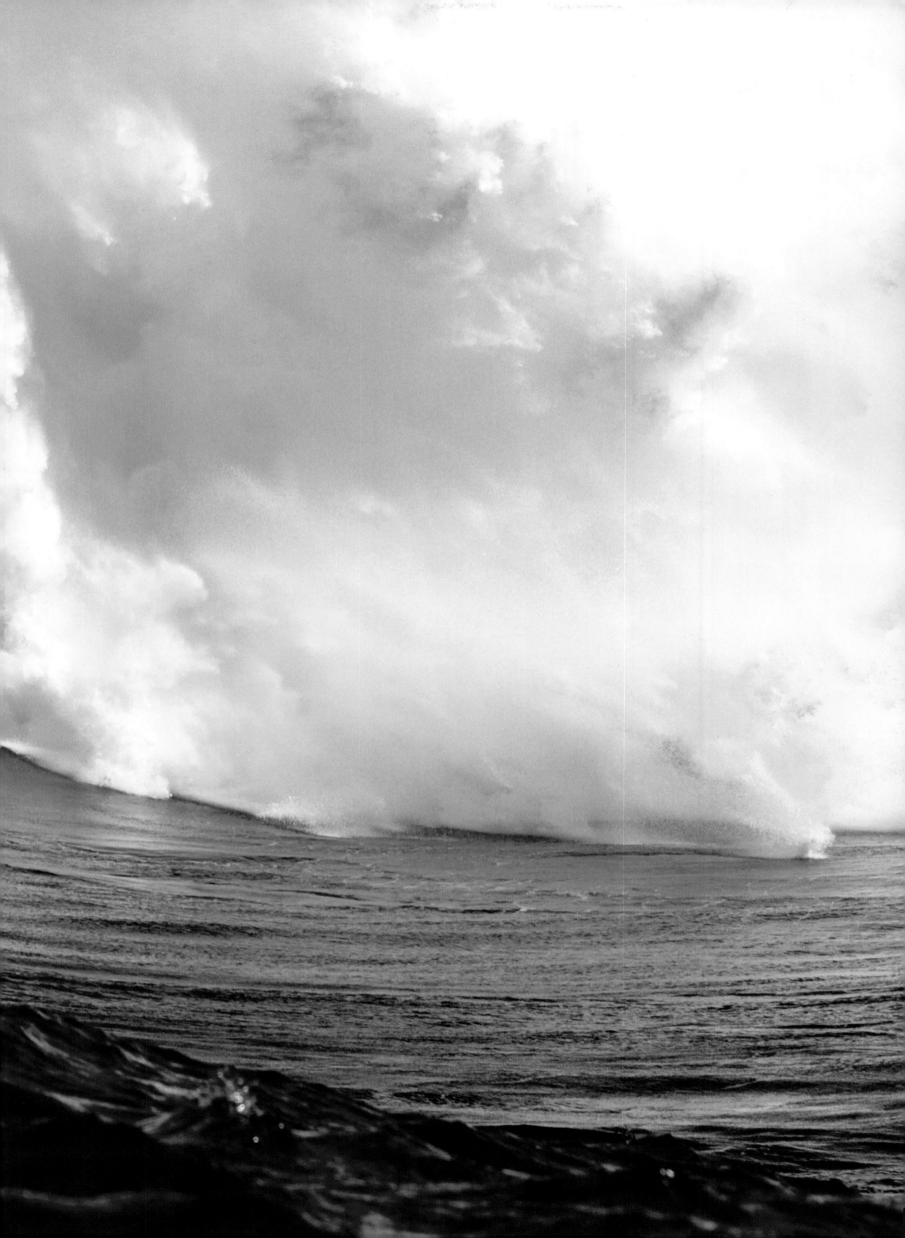

Previous pages: A tow-in surfer drops to the curl of Hawaii's big surf at Peahi (Jaws) off Maui, Hawaii.

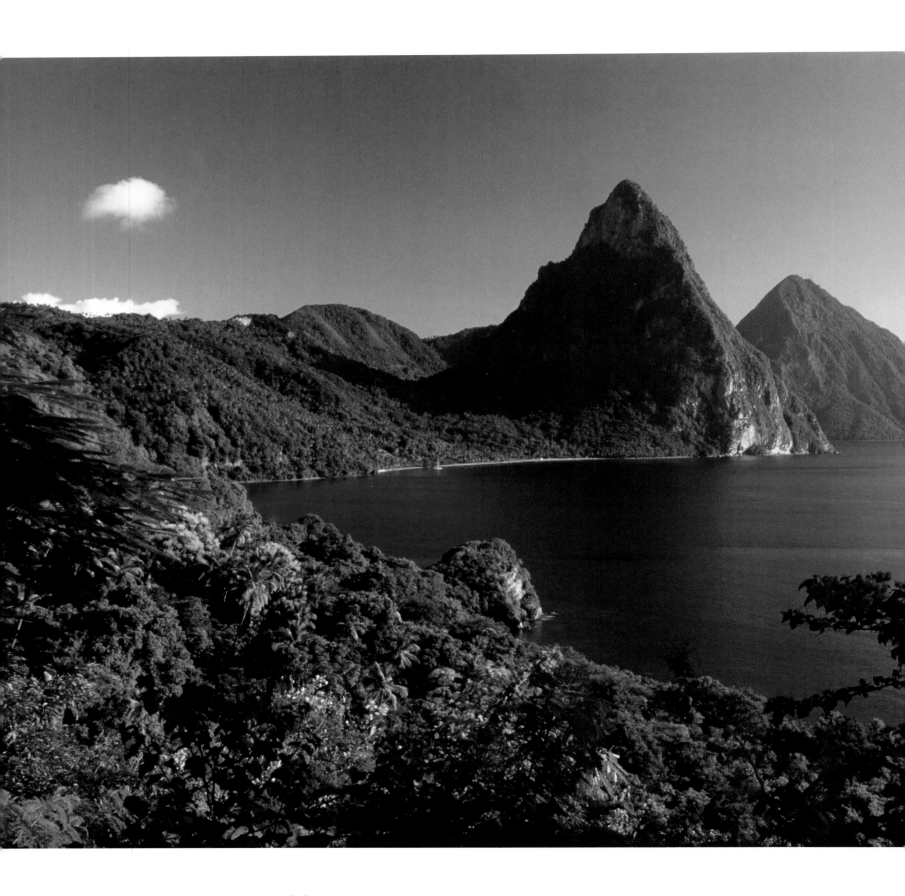

Above: Soufrière Bay landscape with the volcanic peaks of the Pitons, St Lucia, Caribbean.

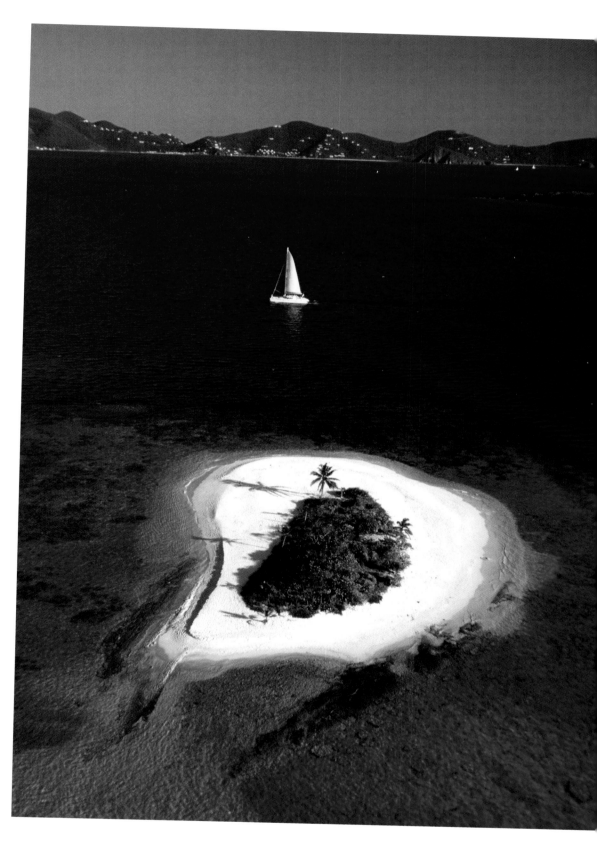

*Sailing yacht near the uninhabited island
of Green Cay, British Virgin Islands,
Caribbean.*

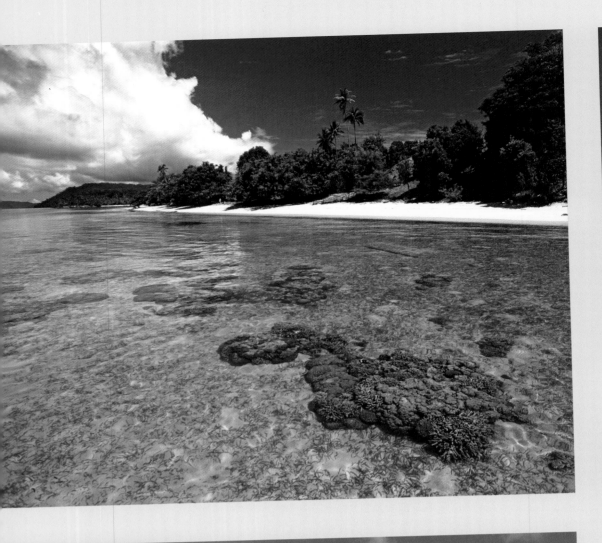

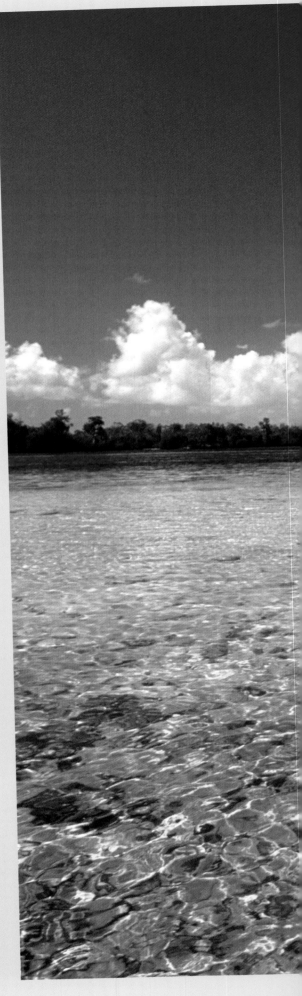

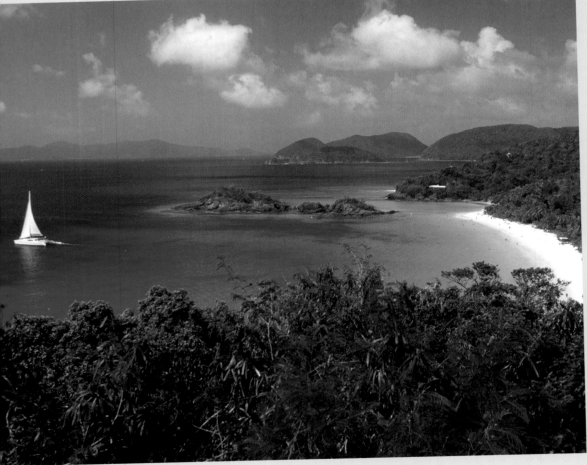

Top: *Coral boulders near the beach at Walea Island, Togian Islands, Sulawesi.*

Above: *Catamaran sailing in turquoise blue water near a secluded white sand beach, Saint John, US Virgin Islands, Caribbean.*

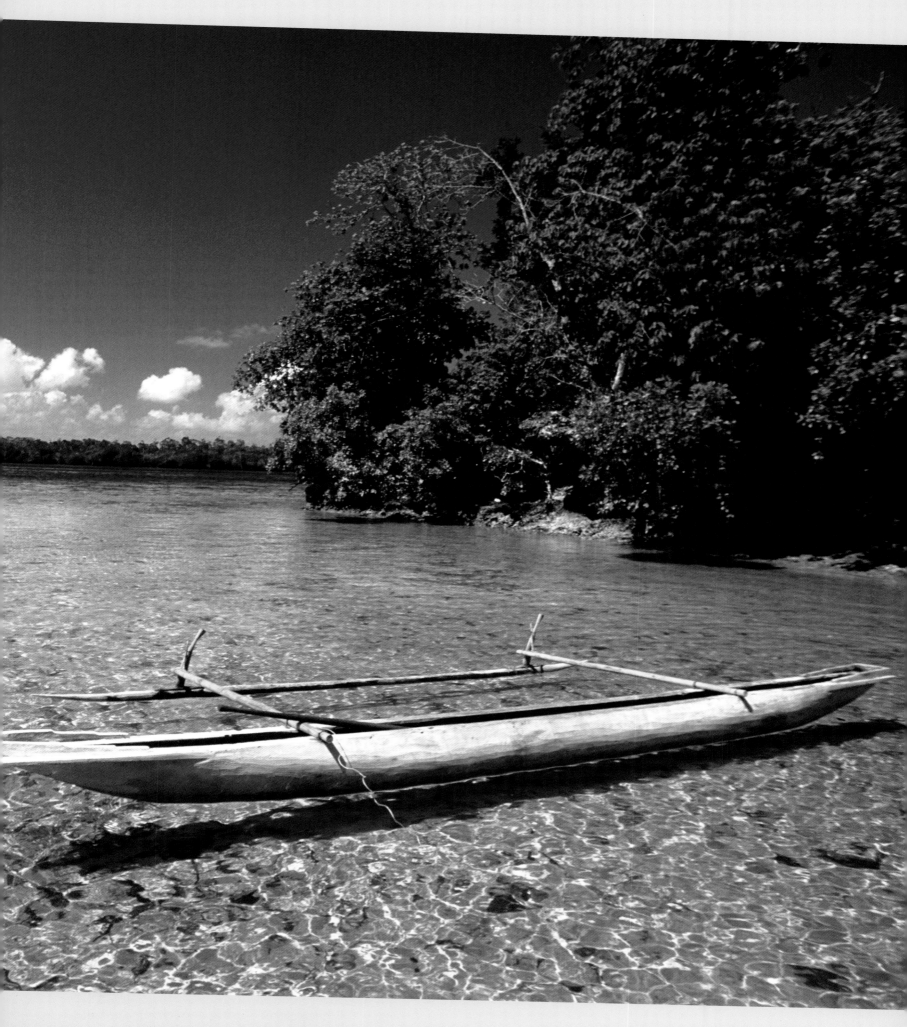

*Traditional canoe (pirogue) in front of a
small island between New Hannover and
New Ireland, Papua New Guinea.*

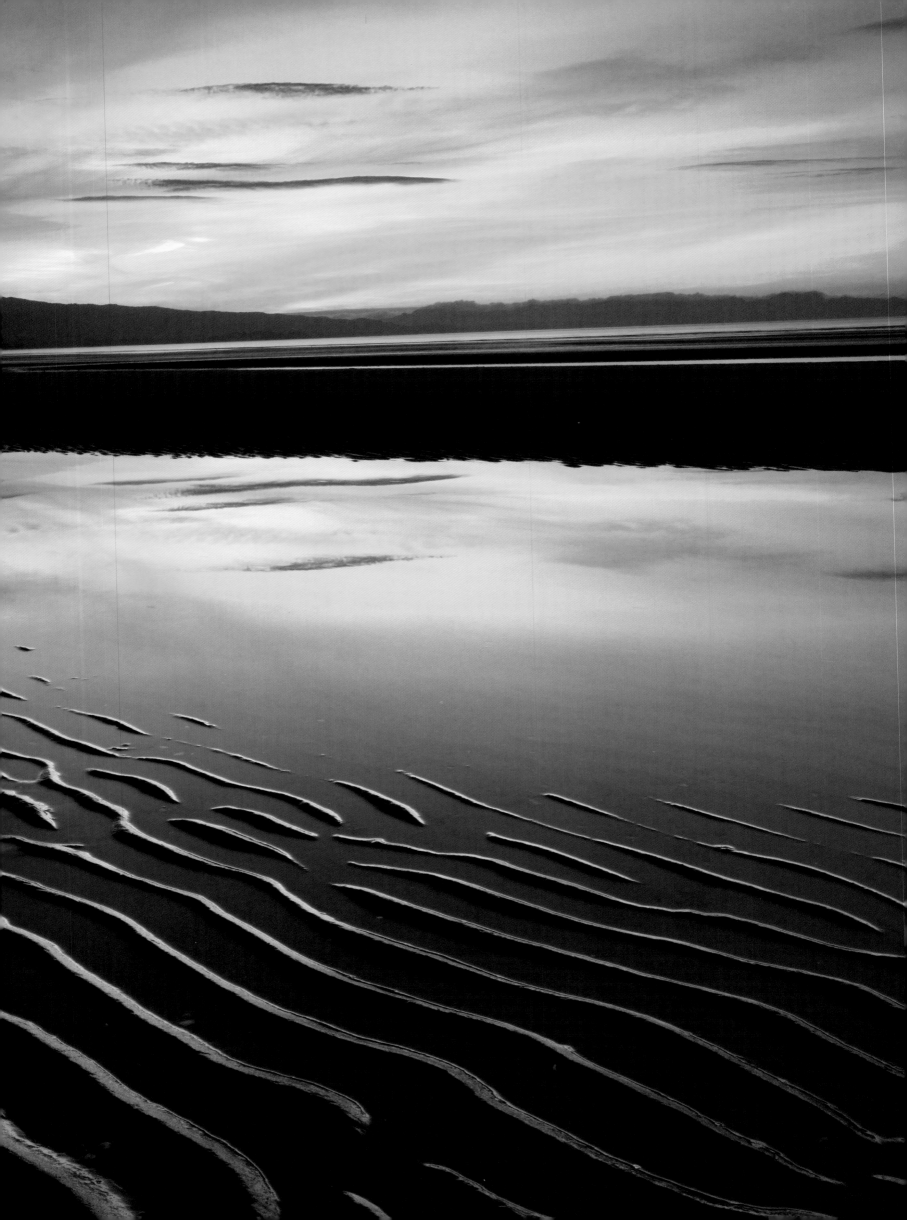

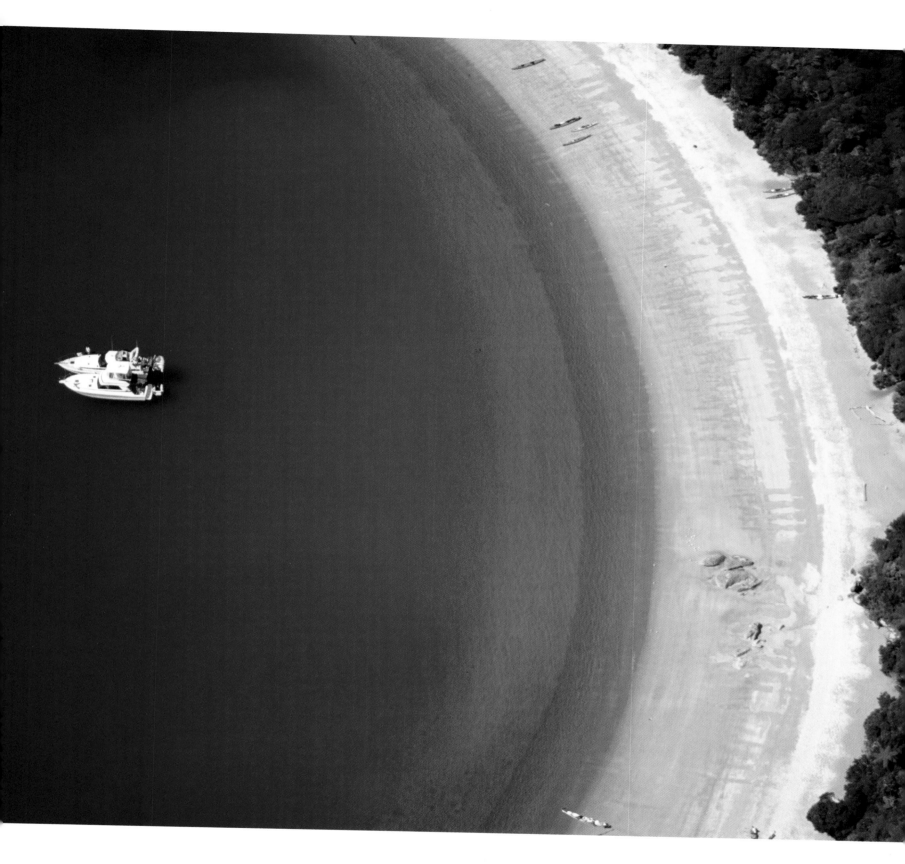

Opposite: Sand ripples at sunset on Pohara Beach in Golden Bay, South Island, New Zealand.

Above: Two motoryachts moored off a secluded beach in the Abel Tasman National Park, South Island, New Zealand.

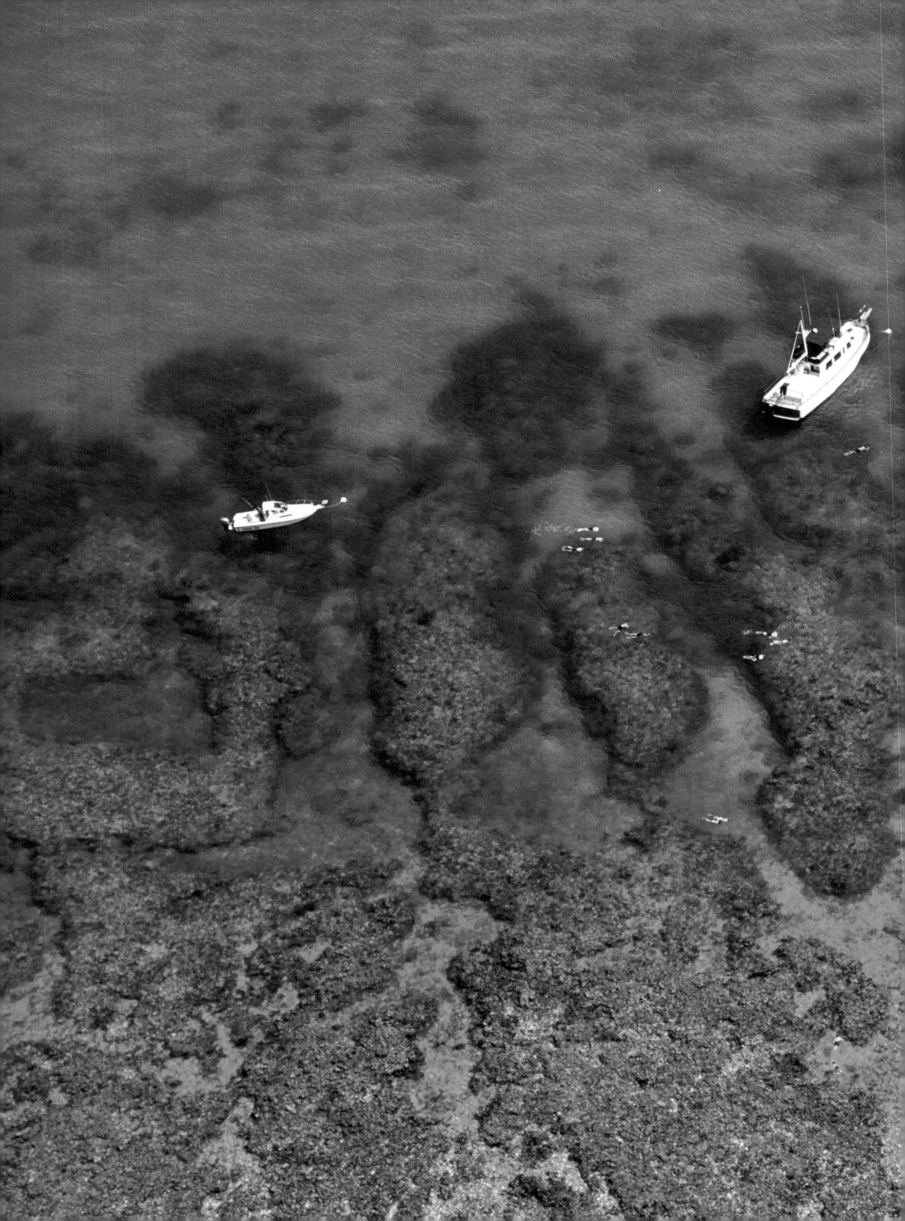

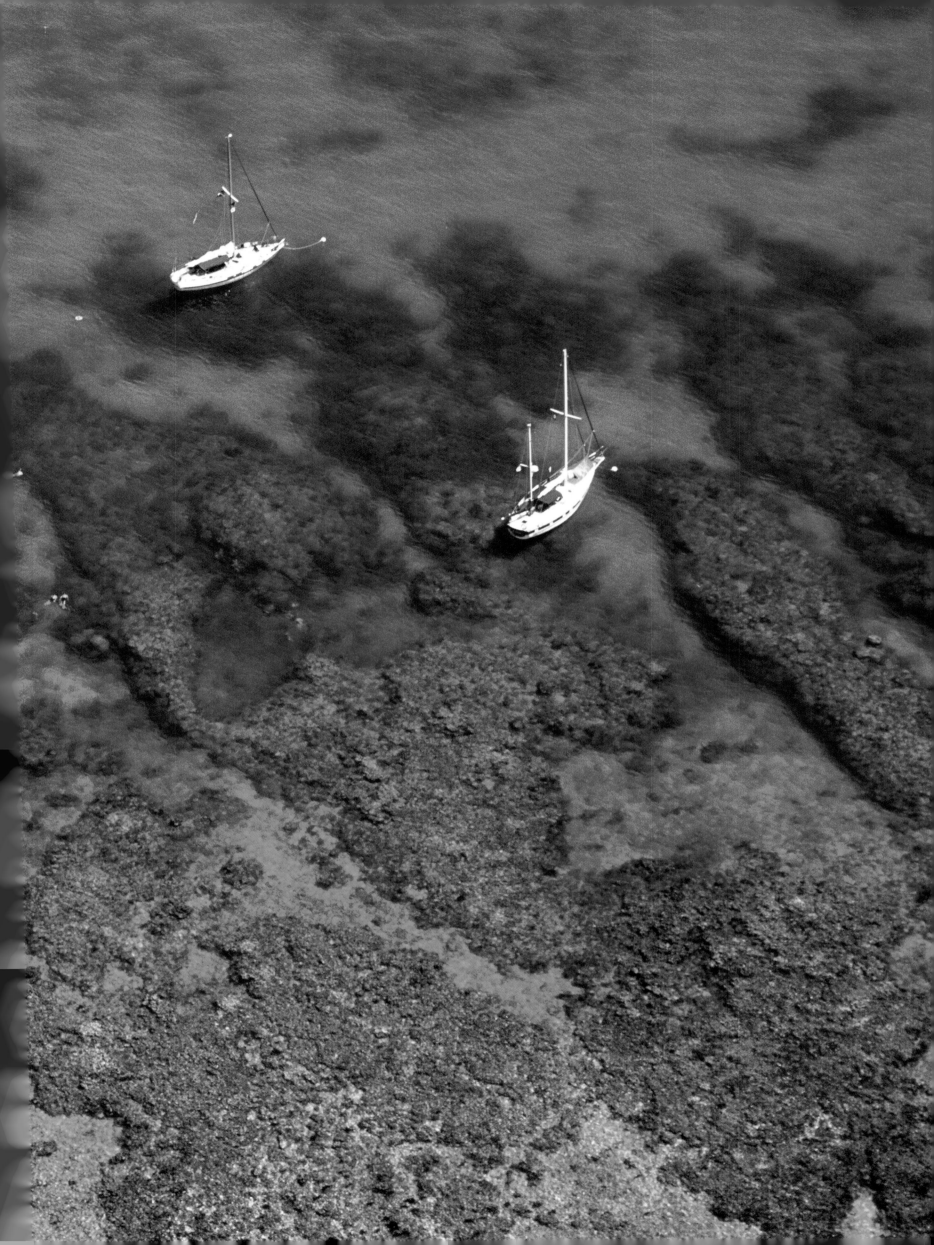

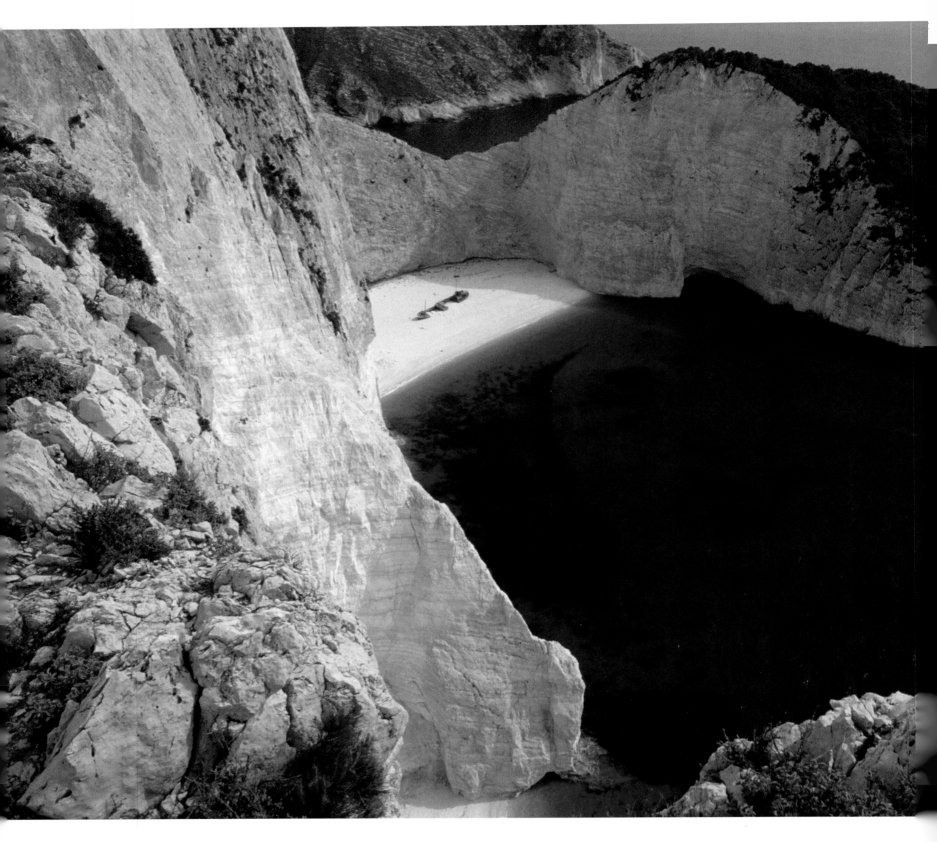

Previous pages: Marina Cay and Scrub Island, British Virgin Islands.

Looking down onto a secluded beach and cove, Zakynthos, Greece.

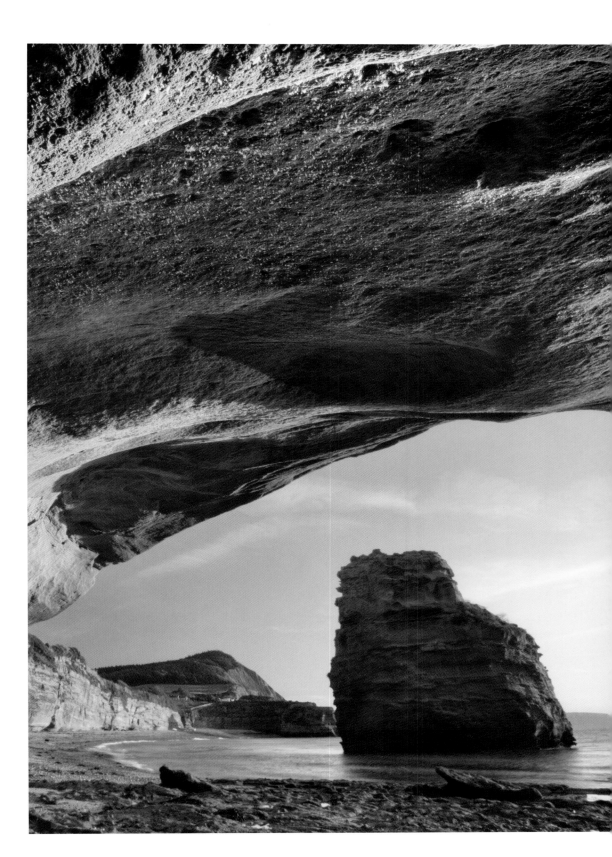

Wavecut under red sandstone cliffs at Ladram Bay, Jurassic Coast World Heritage Site, Devon.

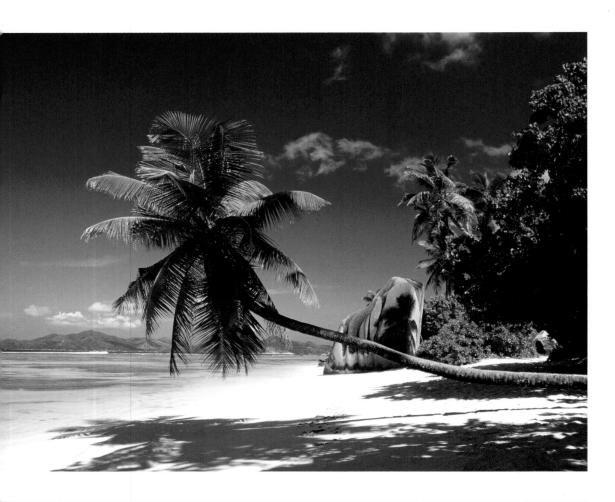

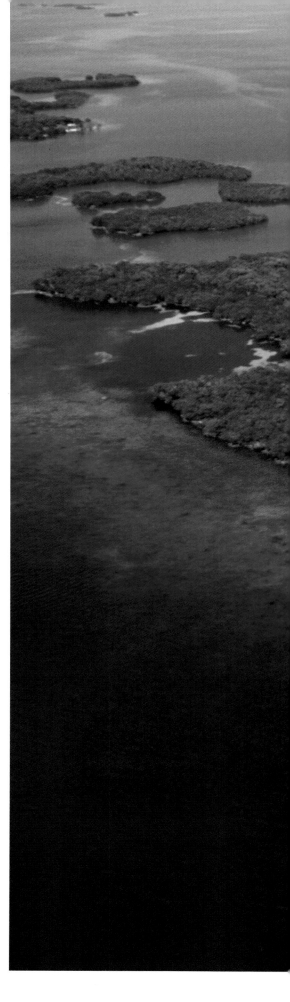

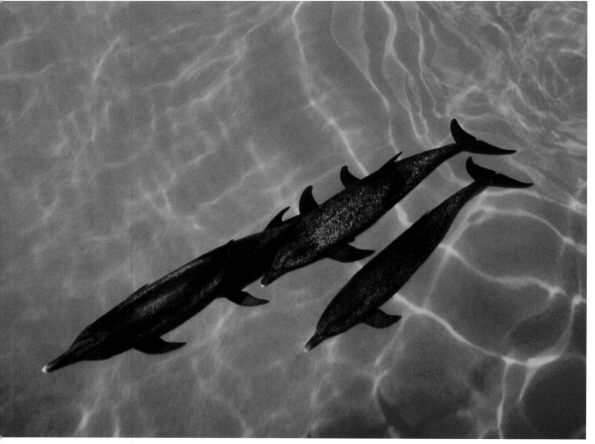

Top: Anse Source d'Argent Beach with granite boulders, La Digue Island, Seychelles, Indian Ocean.

Above: Atlantic spotted dolphins swimming at the surface, Bahamas, Atlantic.

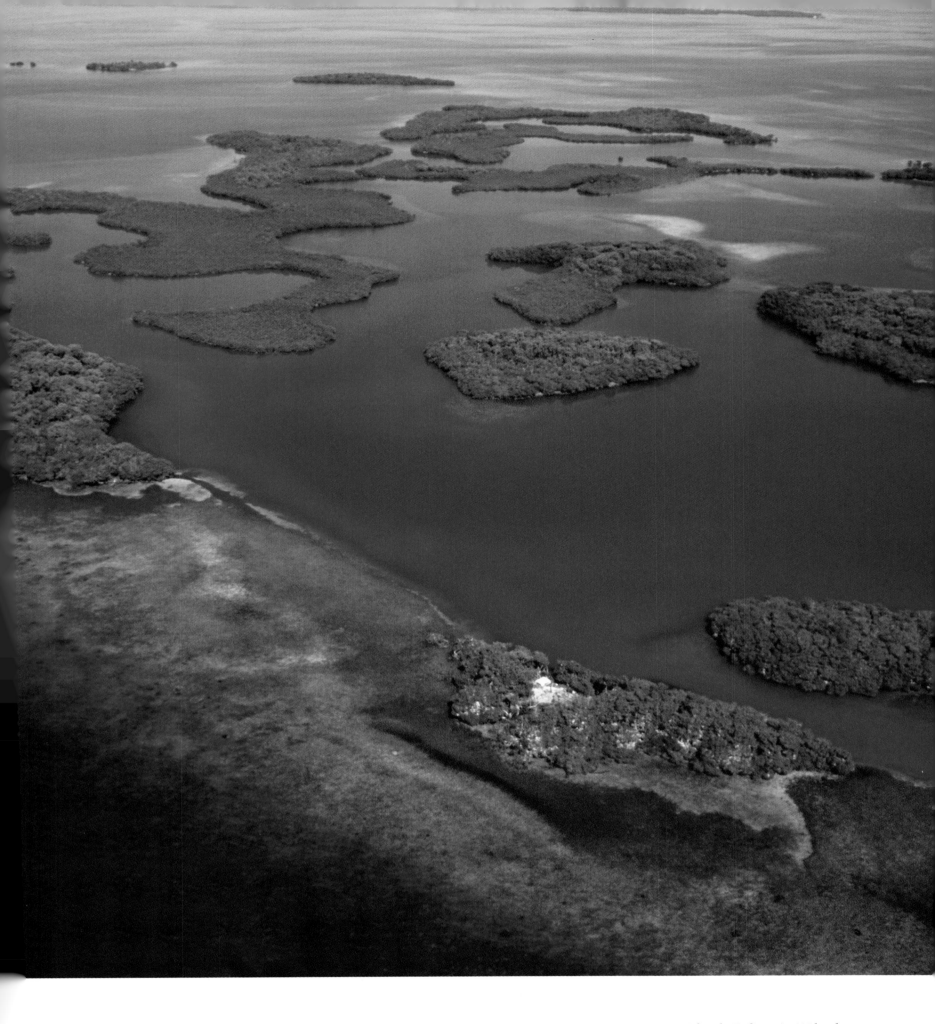

Mangrove islands, Belize. At 600km long, the Belize Western Caribbean Barrier Reef is the longest chain of coral in the Northern hemisphere.

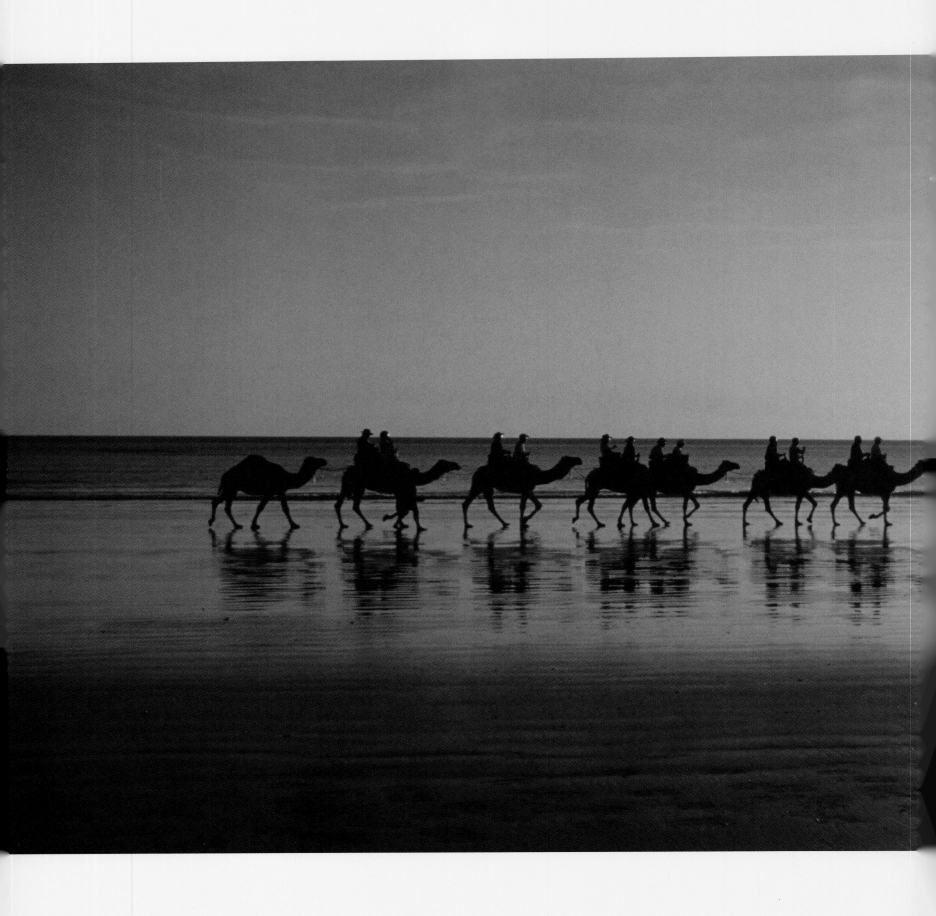

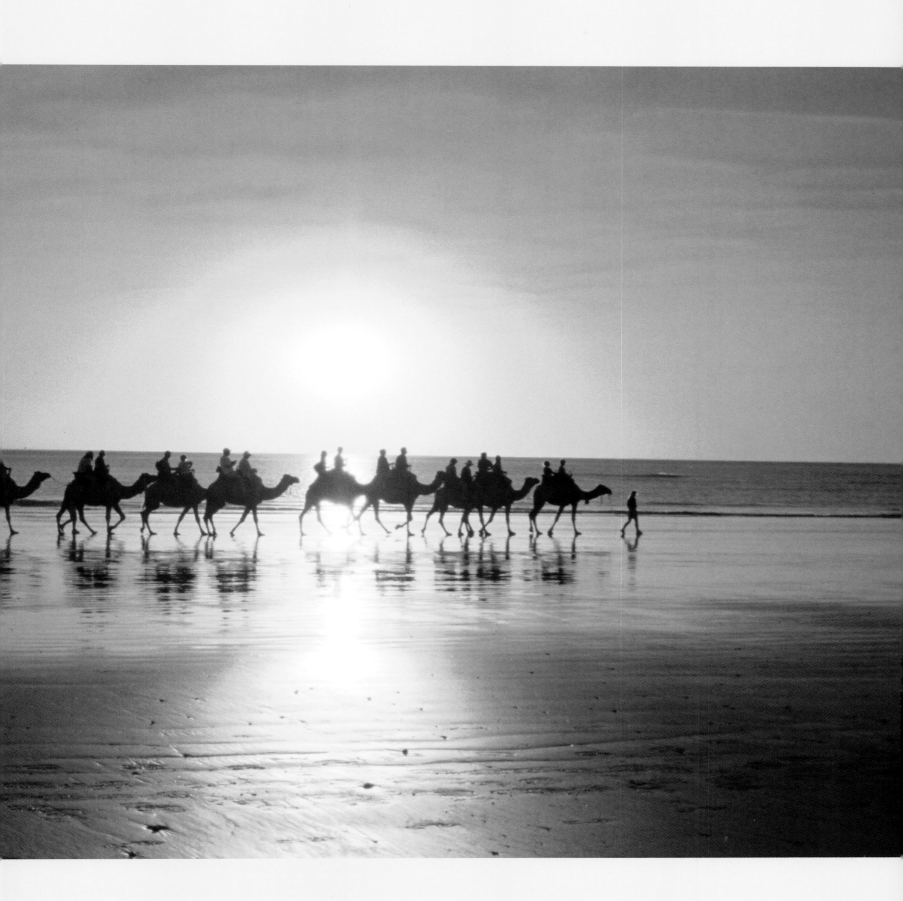

Camel riders on the beach at sunset,
Broome, Western Australia.

Credits

Published by Adlard Coles Nautical, an imprint of Bloomsbury Publishing Plc
36 Soho Square,
London
W1D 3QY
www.adlardcoles.com

Text copyright © Adlard Coles Nautical 2011

Photography copyright © Bluegreen Pictures 2011

First edition published 2011

ISBN 978-1-4081-4665-1

A CIP catalogue record for this book is available from the British Library.

This book is produced using paper that is made from wood grown in managed, sustainable forests. It is natural, renewable and recyclable. The logging and manufacturing processes conform to the environmental regulations of the country of origin.

Typeset in 10.75pt Didot

Printed and bound in China by C&C Offset Printing Co., Ltd

Cover photographs:

Front cover, top: Pointe des Poulains lighthouse on Belle-Ile Island, Morbihan, Brittany (Philip Plisson)

Front cover, bottom: An aerial view of Exuma, part of the chain of 365 islands that form the Bahamas (Onne van der Wal)

Back cover, top: The limestone sea stacks known as the Twelve Apostles, on the Port Campbell coast, Victoria, Australia (Ian Cameron)

Back cover, bottom: A waved albatross at Punta Cevallos, Española Island, Galapagos Islands (Pete Oxford)

Half title page: Half title page: A whirlpool at Saltstraumen, Bodö, Norway (Magnus Lundgren)

Title page: Waves crashing around Tevennec lighthouse in the Sein channel, Finistère, Brittany (Benoit Stichelbaut)

Contents page main photo: Sunrise near Bamburgh Castle, Northumberland (Adam Burton).

Other inside pages, by photographer:

Francis Abbott 135
Aflo 134 (top)
Doug Allan 52
Ingo Arndt 58–9
Franco Banfi 116
Sascha Burkhardt 34 (bottom)
Adam Burton 40–1, 142
Brandon Cole 148 (bottom)
Ian Cameron 6–7
Guy Edwardes 9, 145
Christian Février 23, 39, 66 (top), 88, 91, 98–9, 143, 149
David Fleetham 15, 106–7, 110, 136–7
Sue Flood 51, 80
Jurgen Freund 10, 37, 104
Chris Gomersall 105

O Haarberg 5, 11
Tony Heald 122
Brent Hedges 150–1
Gavin Hellier 138, 148 (top)
Pål Hermansen viii–1
Ashok Jain 130–1
Steven Kazlowski 45, 60, 94–5, 100, 101
Richard Langdon 64, 75
Diego Lopez 18–19, 24 (top), 25, 31, 34 (top)
Magnus Lundgren 93, 111
Roy Mangersnes 102 (bottom), 103
Juan Carlos Muñoz 21, 24 (bottom)
Rolf Nussbaumer 132–3
Pete Oxford 47, 127
Doug Perrine 119, 128, 146–7
Michael Pitts 26–7, 30, 38
Guillaume Plisson vi–vii, 4 (top), 12, 36
Philip Plisson 2–3, 8, 14, 17, 28, 29, 33, 35, 50, 53, 70, 76–7, 79, 82, 84, 85
Philip and Guillaume Plisson 13, 16, 78, 81, 83, 90
Neil Rabinowitz 139, 141 (bottom)
Roberto Rinaldi 112, 134 (bottom), 140, 141 (top)
Catherine Jouan and Jeanne Rius 48–9, 54–5
Gabriel Rojo 57
Jeff Rotman 129
Andy Rouse 42, 56, 120, 121, 124, 125
Peter Scoones 118
David Shale 114, 115
Benoit Stichelbaut 32, 66 (bottom), 67, 96, 102 (top)
Rick Tomlinson vi, 4 (bottom), 46, 61, 62–3, 71, 97
Onne van der Wal 22, 44, 68–9, 74, 86–7
Michele Westmorland 109
Staffan Widstrand 126 (bottom), 144
Doc White 123
Solvin Zankl 117, 126 (top)
Yvan Zedda 72–3